Other Books by Vilém Flusser
Published by the University of Minnesota Press

Does Writing Have a Future?

Into the Universe of Technical Images

*Vampyroteuthis Infernalis: A Treatise, with a Report by
the Institut Scientifique de Recherche Paranaturaliste*

Writings

Gestures

Vilém Flusser

Translated by
Nancy Ann Roth

UNIVERSITY OF MINNESOTA PRESS
Minneapolis
London

The English translation of "The Gesture of Photographing" previously appeared in *Journal of Visual Culture* 10, no. 3 (2011): 279–93.

Originally published in German as *Gesten: Versuch einer Phänomenologie* by Bollmann Verlag. Copyright 1991, 1993 by Bollmann Verlag.

Published by the University of Minnesota Press
111 Third Avenue South, Suite 290
Minneapolis, MN 55401-2520
http://www.upress.umn.edu

Library of Congress Cataloging-in-Publication Data

Flusser, Vilém, 1920-1991.
 [Gesten. English]
 Gestures / Vilém Flusser ; translated by Nancy Ann Roth.
 Includes bibliographical references and index.
 ISBN 978-0-8166-9127-2 (hc : alk. paper)
 ISBN 978-0-8166-9128-9 (pb : alk. paper)
 1. Body language. 2. Gesture—Psychological aspects. I. Title.
 BF637.N66F5813 2014
 153.6'9—DC23
 201303893

Printed in the United States of America on acid-free paper

The University of Minnesota is an equal-opportunity educator and employer.

23 22 21 20 19 18 17 16 10 9 8 7 6 5 4 3

Contents

Translator's Preface

Flusser selected and ordered the essays to be included in *Gestures*[1] in 1991, just months before he was killed in an automobile accident. He was living in France at the time, traveling frequently to Germany for speaking and teaching engagements, for at seventy years of age, he was enjoying a degree of fame for the first time in his life, primarily as a critic and theorist of new media in a German-speaking context. The new notoriety brought new publishing opportunities: the *Gestures* book was to be published in German. Yet nearly half of the selected essays were in French.

Flusser wrote for publication in four languages. Of these, German was the language he used most often,[2] followed, in descending order, by Portuguese, English, and French.[3] He developed what appears to have been a unique pattern of translating his own essays into the other languages available to him. At the same time, he was articulating a theory of translation closely bound up with his own sense of himself as leading a nomadic, *"bodenlos"*—literally, "foundationless"—life. Flusser describes his own process of translation and "back-translation" (moving from a target language back into the source language) in some detail in "The Gesture of Writing," a text written in English.[4] A version of the essay—by the same name—appears in this volume of *Gestures,* my translation from the German text that formed part of the 1991 edition. The text published here covers much of the same theoretical ground as the version Flusser wrote in English but does not include nearly so extensive a description of his idiosyncratic patterns of thinking and writing in different languages. In fact, there are seven different versions of "The Gesture of Writing" in four different languages,[5] making it a good example of the difficulty that

accompanies any search for an "original" text, of deciding which of many existing versions was "first," to say nothing of which should be considered "authentic," "definitive," or even "complete." It is as if we are dealing with seven different originals.

Rainer Guldin sees translation as a central idea that structures Flusser's thought as a whole.[6] In a very succinct recent account of the translation practice, he writes,

> In Flusser's work, nomadism is . . . metaphorically linked to a specific notion of translation as a basically endless, open-ended enterprise. The translator is forced to move on continuously, striving at the same time to get back to the origin, only to discover that there is no such possibility. Meaning is homeless and itinerant.[7]

Depending as it did on his very particular engagement with the languages at his command, Flusser's self-translation process was clearly unique to him. Evidence of the idiosyncrasy and particularity of his sense of what translating is and does appears in many places, sometimes very fleetingly. In *Does Writing Have a Future?*, for example, he asserts that "a writer forces the spoken language to accommodate itself to orthographic rules. Language defends itself. Each language defends itself according to its character. German is slippery, English brittle, French deceptive, Portuguese sly."[8] This particular conclusion must be Flusser's alone. Given that no one else would sense the same relationships among these languages, he is right to say that the only translation that meets the criteria he sets will be one by the author himself, neatly ruling out the intervention of any other translator.

And yet even the first edition of this book involved an external translator. One possible resolution to the apparent conflict might be that publication did have some stabilizing effect on Flusser's nomadic patterns of writing. It seems likely, too, that Flusser recognized others'—notably publishers'—understanding of translation while continuing to practice and theorize his own:

> if the solution reached is more or less satisfactory, the text will be published . . . the publication of a text, however, is a profoundly ambiguous act in a way, embodying only a temporary compromise.[9]

The first publication of *Gestures* in 1991 should be understood as such a solution. No doubt Flusser considered the decisions tentative and ambiguous. Still, that was the moment he deliberately ordered particular texts in a particular way in one language. On that occasion, the French texts mentioned earlier were translated into German by Wilhelm Miklenitsch under Flusser's direction, and some new text was dictated as well.[10] "Texts must flow," he had written a little earlier.

> Compressed letters, words, sentences and paragraphs must follow one on the other without gaps. Particles of text must be built into a wave structure. It is about rhythm, about layered levels of rhythm. . . . Texts must harmonize. There are two sorts of harmonies, rhythms. In the first, one wave of discourse follows another. In the second, they crash, foaming, into one another. This second sort of rhythm could be called "syncopation." A text is syncopated if it continually contradicts itself and still flows smoothly along. Such a text grips the reader by going against the heartbeat, tempting him into contradiction, drawing him in against his will.[11]

It is no longer possible to return to a time before 1991, to the fluid context, the multiple texts in multiple languages and the author's own unique sense of their relationship to one another and to him. The best possibility, in my view, was to understand the decisions made at that time as a philosophically oriented snapshot, that is, to treat the whole book (with the appendix that was added to the second edition in 1994) as the source text. There are five essays relating to gesture that Flusser himself either wrote in English or translated into English at some point ("The Gesture of Writing," "The Gesture of Painting," "The Gesture of Making," "Gesture and Sentimentality," and "First Sketch for a General Theory of Gestures"). Some are very close to the translations given here, some are not. All have been taken into consideration; when decisions had to be made, however, preference was given to the shape and order—the "syncopation"—of the German work Flusser himself prepared for publication.

Gestures is unique among Flusser's books, both in the way it came to be a book and in the way it positions its reader. For if Flusser's "media" books examine comprehensive historical shifts in which both reader and writer

are immersed, most of the *Gestures* essays reflect on specific movements of a human body. They cultivate the reader's own sense of embodiment, of actually or potentially making the movements under consideration. Rather than moving out from a topic framed at the outset, these essays tend to spiral in on the meaning of *gesture* from many different angles. In "The Gesture of Photographing," Flusser memorably describes a photographer moving around a person who is being photographed, changing distances, angles, lighting, asking the sitter to adjust the pose. In the argument, we, too, move, from the position of the photographer to that of the subject being photographed and on to that of an observer of the scene, noticing how each kind of awareness affects the others. Through observation, we establish that the photographer's decisions—his position, his interaction with the subject, his critical relationship to his own activity—are all free decisions, articulating his way of being in the world. In this, his direct interaction with the "object" he is photographing, the photographer differs from a painter. It is a difference Flusser sees more broadly between traditional images (painting and drawing) and technical images (photography, film, digital sampling, and synthesis): one might contend that if, in his media books, Flusser paints his topic, in *Gestures,* he photographs it.

I'd like to thank a number of people who have made this translation possible. Flusser's widow Edith, and their daughter Dinah, continue to be generous and steady in their support of efforts to make the work better known, especially in English. The University of Minnesota Press remains committed to publishing Flusser's work and to positioning it thoughtfully in an English-language context. I'd particularly like to thank Danielle Kasprzak for her consistent kindness and understanding and to say that working with everyone at Minnesota has been an unalloyed pleasure. Claudia Becker, archivist at the Flusser-Archiv, Universität der Künste, Berlin, went to extraordinary lengths to ensure that I was able to see relevant documents from the archival collections, for which I am most grateful. Over the past few years, I've further come to rely on the high spirits, keen insight, and sound judgment of Anke Finger, at once a colleague and a trusted friend. Finally, I'd like to thank two exceptional doctoral students at the University of Edinburgh, Fiona Hanley and Tami Gadir. Their invitation to give a keynote talk at a two-day conference titled

"Extending Gesture" took me completely by surprise. One weekend in October 2012, I had an opportunity to exchange perspectives on gesture with some thirty colleagues from diverse fields, including literature, art, music, dance, cognitive science, and game design. In those few days, we saw how the concept could cut across disciplinary boundaries, language differences, nationalities, and generations. It was a moment in which to appreciate Flusser's prescient recognition of "gesture" as a potentially revolutionary way of reflecting on the way we are in the world—and on the way we could be.

Gesture and Affect

The Practice of a Phenomenology of Gestures

As a matter of courtesy, as well as for other reasons, a writer should define his concepts. In this essay, I will do this for the concept of "gesture" but not for that of "affect."[1] I hope that the reader will excuse this impropriety. My plan is to feign ignorance of the meaning of *affect* and, by observing gestures, try to discover what people mean by this word. It is a kind of phenomenological effort, through the observation of gestures, to take *affect* by surprise.

I will start by attempting, for the remainder of this essay, to define the word *gesture*. I believe that many people will agree that gestures are to be considered movements of the body and, in a broader sense, movements of tools attached to the body. But many would also agree that the term does not apply to all such movements. Neither the contraction of the pupil, for example, nor intestinal peristalsis is an instance of what is meant by *gesture,* even though both are movements of the body. The word refers to specific movements. These movements can be described as "expressions of intention." That gives us a good definition: "Gestures are movements of the body that express an intention." But this is not very serviceable. For "intention" needs to be defined, and because it is an unstable concept that involves issues of subjectivity and of freedom, it will surely get us into difficulties. Still, the manner of bodily movement that is called "gesture" can also be defined methodologically, which helps to avoid the ontological trap just mentioned. For example: surely all movements of the body can in principle be explained by spelling out their causes. But for some movements, such an explanation is unsatisfactory. If I raise my arm, and someone tells me that the movement is the result of physical, physiological,

psychological, social, economic, cultural, and whatever other causes, I would accept his explanation. But I would not be satisfied with it. For I am sure that I raise my arm because I want to, and that despite all the indubitably real causes, I would not raise it if I didn't want to. This is why raising my arm is a gesture. Here, then, is the definition I suggest: "a gesture is a movement of the body or of a tool connected to the body for which there is no satisfactory causal explanation." And I define *satisfactory* as that point in a discourse after which any further discussion is superfluous.

This definition should suggest that the discourse of gestures cannot end with causal explanations, because such explanations do not account for the specificity of gestures. Of course, causal ("scientific," in the strong sense of the word) explanations are needed to understand gestures, but they don't produce such understanding. To understand gestures, these specific physical movements that we perform and that we observe around us, causal explanations are not enough. Gestures have to be properly interpreted, too. If someone points to a book with his finger, we could know all the possible causes and still not understand the gesture. To understand it, one must know its "significance." That is exactly what we do continually, very quickly and effectively. We "read" gesture, from the slightest movement of facial muscles to the most powerful movements of masses of bodies called "revolutions." I don't know how we do it. I do know that we have no theory of the interpretation of gestures. But that is no reason to take pride in, for example, our mysterious "intuition." In prescientific times, people had the wit to know what was going on when they saw stones falling. But only we who possess a theory of free fall really understand it. We need a theory of the interpretation of gestures.

The so-called humanities appear to be working on such a theory. But are they? They work under the influence of the natural sciences, and so they give us better and more complete causal explanations. Of course, these explanations are not and perhaps never will be as rigorous as those in physics or chemistry, but that is not what makes them unsatisfactory. The most unsatisfactory aspect of the human sciences lies in their approach to the phenomenon of gesture. They consider it to be simply a phenomenon rather than one that also confers a codified meaning. And even when they admit the interpretive character of a gesture (that which

was once called its "mental aspect"), they still tend to reduce the gesture to causal explanations (that which was once called "nature"). They do this to win the right to call themselves "sciences." But it is exactly what keeps these disciplines (psychology, sociology, economics, historical area studies, linguistics) from developing a theory of the interpretation of gesture.

Of course, there are newer research fields called "communication research" that are rapidly accumulating knowledge and that appear to be particularly concerned with working out such an interpretive theory. In contrast to the phenomenological character of the other "humanities," communication research has a semiotic peculiarity. It is concerned with the same phenomena as the other "human sciences" but focuses more particularly on their symbolic dimension. Words such as "code," "message," "memory," and "information" do occur frequently in the discourse of communication and are typical for interpretation. But then something remarkable happens that I think sometimes goes unnoticed. These semiological terms pass from communication research into the causal disciplines and change their original meaning. So we have concepts like "genetic code," "subliminal message," "geological memory," and others. Then these concepts return to communication research, but because they have taken on explanatory meaning, they no longer serve the needs of interpretation. In following a fashion for being "scientific," communication research, initially a field of semiotics, is very rapidly moving away from interpretation and toward explanation.

I will summarize the preceding: one way of defining "gesture" is as a movement of the body or of a tool attached with the body, for which there is no satisfactory causal explanation. To understand a gesture defined in this way, its "meaning" must be discovered. That is exactly what we do all the time, and it constitutes an important aspect of our daily lives. But we have no theory of the interpretation of gestures and are restricted to an empirical, "intuitive" reading of the world of gestures, the codified world that surrounds us. And that means that we have no criteria for the validity of our readings. We must remember this as we try, in what follows, to read gestures, to discover the affect in them.

The definition of *gesture* suggested here assumes that we are dealing with a symbolic movement. If someone punches me in the arm, I will move, and an observer is justified in saying that this reaction "expresses"

or "articulates" the pain I have felt. There would be a causal link between the pain and the movement, and a physiological theory to explain this link, and the observer would be right to see this movement as a symptom of the pain I have suffered. Such a movement would not be a "gesture" according to the suggested definition, for the observer would have explained it in a satisfactory manner. But I can also raise my arm up in a specified way when someone punches me. This action also permits the observer to say the movement of my arm "expresses" or "articulates" the pain I have felt. But this time, there is no seamless link between cause and effect, pain and movement. A sort of wedge enters into the link, a codification that lends the movement a specific structure, so that it registers as an appropriate way to express the "meaning"—pain—to someone who knows the code. My movement depicts pain. The movement is a symbol, and pain is its meaning. My movement is, according to the standard of the suggested definition, a "gesture," for none of the theories available to the observer offers a satisfactory explanation for it. Of course, one can claim that such a movement is always the symptom of something else (e.g., of the culture in which it was codified), but that is not the basis for calling it a gesture. A gesture is one because it represents something, because it is concerned with a meaning.

A reader will have noticed that the verbs *express* and *articulate* in the last paragraph were used in different ways. The reactive movement of my arm announces pain, and in this sense, it is to be understood that pain comes to expression through the movement. In the active movement of my arm, I represent pain, and in this sense, it is to be understood that I express something through my gesture. Let us be clear, incidentally, about the way the language nearly demands the use of the word *I* in the description of the second movement and the way it nearly rules out the use of this word in the first. But let us not be overly impressed by this idealistic tendency of the language. From now on, I will restrict my use of the words *express* and *articulate* to the second meaning and say that gestures express and articulate that which they symbolically represent. I will proceed as if I wished to defend the thesis that "affect" is the symbolic representation of states of mind through gestures. In short, I will try to show that states of mind (whatever the phrase may mean)[2] can make themselves manifest through a plethora of bodily movements but that they express

and articulate themselves through a play of gesticulations called "affect" because it is the way they are represented.

No doubt I will find it difficult to hold firmly to my thesis. There are two reasons for this. First is the fact that with concrete phenomena, it is difficult to distinguish between action and reaction, representation and expression. For example, I see tears in someone's eyes. What criteria could I use to justify saying that this is a representation of a state of mind (a codified symbol) and not its expression (symptom)? In the first case, the observed person is active, "acts out" a state of mind. In the second case, this person suffers, "reacts" to a state of mind. Both can occur at the same time, or one can be the case and I can read the other in error. The second reason for my difficulties is the ambiguity of the phrase "state of mind," which opens onto a broad and ill-defined area stretching from sense perception to emotion and from sensibility all the way to ideas. If I want to go on taking affect to be the way states of mind are expressed through gestures, I must first know the meaning of "state of mind." But I can't know it without doing violence to it. This becomes circular: to get closer to the meaning of *affect,* I must interpret gestures.

Nevertheless, my difficulties are not so great as they first seemed to be. When I observe another person and see gesticulation, I do in fact have a criterion for deciding between reaction and gesture, between the expression of a state of mind and its codified representation. This criterion is the fact that I recognize myself in others and that I know from introspection when I am expressing a state of mind passively and when I am representing it actively. Of course, I can make a mistake in recognition or deceive myself in my introspection, but the criterion is available. As far as the term "state of mind" goes, I cannot know its meaning, but I do know that it refers to something other than "reason." And because I have a fair idea what "reason" is, such a negative awareness is enough. And so I can proceed with my observation of affect as states of mind translated into gestures.

So there are two focal points that give these observations an elliptical shape: "symbolic representation" and "something other than reason." It follows that when I interpret specific gestures as something, I am dealing with affect. But doesn't that last sentence describe the experience of art, so that seen in this way, "art" and "affect" blend into one another? When I look at a work of art, do I not interpret it as a frozen gesture that

symbolically represents something other than reason? And isn't an artist someone who "articulates" or "expresses" something that reason (science, philosophy, etc.) cannot articulate, or not in the same way? Now whether I agree, in something approaching a romantic manner, that art and affect blend into one another, or deny it in something approaching a classical manner, there is no doubt that the question is not an ethical, still less an epistemological, but rather an aesthetic one.

The question is not whether the representation of a state of mind is false, still less whether a represented state of mind has the capacity to be true. Rather, it concerns whether the observer is touched. If I accept that affect is a state of mind transformed into gesticulation, my primary interest is no longer in the state of mind but in the effect of the gesture. As they appear in symptoms and as I experience them through introspection, states of mind throw up ethical and epistemological problems. Affect, conversely, presents formal, aesthetic problems. Affect releases states of mind from their original contexts and allows them to become formal (aesthetic)—to take the form of gestures. They become "artificial."

At this point, the reader has grounds for objecting that I have taken the long way around and arrived at a banal conclusion. From the beginning, my feigned ignorance of the meaning of *affect* required that I remain silent about affect constructing a state of mind, when saying it would have circumvented unnecessary difficulties for me and for the reader. But the reader's objection would be an error. It is one thing to take up a dubious commonplace about affect constructing a state of mind and quite another to reach this conclusion through close consideration of the meaning of gestures. The difference lies in the use of the word *artificial* or *constructed*. If I just bluntly say that affect is artificial, I run the risk of not noticing that affect, inasmuch as it represents states of mind, is in reality one of the methods through which human beings try to give sense and meaning to their lives and to the world in which they live.

When someone punches me in the arm and when I react by moving my arm, that is an absurd event, meaningless, at least to the extent the punch is not the gesture of someone who lends it meaning. But when someone punches me in the arm and I respond with a codified gesture, the event is charged with meaning. Through my gesture, I release the pain from its absurd, meaningless, and "natural" context and, by inscribing

it in a cultural context, give it symbolic meaning. In this example, the pain is real, although the gesture probably exaggerated it. But that's not especially important. Crucial is the articulation of pain, its symbolic expression to another. Precisely this symbolic aspect, and not the "real" presence or absence of the represented pain, makes the gesture stand for the state of mind. Fernando Pessoa actually insists that it is more difficult to represent real than imaginary pain symbolically; it presents a greater challenge to a poet: "O poeta e fingidor qu fing tao perfeitamente que fing até a dor que deveras sente" (A poet is a swindler so skilled at swindling that he can falsify even the pain he actually feels). It is just this unnatural, represented, symbolic character of affect, exactly this "artificiality," that lends meaning to states of mind (whether real or imaginary) and so to life. One might prefer the formulation that affect "intellectualizes" states of mind by formalizing them into symbolic gestures. In this sense, it is to be understood that as affect, states of mind have become constructs.[3]

The "artificiality" of represented states of mind is first of all an aesthetic problem. The world and life in it get an aesthetic meaning from the emotion-rich play of gesticulation. If we want to criticize affect, we must do it using aesthetic criteria. The scale of values we use to evaluate may not oscillate between truth and error or between truth and lies but must move between truth (authenticity) and kitsch. I believe that this distinction is critical. When I see a gesture emphasizing feeling, for example, that of a bad actor in the bad play who wants to convey the emotion of fatherly love, I would call it "false." But it would be not be right to call it an "error" or a "lie." It is "false" in the sense of "in poor taste," and it would remain inauthentic even if the actor really were a loving father. I consider the distinction important because of the ambiguity embedded in the word *truth*. In epistemology, *truth* means agreement with the real; in ethics and politics, it refers to an internal consistency (loyalty); whereas in art, it becomes a "truth" to the materials at hand. It is very obviously no accident that the same word has these three meanings: all of them participate in what is called "honesty." But it is entirely possible for a gesture indicating feeling to be epistemologically and morally honest but aesthetically dishonest, like the gesture of the bad actor. And it is entirely possible for an emotionally powerful gesture to be epistemologically and morally dishonest and aesthetically honest, as in the case of the gesture

that resulted in a Renaissance sculpture that retrospectively engaged that of the ancient Greeks. In this case, one must judge the gesture to be "true." On the scale of affect, Michelangelo must be located near the "truth," and an actor in a Hollywood potboiler at a point close to the border of "kitsch," quite apart from any consideration of whether the affect they express is real or whether they believe in it.

Yet it is well to remember at this point that, in the absence of a theory of the interpretation of gesture, any judgment remains empirical and "intuitive." Without such a theory, there is no objective and not even an intersubjective art criticism that would survive a statistical examination, and until there is such a theory, "de gustibus non est disputandum" remains in force. So one observer's kitsch can be another's true affect. And if one tries to get around the absence of this kind of theory, for example, by saying that the truer a work is, the more observers will be moved by it, then we'll have to admit that Pavarotti's affect is truer than Byron's. And yet there is a kind of intuition that would put Pavarotti nearer to kitsch than Byron on the affect scale. Information theory (this timid step toward a theory of interpretation for gestures) confirms this intuition.

We don't have to rely on the mathematical detail of this theory to grasp the problem (in my view, much of the effort to develop it has been expended on becoming "scientific"). The theory claims that the more information a gesture contains, the less it is like kitsch, and furthermore, that the quantity of information conveyed by the gesture is related to the gesture's code. This contention has an important implication. The more information a gesture contains, the more difficult it apparently is for a receiver to read it. The more information, the less communication. Therefore, the less a gesture informs (the better it communicates), the more empty it is, and so the more pleasant and "pretty," for it can be read without very much effort. So information theory gives us a more or less objective gauge for the fact that the emotion-laden gestures in television series move the "masses" deeply. Yet it is important to note that information theory works much better for kitsch than it does for real affect. It can measure the banality of kitsch, but faced with the originality of true art, it appears to be as empirical as our "intuition." It can in no sense replace the intuition of art criticism, and still less can it obviate the need for a theory of interpretation.

And yet, on one point this theory can help us: that of the "empty" and the "full." I have maintained that affect is a method of lending states of mind meaning by symbolizing them. What information theory suggests (and the step it actually takes toward a theory of interpretation) is that a symbol expressing a state of mind can be more or less empty and that the gauge of affect runs between fullness and emptiness, from inexhaustible meaning to empty gesture. At one end of the scale are majestic and rare gestures, whose meaning is still not exhausted after millennia. At the other end are the infinitely many empty gestures we make and see all around us that try to exhaust the "original" meaning our gestures retain by formal reference to the majestic ones. The affect of friendship, for example, is expressed through the gesture of Castor and Pollux and through the handshake, the one a full existence, the other by contrast emptied of almost all meaning. In this way, I think, a criticism of affect (and simply of art) could become less subjective and one day—certainly with great effort—arrive at an interpretation not only of kitsch but also of those great moments in which humanity confers meaning on its actions and sufferings.

Beyond Machines
(but Still within the Phenomenology of Gestures)

Work presumes that the world is not as it should be and that it can be changed. Such hypotheses present problems. Ontology is concerned with problems of the way the world is, deontology with the way it should be, and methodology with the means of changing it. These problems are intertwined. We cannot know that the world is not as it should be without knowing how it is, nor can we know that the world is as it is without knowing how it should be. We cannot know that the world is not as it should be without knowing that it can be changed, nor can we know that it can be changed without knowing how it is. It follows, then, that there can be no ontology without deontology, no deontology without ontology and methodology, and no methodology without ontology and deontology.

In *illo tempore,* at the moment human beings began to work, these three aspects of work were not separated. Ontological, ethical, and technical aspects of magic, although visible to us, were not distinguishable to the magician himself. The exact moment when the tri-partition asserts itself is the moment when history, in the strict sense of the word, emerges. History can be understood as an unfolding of this of this tri-partition. During its first phase (antiquity and the Middle Ages), history emphasizes the way the world should be; that is, people work to realize a value—ethical, political, religious, practical, in short, "in good faith." During its second phase (modernity), it emphasizes the discovery of being in the world; that is, people work epistemologically, scientifically, experimentally, and theoretically, in short, "without faith." During its third phase (the present), it emphasizes methods; that is, people work technically, functionally, efficiently, strategically, and cybernetically, in short, "in great doubt," "in

despair." During the first phase, the prevailing questions are directed toward purpose (for what?); during the second, toward causes (why?); and during the third phase, the prevailing questions are formal (how?). So history offers us three models for work: classical (engaged) work, modern (research) work, and contemporary (functional) work.

Most people don't work. They serve as tools in the work of others. In their alienation, they have no wish to know how the world is or how it should be, and the idea of changing the world does not even occur to them. They participate only passively in history; they put up with it. As far as the working minority is concerned, it is always and everywhere engaged, researching and functional at the same time, for these three moments of work intersect. The three phases of history proposed here are only schematic, and the three models of work are never realized in pure form. But they serve a purpose, and they are adequate models, for they open a perspective on the so-called crisis of values.

Before we analyze this perspective, we need to get one commonsense prejudice out of the way, namely, that people work to "satisfy needs." In this way, we become "animals," and so need certain things to survive. These things can be quantified, for example, in calories. If work were a tendency to strive for the satisfaction of these needs, we could speak of setting goals for work: one works to meet the needs, and after that, no more. But it's not like that. Animals don't work but meet their needs without changing the world. The Swiss, for example, work far beyond the point of satisfying all biological needs and think nothing of excess. Work is, then, a gesture, an unnatural expression of the effort to realize values and to devalue realities.

The three models of work open up the following perspective: in prehistory (magical work), the values were unquestioned; in the classical and medieval periods (engaged work), a decision had to be made between values; in modernity (work as research), the question of values lost its force; in the present (the time of technical work), the question of values has become nonsensical. This is the framework to be analyzed in what follows.

In prehistory, values were unquestioned, because a value is a standard of measure, and to be able to question measurement, one must be able to stand apart from the thing to be measured. Only the thing to be measured

using values is what the world should be, and in magic, people are immersed in the world. Just as the world they engage is full of compulsions ("full of gods"), and their lives are conditioned by the "laws" of taboo and the breaking of taboo, that is, by rules of obligation. The question of values, "What should I do?" cannot be asked. The only question that presents itself, and with great intensity, is, "What happens if I don't do my duty?" Values were unquestionable "givens," for there was no distance between a person and a value. Obligations were not inside, before, or beneath people; rather, people were immersed in their obligations.

The question "What should I do?" first arises for humanity when a human being is "driven" out of his obligations. Now, that is a historical question. Historical existence is problematic, for it has a duty to ask about obligations, to raise the question of values. It has an obligation to formulate laws, imperatives, and legal systems, to live religiously and politically. In short, it is "condemned to work," and it works to do "good."

One can be seduced into thinking that an assessment of values (practical reason) and an assessment of essence (pure reason) imply one another. In fact, theoretical elements can be distinguished in the work of the Babylonians or Egyptians from the beginning of history, and only a narrow concept of theory supports a claim that Greeks invented theory. But theory in the modern sense, which is to say a gesture that consciously refuses the assessment of values and limits itself to the assessment of essence, first appears in fifteenth-century Italy. It has to do with a gesture that divides practical from theoretical work by freeing epistemology from the tyranny of religion. It sets the "good" in quotation marks and separates it from the "true." And this is the specifically modern occidental theory that cuts history in two.

With this gesture, the world under consideration is divided into two spheres: the sphere of values (society), where the question is "To what purpose?" and the sphere of the given (nature), where the question is "Why?" As a result, there are two cultures, one for each of the world's spheres: the scientific and the culture called humanist. Modern history begins with the separation of what should be from what is, of politics from science. It is characterized by the progression of science toward politics, by progressive invasion of the sphere of values by the sphere of givens. The question "What should I do?" persists in the modern period

in the form of political and religious wars or in the form of ideological disputes. But in the form of sociological, psychological, economic, and political theories, the question "Why do I do what I do?" asserts itself with increasing clarity with respect to the first question. As modernity advances, the more difficult the question "What is the value?" becomes, and the more readily the question "What is a 'value?'" arises. The imperative transforms itself into a function: "Thou shalt not steal!" becomes "If you steal, you will go to prison."

Since the nineteenth century, this sort of methodological schizophrenia, in which one-half of consciousness engulfs the other, in which theoretical and practical work are at odds, has led to a technologizing of work. When politics and science part company, technology holds sway, and when the ontological aspect of work parts company with the deontological, the methodological aspect triumphs. The questions "To what purpose?" and "Why?" shrink to the question "How?" The results of this process remain unforeseeable, despite the triumph of method's self-generated counterresponses: the Industrial Revolution, the bourgeois work ethic, the fascist glorification of action, and the Marxist philosophy of work. For only now is it clear that the victory of method is inevitable.

That is, only now are we beginning to see the results of the "good" and "true" being displaced by the "efficient." It can be seen in brutal forms, such as Auschwitz, atomic weapons, and various technocracies. But it is above all apparent in more subtle forms of thought, such as structural analysis, cybernetics, game theory, and ecology. That is, it is becoming clear that wherever methods, rather than politics or science, are the focus of interest, any question about values becomes "metaphysical" in the discrediting sense of the word, as does any question about the "thing itself." Ethics as well as ontology become meaningless discourses, for the questions they raise do not present any methods that would make answers possible. And where there is no method to ground an answer, the question makes no sense.

Strictly speaking, then, work has become impossible. For if the question "To what purpose?" makes no sense, the gesture of work becomes absurd. In fact, work in the classical and modern sense is being displaced by functions. One no longer works to realize a value, nor to discredit a reality, but rather functions as the functionary of a function. This absurd gesture cannot be grasped without observing machines, for we are actually

functioning as functions of a machine, which functions as the function of a functionary, who in turn functions as the function of an apparatus, which functions as a function of itself.

Machines are objects produced to defeat the world's resistance, the substance of work. That is what machines are "good" for. A Paleolithic arrow is good for killing a reindeer, a Neolithic plow for working the land, and a classical windmill for transforming grain into flour, for the reindeer must be killed, the land worked, and the grain ground into flour. There is no problem with any of it: the machines are made to solve problems, not to create other problems.

Machines become problematical in the modern period, which is to say they become the opposite of what they should be, and that is the reason they attract interest to themselves (by way of definition, an interesting machine cannot be a good one, for by definition, interest in a good machine is in the thing for which it is good). Machines actually cause problems for two different reasons. The first reason is bound up with the sudden interest in questions of causality, that is, with research. Theoretical work in the modern sense (the gesture of evaluating essence) results in machines such as a telescope (so-called observational instruments), which are problematical. They are good for something (e.g., for seeing the mountains on the moon), only the word *good* has shifted meaning: no one can claim that the mountains on the moon need to be seen in the same sense that grain needs to be ground into flour. The second reason that modern machines are problematical is bound up with their being themselves objects of research. The question becomes "Why does a machine function?" rather than just "What is it good for?" This reversal in the relationship to the machine has a double result: the machine is perceived, for one thing, as a system that may serve as a model for the world, and for another, the machine's theoretical principles of construction are revealed. The first result, diverse mechanistic perspectives on the cosmos, makes machines problematic because it is difficult to ask the question "What is it good for?" about a world-machine. The second result, the theoretical relations to machines, makes machines problematic by making them increasingly interesting. In short, machines become problematic in modernity because they raise the question of values instead of realizing a value.

With regard to the separation between science and politics that is

characteristic of modernity, there are two faces to the problems machines present. Science is concerned with legitimizing work by discovering the impetus for it and so with creating machines capable of doing any sort of work at all. Politics is concerned with the question "Who should own the machines?" These two sides to the problems raised by machines explain the optimism—very strange, from our standpoint—that is characteristic of modernity. It is the time of a "belief in progress." It will ultimately be possible to build machines that will replace human work in all fields, and people will be "free." Machines will be the slaves of the future, and all human beings will become subjects of history, as they are freed from alienated labor. Machines will be the property of the whole of humanity, and each individual will be equal to others. The "classes," that is, the division of humanity into those who do and those who do not possess machines, will die out, and there will then be a classless society. This optimism appears strange from our point of view, for to those who have lived in the late twentieth century, with automation, it seems obvious that the questions of value posed by modern machines rule out any optimistic interpretation, and have done so since the Industrial Revolution in the late eighteenth century.

For it had to have become clear, at the latest with the Industrial Revolution, that the program of "freeing oneself from work" made the question "For what?" unavoidable and that the question "Who should own the machines?" carried with it the question "To do what?"—and that these two questions were therefore not good questions. In fact, the Industrial Revolution accumulated machines very quickly, synchronized them with complex switching mechanisms, and so turned them into "apparatuses," and the apparatus quickly made it clear that machines would have to be rethought. The nineteenth century and the first half of the twentieth century were optimistic, for they put off any radical rethinking of machines in terms of apparatus, with the sole exception of that technology that passed through the conveyor belt and rationalization of labor to full automation.

Under preindustrial conditions, machines stand between people and the world on which they work. They are "attributes" of human beings in a juridical but also in a logical sense. A person can replace one machine with another while he is working. That is, under preindustrial conditions, a human being is the constant and the machine is the variable. Under

industrial conditions, a person stands inside the machine as he is work-
ing, and the world on which he is working lies beyond his horizon (in the
"metaphysical"). In a logical sense, the human being is an attribute of
the apparatus, for someone else can replace him as the work proceeds,
although the machine still retains human properties in a juridical sense. In
the "man–machine" relationship, the machine is the constant and the hu-
man being the variable, which in itself renders the concept of "property"
problematic: capitalists as well as proletarians become the property of
machines, although in different ways. Freeing themselves should therefore
mean a freeing from, and not by means of, machines, and the question
"Who should own the machines?" therefore means "Is there anyone or
anything beyond machines?" This really should have been understood
immediately after the Industrial Revolution.

Of course, such a Kafkaesque understanding of the apparatus has now
become obvious, and the persistence of modern and progressive optimism
(whether in the form of liberalism or socialism) has taken on a poignant
quality. For we have existentially experienced a reversal of the preindustrial
relation "man–machine": in our activities ("work"), we function just as we
do at leisure ("consuming"), as functions of many apparatuses. We know
from painful experience that a change in the legal status of an apparatus
does not change its ontological status (a state or party apparatus occupies
the same position with respect to human beings as a legally "private"
industrial apparatus), and we know, too, that being freed from work by
machines does not mean becoming the subject of history; rather, it means
functioning as a consumer as a function of the apparatus. But that is not
all: we have learned other, far more unsettling lessons about the apparatus.

We have learned that we cannot live without the apparatus or outside
the apparatus. Not only does the apparatus provide us with our bodily and
"intellectual" means of survival, without which we are lost, because we
have forgotten how to live without them, and not only because it protects
us from the world it obscures. It is primarily because the apparatus has
become the only justification and the only meaning of our lives. There is
nothing beyond the apparatus, and any ontological or ethical speculation
that goes beyond it, any questioning of its function and functioning, has
become "metaphysical" and lost its meaning (that was what I meant when
I spoke of "despair" earlier).

Our dependence on the apparatus keeps us from posing questions of cause or purpose with respect to apparatuses. "What is the purpose of France?" or "Why industrialize?" (to take just two very typical examples of apparatuses) are theoretically possible but existentially false questions, for they assume a transcendence of apparatuses that we do not have. We are limited to functional questions only, for to us, "living" is functioning in and as a function of an apparatus. So it makes no sense to "free ourselves from the apparatus." Beyond the apparatus, there is nothing to do. To formulate it as a thesis, the apparatus can do everything; everything human beings can do without it, it can do better. Optimists with a faith in progress paint a picture of machines as slaves that will free human beings' freedom for creative achievements. Only thanks to cybernetic apparatuses, "creation" is a concept quantifiable by means of information theory. Machines can be shown to be potentially far more creative than any human beings, if they are appropriately programmed by a human being or by another machine.

If, by "getting free of machines," we mean doing something or other in a space beyond machines, we are challenged by insufficiency. And if by "getting free of machines," we mean not doing anything anymore, we are challenged by consumption, which is contained in the programs of the apparatuses. This second interpretation is synonymous with "getting free by means of machines." In short, beyond machines, there is nothing to do, for work in the classical and modern sense has become absurd. Where apparatuses prevail, there is nothing left to do but function.

There are various ways of functioning. With personal commitment, one loves the apparatus for whose function one is functioning (that is the good, career functionary). In despair, one turns in circles within the apparatus, until he withdraws (that is the man of mass culture). With a method, one continues to function within the apparatus, even if those functions change as a result of internal back-switching and merging with other apparatuses (that is the technocrat). In protest, one despises the apparatus and tries to destroy it, an effort the apparatus recuperates and transforms into its own functions (that is the terrorist). In hope, one tries gradually to dismantle the apparatus, to make it permeable, that is, one tries to reduce the quantity of functioning, to raise the "standard of living," which automatically becomes another of the apparatus's functions (those are environmentalists, hippies, etc.). There are more ways in

which to function. But none escapes the fact that, because the question of value has sacrificed its meaning, the gesture of work beyond machines has become absurd.

At the outset, this essay claimed that there could be no methodology without ontology and deontology. This is to say that there can be no technology (no art in the broad sense) without science and politics. But the history of mankind (and specifically of the West) first separated the three aspects of work and then established a division between science and politics. The result was that technology became embedded in science and politics, and methodology engulfed both being and obligation. All the nostalgic objections in the world are not enough to restore "reality" and "value" after the triumph of function. Relations, fields, the ecosystem, gestalt, and structure are replacing object and process, dialectic and project, once and for all. The concept of the "true" as well as that of the "good" have finally been packed away into the black box of "nonsense." Epistemological and ethical thought has been replaced once and for all by cybernetic, strategic thought and by program analysis. History is over.

For when methods infiltrate being and obligation, and technology infiltrates science and politics, the absurd eats its way in. Method for method's sake, technology as a goal in itself, and *"l'art pour l'art,"* that is, function as the function of a function—that is the posthistorical life without work. It is posthistorical because history is a process in which people change the world so that it is as it should be, and when work stops, history, too, is still. And work stops when it no longer makes sense to ask how the world should be. It stops when the apparatus determines itself. Not because the apparatus "works for us," but because the apparatus changes the world in a way that makes the question impossible. The apparatus is the end of history, an end that was always already foreseen by all utopias. It is existence without work, an existence given over to art for art's sake, it is the consuming and contemplative existence. The fullness of time. We live in it. Or just about. But we don't recognize our situation as utopia. For although we are already beyond machines, we remain incapable of imagining life without work and without meaning. Beyond machines, we are in an unimaginable situation.

The Gesture of Writing

It is about bringing material to a surface (e.g., chalk to a blackboard) to construct forms (e.g., letters). So it would seem to be about a constructive gesture: *con-struction* = connecting different structures (e.g., chalk and board) to form a new structure (letters). But that is an error. Writing does not mean bringing material to a surface but scratching at a surface, and the Greek verb *graphein* proves it. Appearances are deceiving in this case. Several thousand years ago, people began to etch into the surfaces of Mesopotamian bricks with pointed sticks, and according to tradition, this is the origin of writing. It was about making holes, pressing through a surface, and that is still the case. Writing still means making an in-scription. We are concerned not with a constructive but with a penetrating, pressing gesture.

We are not aware of it, because for us, this gesture is obscured by rather thick layers of habit. Writing is more than a habitual gesture. It is nearly an inborn capacity. There are centers in our brains that monitor writing, just as there are centers that monitor breathing. Only the one for writing is not contained in our genetic program, as nest building is contained in the genetic program of birds. With writing, then, we are concerned with a gesture. The proof: there are illiterate people who are not monsters, as is the case with birds unable to build nests. In fact, they constitute the majority of humanity. It is difficult to grasp the difference between genetic and cultural programming, for the way human beings inhabit culture is similar to the way animals inhabit nature. Still it must be done: gestures must be distinguished from movements conditioned by nature, for the issue is freedom.

To be able to write, we need—among other things—the following: a surface (a piece of paper), a tool (a fountain pen), characters (letters), a convention (the meaning of the letters), rules (orthography), a system (grammar), a system that signifies the system of language (semantic knowledge of a language), a message to be written (ideas), and writing. The complexity results not so much from the number of essential factors as from their heterogeneity. The fountain pen is at a level of reality different from that of, say, grammar, ideas, or a reason to write.

The gesture of writing follows a specific linearity. In the occidental program, it begins in the upper left corner of a surface; it goes to the upper right corner; to go back to the left side, it jumps just under the line just written and continues to move ahead and jump back in this way, until it has reached the lower right corner of the surface. We have here an apparently "accidental" linearity, resulting from historical coincidences. Other structures can accommodate this gesture, and these have in fact been realized in other cultures. I am thinking not only of writing whose structure is completely different, as is the case with Egyptian hieroglyphs or Chinese ideograms. I am thinking of Arabic script, which mirrors ours, and of archaic Greek script, which moves back and forth in a serpentine fashion. This, the structure of our gesture of writing, was brought about by such accidental factors as the resistance of the clay tablet to the pointed stick, the convention of the Latin alphabet, and the cutting of paper into the shape of pages. It is nevertheless a structure that gives a form to (informs) a whole dimension of our existence in the world. We enter into it as a form that is historical, logical, scientific, and progressive and also as a form whose specific linear character has made our gesture of writing irreversible. To alter one single aspect of this accidental structure, for example, to suggest writing in reversible directions as the ancients did, would mean to change our way of being in the world.

The typewriter is a tool that is programmed both for the production of lines, as described, and for mnemonic assistance with certain aspects of the gesture of writing. It runs from left to right, jumps, rings when it is approaching the corner, but also stores the characters of the alphabet in its keys. It is a materialization of a whole dimension of Western existence in the twentieth century, and a phenomenological analysis of the typewriter would be a good method of gaining self-knowledge. There is a

widespread, erroneous belief that the machine "constrains" the freedom of the gesture; one is freer typing than writing with a fountain pen, not only because one writes more quickly and with less effort but because the machine more readily permits an overstepping of the gesture's rules, in fact, exactly because it makes the rules obvious. Concrete poetry, the effort to make writing two-dimensional, is possible only with the machine. Freedom is not about disregarding the rules (which can be done with the pen as well) but about changing them (which is possible with the machine).

The fountain pen is still a pointed stick, as in Mesopotamia, even if it no longer scratches into the surface but adds ink to it. The typewriter, by contrast, more closely resembles a piano. Some will want to say that the pen is more of an "engraver," and so more authentic. Error. The machine strikes the surface with its hammers; so typing is a more incisive, specifically graphic gesture than writing with a fountain pen. Writing is one of the ways thought becomes phenomenal. Typing on a machine is a more open form of thinking than writing with a pen, a stick of chalk, or a pencil. It is the gesture most characteristic of writing.

Let us compare three examples. If a chimpanzee tromps about on a typewriter, it does not select any keys. The text it writes will be accidental. When a typist types, she chooses keys in relation to an existing text. The chimpanzee does not write; he hammers. The typist does not write; she is a typewriter for another. Writing on the machine is a gesture in which particular keys are chosen in accordance with the specific criteria of orthography, grammar, semantics, information theory, communication theory, and more, with the intention of producing a text. It may be that even more refined articulations of thought will develop through the use of word processing. Although the criteria cannot be observed directly, it is possible to observe the way these criteria are expressed by observing the authentic gesture of writing on the machine. This is called "seeing" how someone thinks. Introspection enables us to break up the ideological concept of "thinking" and so make it more exact.

Someone who writes expresses something. *Express* is relative. It means "to press from somewhere against something." In this special case, the meaning is obvious: someone who writes is pressing the typewriter's hammers, fitted with letters, against a piece of paper. But *express* also means

to press out from inside. This meaning is less obvious in the gesture of writing. But introspection permits us to say that the one writing is pressing a virtuality hidden within him out through numerous layers of resistance. "What virtualities?" is a bad question at this point, for this virtuality will only be realized in the written text. The answer is the text, which is not known beforehand to the one writing. In fact, the gesture of writing is the answer to the question "What am I trying to express?"

It would be better to ask about the layers that must be penetrated to be able to press the keys of the machine. Such a question offers a criterion for dividing literary criticism into two kinds, a stupid kind that would ask, "What does he want to say?" and a clever kind that would ask, "In the face of what obstacles has he said what he said?" These obstacles are many, and among them are some that precede writing. They have to do with rhythmic and formal rules that weigh against the virtuality to be expressed and assert their own forms. But only after having penetrated these layers, only when the virtuality has met the resistance of the words, does one decide to write. Until then, the virtuality to be expressed might press out in another gesture, such as that of musical composition or painting. When we are talking about writing, we must start by describing the resistance of words.

There are words in my memory. Not only are they instruments for absorbing the virtuality to be expressed, giving it a typeable form, so to speak. Words are also unities that vibrate and have a life of their own. They have their rhythms, harmonies, melodies. In their roots, they conceal the timeless wisdom of all history, to which I am heir. They project a whole framework of connotations. And so, from the words in my memory, I can't just freely choose the ones that "fit" the virtuality to be expressed. First I must listen to them.

In my memory, there are words from various languages. They don't mean the same things. Each language possesses its own atmosphere and, as a result, is a universe in itself. It is inexact to say that I command the languages stored in my memory. Of course I can translate, and in this sense, I transcend them all. In this same sense, I can choose the language in which I would like to write. But in another sense, it is the languages that command me, program and transcend me, for each of them throws me into its own universe. I cannot write without first recognizing this power

that the words and the languages exercise over me. It is, furthermore, the root of my choice of the gesture of writing.

The power of words is so great that each word evokes a whole chain of other words without my knowing it. A whole mob of words can rise up against me and against the keys of the machine. Such a thing as *écriture automatique,* "automatic writing," is a seduction and a danger to be guarded against. It is lovely to dive into the stream of words, to let them flow from within, through the fingers, over the keys of the machine and against the paper, so as to marvel what they have wrought, the sheer musical beauty of the words, their wealth of connotations and the wisdom of generations. But I lose myself in the flow, and the virtuality that pushes out to be typed in the machine dissolves. Once again, writing means leaving the magical power of the words behind and, by doing so, gaining a certain control over the gesture.

This dialectic between word and self, between what the words say and what I want to write, takes a completely different form when I decide to speak rather than write. When I speak, the words impose phonetic rules, and if I speak them, they become sounding bodies and vibrations in the air. This is a different linearity from that of writing. It is therefore inexact to say that writing is a record of spoken language. The transcription of a sound recording is not a written text. The dialectic in the gesture of writing plays out between me and the words of a language whispered *sotto voce.* It concerns a dialectic between me and the words that remain in the virtuality. The beauty of the act of writing consists in realizing the words. Being a writer does not necessarily mean being a speaker. A bard is not a poet. Words resist writing and speech in different ways.

My work begins only after my decision to articulate whispered words in the form of letters in the typewriter. I must first order the words so that the blurred initial thought finds expression. Various orders present themselves. A logical order—and I persuade myself that what I want to express is defending itself against being ordered logically. What is to be expressed must be adjusted. Then on to the grammatical order: and I persuade myself that the two orders do not agree. I begin to play with both orders and to proceed in such a way that what is to be expressed just barely slips between the contradictions of logic and grammar. Then comes orthographic order—and I discover the wonder of alphabetic code: the

function of commas, question marks, the possibility of making paragraphs, of skipping lines, and the inviting possibility of so-called orthographic errors. (Question: Is a deliberate infraction of rules an error?) Yes, I make all these discoveries with my fingers on the keys of the machine and with the automated movement of the page in the machine. As all this is going on, what was to be expressed is expressed: it is realized. And so, in the course of writing, I am surprised to discover what it was I wanted to write.

It is not right to say that writing fixes thinking. Writing is a way of thinking. There is no thinking that has not been articulated through a gesture. Thinking before articulation is only a virtuality, which is to say, nothing. It is realized through the gesture. Strictly speaking, there is no thinking before making a gesture. The gesture of writing is a gesture of work, which makes it possible for ideas to be realized in the form of texts. To have unwritten ideas really means to have nothing. Someone who says that he is unable to express his ideas is saying that he is not thinking. It depends on the act of writing; all the rest is mythical. In the gesture of writing, the problem of style is not added on, it is the problem itself. My style is the way I write, which is to say, it is my gesture of writing. *Le style, c'est l'homme.*

Thinking expresses itself in a whole range of gestures. But writing, with its unique straight linearity and inherent dialectic between the words of a whispered language and the message to be expressed, has a special place among gestures of thinking. What expresses itself in this gesture is the "official thinking" of the West. History begins, strictly speaking, when the gesture of writing makes its appearance, and the Occident became the society that thinks by way of what is written. All that is about to change. The official thinking of an increasingly significant elite expresses itself in the programming of cybernetic data banks and computational facilities that are structured differently from the gesture of writing. The masses are programmed with the codes of technical images and, in this sense, are becoming illiterate again. (A systems analyst does not need to write, the computer functions without the alphabet, and mass culture does not require reading. The television does not need letters to be informative.) The gesture of writing is about to become an archaic gesture, expressing a way of being that has been overtaken by technical developments.

It is possible to regard this development optimistically. The gesture

of writing is actually a poor, primitive, inefficient, and expensive gesture. The alphabet is, in its repertoire, as in its structure, a limited code for self-conscious thinking. The inflation of written texts has further devalued the gesture: everyone is a writer; it isn't very much of an issue. And it has become obvious that the problems lying before us demand that we think in codes and gestures far more refined, exact, and fertile than those of the alphabet. We need to think in video, in analog and digital models and programs, in multidimensional codes. Writing is no longer either effective or valuable as an expression of a way of being. It is time to admit it and draw the consequences, for instance, in the pedagogical programs of elementary schools.

All that is true. And yet there are those who cannot bring themselves to face this truth, archaic beings in whom words of whispered languages sound with such force and seductive power that the temptation to write them down becomes irresistible. Of course they know they are dealing with a linear, pathetically one-dimensional gesture. But they are unable to perceive any such poverty. For them, languages and their virtualities are so rich that all the literatures of the world have hardly begun to bring them to light. There can be no thought, for them, of writing as an "arte povera." They know that writing is no longer worth the effort. They do it anyway. Their motives consist neither in informing others nor in enriching the collective memory, although they could claim these things. That is absurd: they could not live very well without writing, for without it their lives wouldn't have much meaning. For these archaic beings, *writing is necessary, living is not.*

The Gesture of Speaking

The complicated organs in and around the mouth, such as tongue, gums, and lips, move so as to cause the surrounding air to oscillate in ways that have been codified into systems called "language"—would *that* be the gesture of speaking? Are there really specific organs that are "used" for speaking, just as, say, the stomach is used for digestion? Or is it rather like using a fountain pen to write, namely, that these organs developed the function of speech in the course of human evolution? Is the creation of linguistic convention based on organs of speech, or did these organs develop because of the convention, or still another possibility, did the genesis of the convention and the anatomical development of the mouth occur simultaneously? Did the language center in the brain perhaps "realize" the conventions that create language and the organs used to make them, or was it the reverse, that this center developed out of the practice of speaking? And because the organs of speech must be seen in the context of the whole body (e.g., as a function of the rib cage) and the brain center for language in the context of the whole brain (e.g., as a function of the center for writing), is perhaps the whole body the producer of linguistic convention, which is to say, the so-called mind? Or must the whole body and the organs of speech in particular be regarded as a synthesis of material and mind, as having developed historically through a reciprocal testing of linguistic conventions and the mammalian organism? So that we could claim to be able to regard any organ, say, the thumb, as belonging to a speaking mammal? And conversely, that we should regard any linguistic convention, even the most formal, such as symbolic logic, as having been achieved by a mammal equipped with thumbs? Is it the case that no

other mammal can speak because its vocal cords are not appropriate, or conversely, that human vocal cords are as they are because specific functions of linguistic convention (e.g., logical functions) made them that way? Then the question would arise, why don't other animals speak, or do they speak in such a way that we "can't understand" them, because their vocal cords (or antennae or pseudopods) were shaped by a different set of conventions (by another mind)? To sum it up, did the gesture of speaking come from the body, from the mind, from biology, from history, from phonetics, from semantics, from the speaker, or from what is said? Did the word come from speaking or speaking from the word?

If you lie in wait for a word at the moment it comes out of the mouth, try to catch it, to chew it before it is spit out (and that would actually be to grasp the gesture of speaking), you notice that you are always a second too late. Somewhere, somehow, before pronunciation and behind the mouth, the word has already been formed, however briefly before or after, and not somewhere, somehow in the broad stretches of eternal ideas or in the history of humanity. Let's say that the word took shape somewhere in the head, just before the complicated movement of the organs of speech. And so that would be the place to look for the gesture of speaking. The question, about the best point from which to try to catch the word (from science or from experience), is probably not a good one. To be caught, the word itself must rather say where it comes from. Let the word speak, as it takes shape behind the mouth and before it is pronounced, knowing that everything speaks more easily than the word itself.

Rilke says of the prophet that he spits words as Vulcan spits stones and that he does so because the words he pronounces are not his own. But he allows himself the speculation that there is no such thing as one's "own" words, or hardly any, and that in speaking, one is possessed by the words of others. And because these others are possessed in turn by the words of others when they speak, one could claim simply that one is possessed by words when one speaks. Should the word speak, then, it would say of itself that people don't speak but are spoken, and that groups of people do not speak a specific language but that each language trains a group of people. The speaking word will not allow this relationship between person and word to become dialectical so as perhaps to suggest that words make people and people make words. In catching the word

just behind the mouth and just before it is pronounced, it says: in the beginning was the word, and the word was in the speaker, and the word was the speaker. This, word's pronouncement, can of course be scientifically and philosophically refuted, and from the resulting mash, various psychologies, language philosophies, and communication theories can be cooked up (and may taste wonderful). But in this case, the proof of the pudding does not lie in the eating. For if we return to the word, as it speaks, before is it spoken, then it says again and again unmistakably: I am the seat of being, I am the breath of the deity, I am the beginning, logos. To get behind the vocal cords before the moment of pronunciation, to catch the gesture of speaking, is to see the word glow, even knowing that vocal cords and pronunciation will extinguish this glow. And so, strangely, an observation of speaking leads to a question of silence. Silence is, of course, not stillness but the gesture that arrests the word before it comes into the mouth. Silence means that the word speaks rather than coming into the mouth. To grasp the gesture of speaking, one must first observe that of being silent, for in silence the word speaks and glows. To grasp the gesture of speaking, one must learn to be silent.

The word cannot be silenced indefinitely, however. It presses against the mouth to be spoken. People speak not so much because they "have something to say" as because the word pierces the wall of silence. The elementary facts of speaking have been forgotten in the present, it's fair to say. The gates of words are pathologically wide open, and a logorrhea of talk is flooding the area. People talk because they no longer know how to speak, and they no longer know because there is nothing to be silent about: the words have lost their glow. In other, earlier times, before word inflation, there must have been a weight, a solemnity about the gesture of speech, or one might have said, a calibration of words, a measured speech as it is found among farmers or those who live alone, among whom speaking still counts as a break in the silence rather than an antidote to stillness. This original weight of the gesture of speaking, and not the frivolous gesture of talking, is under consideration here. Not the movement of the mouth organs that occurs everywhere, that sets the air of marketplaces, TVs, and lecture halls in motion, but rather the far rarer gesture that moves words from the realm of observation into the sphere of association with others.

The difference between the dialogical and discursive word,[1] so important for the analysis of speech, cannot be discerned by observing conversation. As it breaks through the wall of silence, the word proceeds from the sphere of available words into the sphere of relationships between people, without the question of how these relationships are structured becoming significant. The person who is speaking does direct his word toward a context, he never talks to nothing, and in this sense, his speech is always an address, a pronouncement, that is, dialogic. But the words he formulates build chains. They are linked into one another for syntactic and semantic reasons, and in this sense, the gesture of speaking is always a discursive gesture. The difference between dialogue and discourse probably can be encountered only in the web of human relationships, in the political arena, and remains undecidable at the moment of speaking: the speaking person is accountable for discourse and dialogue as he is speaking. But another decision is required, namely, the one between the two spheres that are divided by the wall of silence, before the gesture of speaking changed into a unity bound up with words.

The speaker's inner space, just behind the vocal cords and just prior to speaking out, cannot be understood as a private space because it is filled with words that have an inherently public character and stem from the public sphere. It would be just as inaccurate to regard the space as some sort of *topos uranikos*, in which timeless ideas are stored in logical order, for it is in fact filled with words that can, however, only become real and so actually become ideas when they are spoken. The inner space could perhaps best be described as a kind of cybernetic memory, were it not for the danger of its being likened to a computer and so displaced into the brain. Viewed objectively, that is, from an anatomical and physiological standpoint, this space has much in common with the brain and with the overall body structure of the speaker. But from such a standpoint, you can't grasp it. For what is characteristic of it is a very particular dialectic of freedom. There, available words press to be chosen to exert a function in the external space, and at the same time, the wall of silence presses, in very complex ways, in the opposite direction. This shadow realm of words that press and are pressed on is commonly known as the realm of thinking, although this terminology carries a risk of forgetting the direct connection between this space and the brain.

And still a question arises with respect to this space: how does one think in the moment of speaking, that is, in the outer edge of the thinking space? For it is clear that one thinks differently there than elsewhere, in the obscure cracks and corners. This could be said more simply: "thinking" in this border situation means choosing words that are meant to refer to specific problems in the external space to resolve them. Stated so simply, this contention cannot actually be sustained. But it does give us a view of the space external to the speaker, as a function of which he chooses his words. It is a space filled with problems and with other people, but it would be wrong to equate it with "the world." The speaker does not speak to the world but past the world to others. Speaking is an attempt to bypass the world to reach others but in such a way that the world is absorbed, "spoken" in the move. Speaking is not an attempt to bracket out the world to get at something else but rather to catch it in words, to reach another. The speaker grasps the world in words he directs toward others. So the world outside the speaker is a world that can be grasped in words, with other worlds behind it. A speaker chooses his words as a function of this very particular space, the space of graspable problems and reachable others, in short, the political space. This is how he "thinks."

But the choice cannot be taken to be a matching of available words to existing problems, an *adequatio intellectus ad rem,* and so any mechanical model, whether Aristotelian, Cartesian, or any other kind, must be abandoned. The gesture of speaking shows that this is not about touching problems with words or about the effort to capture problems in word-boxes ("categories"). The speaker is not a hunter of problems, setting up word traps, or a fisher of the world with a net of words, however much the greater part of traditional philosophy may make us want to believe it. On the contrary, the speaker seeks others; his words are tentacles in the direction of others, and although the words are selected in the function of problems, their primary intention is to be understood by others. So a speaker's thinking is an *adequatio intellectus ad intellectum,* and his intention is not to capture some sort of "objective" truth but to make an intersubjective understanding possible. The words are indeed chosen in the function of problems, but the criterion for the choice is not the problem alone but equally the words' comprehensibility. The gesture of speaking is not only an epistemological but also an aesthetic gesture.

The complexity of choosing words can be appreciated only in light of a realization that a speaker's thinking is as least as much as a function of words as of problems, that he matches problems to words at least as much as he matches words to problems, in short, that the speaker thinks as a living being and not like a scientific computer. And at least two adjoining factors can be recognized in this choice: problems that refuse to be grasped in words and words that refuse to be spoken. So one runs into at least two types of silence. One is that of problems that cannot be articulated, of which Wittgenstein said, "What we cannot speak about we must pass over in silence." And the other is that of unspeakable words, of which the Bible says, "Thou shalt not take the name of the Lord thy God in vain." Let's call them epistemological and aesthetic silences. And one can identify at least two ways to break the silence: irresponsible and shameless speech—that which speaks about things that cannot be spoken of and that which speaks of things that should not be spoken of—the two forms of refusal to recognize human limitation, the two excesses of freedom. Conversely, however, one might say that the motive for speech consists in exactly this: to give voice to unspeakable problems and to say unspeakable words, to push the boundaries of the human condition and to expand the space of human freedom.

The Gesture of Making

The symmetry of our hands is such that the left hand must be turned in a fourth dimension for it to coincide with the right hand. Because this dimension is not actually accessible to hands, they are condemned to forever mirror each other. We can of course imagine their congruence, achieved through a complex manipulation with gloves or through animation. But the excitement it produces is so strong as to approach philosophical delirium. For the symmetrical relationship between our two hands is among the conditions of being human, and when we imagine the hands being congruent, we imagine having overstepped the boundaries of our constitutional foundations. Yet we can exceed them in a certain sense: we can make a gesture through which the two hands reach agreement. Of course, it will not be the "empty" gesture of grasping one hand with the other. That gesture confirms the hands' difference. But we can try to make the two hands converge on an obstacle, a problem, or an object. This "full" gesture is the gesture of making. This gesture presses from two sides on an object so that the two hands can meet. Under this pressure, the object changes form, and the new form, this "information" impressed on the objective world, is one of the ways of getting beyond our basic human constitution. For it is a method of bringing the two hands together in an object.

The words we use to describe this movement of our hands—*take, grasp, get, hold, handle, bring forth, produce*—have become abstract concepts, and we often forget that the meaning of these concepts was abstracted from the concrete movements of our hands. That lets us see to what extent our thinking is shaped by our hands, by way of the gesture of making, and by the pressure the two hands exert on objects to meet. If we imagine a

being that is just as capable of thinking as we are but that has no hands, we are imagining a way of thinking completely different from our own. Let's assume that an octopus had a brain comparable to our own. It would never be able to grasp, nor would it be able to define or calculate, for these are aspects of movements of our hands (unless it gesticulates with its tentacles in a handlike way). To understand how we think, we must look at our hands: the fingers and the way the thumb opposes the other fingers; the way the fingertips touch; the way the hand opens as a plate and closes as a fist; the way one hand relates to the other.

It is not enough to say that the world lies "within the hand's reach," to describe our position in the world. We have two hands. We comprehend the world from two opposing sides, which is how the world can be taken in, grasped, intended, and manipulated. We do not comprehend it from eight sides, as an octopus does. Because of the symmetry between our opposed hands, the world is "dialectical" for us. We can suppose that the world is anthropomorphic. But this supposition is not "practical" ("good for the hands"), because we can't "get" it, "grasp" it, "do something with it." For us the world has two sides: a good and a bad, a beautiful and an ugly, a bright and a dark, a right and a left. And when we conceive of a whole, we conceive of it as the congruence of two opposites. Such a whole is the goal of the gesture of making.

The structure of our hands demands that the gesture of making strive for wholeness ("perfection") but also forbids ever reaching it. For the symmetry of our hands permits no congruence in the three-dimensional space of the objective world. We can project a fourth dimension "behind" the world so as to have a model for the gesture of perfected making: "God as Creator"—a creator whose two hands agree completely, in "transcendence" of the world He has made. Plato's third gender is incomprehensible.[1] Yet no special theological research is needed to recognize that such a model is itself the product of a gesture of human making. And so is every model: a product of our two hands. The gesture of making can therefore not be approached using a model without falling into circular reasoning. This gesture must be observed without a model; that is, it requires phenomenological exertion. And that is not easy, for we are ourselves gestures of making. This is about committing ourselves to observing ourselves as makers, as *homines fabri*. We have to become Martians.

A Martian watching our hands would probably be more deeply re-
pulsed than we are watching spiders. Our hands are hardly ever at rest:
they are like five-legged spiders that never stop testing and touching and
making noise and doing things to and in the world. The Martians will be
disgusted to find earthly entities that are comparable to our hands: organs
of perception, weapons of attack and defense, means of communication.
But they won't find anything so hungry, so persistently wary, so restless as
our hands. This disgusting form of being in the world is exclusively human.

From the standpoint of order, harmony, perfection, which is to say
from standpoints that are not human, hands are monsters, for their in-
satiable craving, their curiosity, subverts any order. Within the order of
things, hands are in fact agents of provocation and subversion. They have
infiltrated nature to subvert it, and, being unnatural, they become unset-
tling, even repulsive. And very obviously, hands are one of the ways we
human beings are in the world. We must evoke disgust in all other animals
(except perhaps dogs).

Our hands move almost constantly. If we were to record the lines the
hands draw back and forth, for example, on video, we would have an im-
age of our being in the world. And we do actually have access to such a
video: the world of culture. That is a world in which the pathways taken
by our hands for thousands of years have been fixed, if also modified by
the objective world's resistance to our hands. And that is, surely, the symbol
of what we find beautiful.

The gesture of making has a complexity that defies description. But for
didactic purposes, the gesture can be divided into simple phases. Simplified
in this way, the gesture of making may be described something like this:
both hands reach out toward the world of objects. They grasp an object.
They tear it from its environment. They press on the object from two
sides. They change its form. The simplification consists solely in focusing
attention on the hands. For the whole body (and, on another ontological
level, the "mind" as well, when it becomes impossible to ignore) surely
participates in the gesture of making. But by paying attention in this sim-
plified way, the hands alone are illuminated, and everything else is left in
diffuse and obscure margins of the field of vision.

So the hands first reach out toward the world with open arms, fingers
spread, surfaces facing one another. We know this gesture. It is the gesture

of reception, of taking in, of opening up to the future. It could be called the "gesture of perceiving." But let's not be deceived by its friendly and conciliatory appearance. Perception is no immaculate conception. It is a powerful, active gesture. It exerts force in the world, for it divides the world into an area between the hands' two surfaces (that it takes in) and an area outside of this (that it turns back). It has an effect on the future, because it opens a channel through which certain things flow and others are excluded. It is a gesture of division, a "categorical" gesture in the Kantian sense. It receives the objective world into the categories opened by the gesture of perception.

Once they have defined their field of action, the hands move toward each other until they are stopped by something. It is certain that there will be something, because the object world is "full" of something. Even if what the hands are reaching through is only air. In fact, hands despise things that offer no appreciable resistance and that may therefore be penetrated or brushed aside without much effort. For them, such things are no object. For we are dealing with an imperialistic gesture, a gesture of dominance, distaining the world, and taking control over what does not resist. The world consists of nits the hands brush aside as they come together.

There are occasions when these hands encounter no resistance along their way; they will have perceived "nothing." That will be an "empty" gesture. But it also happens that the hands come across something that inhibits further movement. Then there are two possibilities. The hands can either pull back or insist on meeting. The first alternative will produce a gesture of fear, flight, or escape, or one of disgust or revulsion, and this gesture lies outside the topic under consideration here. Here we are concerned with hands in the case of the second alternative. They begin to touch the object with the fingertips, they follow its outline, feel its weight on the hand surfaces (they weigh it up), pass it from one hand to the other (think it over). That is the "gesture of grasping." It is not about a "pure" gesture of "objective" observation (despite the claims of our scientific tradition). It is true that the hands are not interested in the object they grasp for its own sake; they "play with it," and that is a specifically human movement. And to the same extent, they pursue an interest: they want to meet. Certainly they are not interested in the object in itself; rather, the object interests them as a "problem," as an obstruction. The gesture

of grasping is not "pure." It is not contemplative. It is "practical." It has a purpose, like all other gestures. There is no pure understanding; "pure" knowledge is a myth.

The gesture of grasping is practical. It does need to grasp everything that relates to the object. That would be an absurd goal. The hands can never grasp all sides of an object, for from a practical point of view, any object has innumerable sides. So the object is "concrete"; with its innumerable sides, it is unique and incomparable. But the hands don't appreciate the absurdity of a total knowledge of the object. To meet, it is enough for them to grasp the sides that matter for this meeting, the sides from which they seem likely to be able to penetrate the object. Accordingly, the hands concentrate on such sides. That is the "gesture of comprehending" *(cum-prae-tendere)*. It is in fact the gesture that compares the object with objects that were grasped previously. It is the case that the object, as a concrete object, cannot be compared to anything. But through some of its sides, it becomes more available to generalization. The tradition speaks of classification, induction, of a progressive generalization. These concepts give the impression that we are dealing with a logical, mathematical, formal, and abstract activity. When one forgets that the meaning of these concepts has been abstracted from a gesture of comprehending involving the hands, comprehension actually becomes a movement of the "mind." But if we return to the hands as they move around the object, if we let them speak, we can see how thoroughly our engagement is in a concrete movement. "Comprehending" then again becomes a "grasping together," or even a "shared apprehension" of various objects, so as to be able to penetrate them.

An object is understood practically when the hands begin to penetrate it. There are of course incomprehensible objects. There are objects that show the hands that want to penetrate them that they are, practically, impenetrable. Such objects are not suitable for the gesture of making. When this happens, the hands perform entirely different gestures that are not within the scope of this essay. But it is advisable to remain aware that there are incomprehensible things and that our hands cannot grasp everything. There are boundaries for the gesture of making: the incomprehensible.

Still, the vast majority of objects around us are comprehensible, and hands, through their movements, steadily increase their numbers. They

play with objects that are not yet understood to understand them. They are intent on what is "noteworthy" in some "curious" way. They are, in short, curious. There are certainly many noble speculations on this topic in our tradition: the curiosity of our hands is the atmosphere in which our hands take possession of more and more of the world. But if we focus our attention on the concrete movement of our hands, the explanation of their curiosity looks less noble. The hands want to meet, for that is their symmetry. But they can't do it, for there are objects in the way. So they are compelled by their very form to gradually comprehend, to progressively conquer the world. The curiosity of our hands is one of conditions we have been given.

Now to describe how the hands move, once they have understood the object. But at this point, a barrier appears in the way. For we are not forgetting that we are describing the movement of our own hands. And at this point, we have the feeling that an "inner" motive—we don't know where it comes from—affects, changes the gesture. It is intellectually honest to recognize this barrier, which demands that we turn our attention from the hands to this "inner" concern. We can hope that after this departure, we'll very quickly return to the hands.

The feeling is the following: after they have understood the object, the hands seem to know how the object should be. That is not a very satisfactory sentence. Every word raises doubts. Who is this mysterious being that "knows"? What does it mean to "know" in this context, or indeed to "have understood"? And what kind of difference is there between "is" and "should be," between reality and an ideal? Obviously, there is an extensive and interminable (although not very satisfying) discussion of this theme in our tradition. But didn't we close off this discussion at the moment we bracketed out all models? All that is true, but the power of our hands over our thought is so strong that we can't honestly avoid such an unproductive dialectic between "subject and object," "real and ideal," "material and form." The old circular argument "the two hands"[2] closes in, and there is no honorable way to escape.

Let us formulate the uncertain feeling in "manual" concepts: the understood object is understood between the two hands. The left hand has understood what the object is, that is, it has compared the object with other objects. And the right hand has understood what the object

should be, that is, it has compared the object with a form. Of course, the concepts "left hand" and "right hand" are used metaphorically in the last sentence and not as description or observation. Nevertheless, there is a noticeable difference between the left and right hands. Let us hope that the metaphorical way of speaking in some sense reflects this perceptible difference. Speaking metaphorically, let us call the left hand that of "practice," the right hand that of "theory," and let us say that the movement the hands make as they try to meet is the effort to ground theory in practice and to support practice theoretically. A movement that changes the object so that it becomes what it should be. The two hands will meet when the object is as it should be and when the intention has become objective and concrete, the object valuable and the value an object. There we have the "fourth dimension," where the two hands must turn if they are to agree: the dimension of values. The wholeness we seek is to be found in the realm of values.

After they have understood their object, the two hands begin to instill a form or value in it. The left hand tries to force the object into a form, and the right hand tries to press a form onto the object. That is the "gesture of evaluation." The two hands have somehow come to an agreement about the form appropriate to the object. They have come to the understanding that the object "leather" suits the form "shoe" and that the form "shoe" is good for the object "leather." Evaluation is a gesture of weighing, in which hands are trays of a scale, weighing the value of what is against the value of what ought to be.

Of course, the gesture can also proceed in the opposite way. The hands can choose an object that exhibits a particular form. Tradition tells us that two different gestures are involved in this. When a form is selected as a function of an object, we say that it is a technical gesture, the result of "value-free" scientific research. When an object is selected as a function of a form, conversely, we say that it is an artistic gesture, design. But tradition exaggerates the difference between technology and art, between the gesture of making shoes and the gesture of designing forms for shoes. The choice of a form in consideration of an object and the choice of an object in consideration of a form imply one another, for this concerns exactly the dialectic between theory and practice, and it does not matter too much whether the initial emphasis is on the form or the object. The

gesture of making switches with such speed from object to form and from form to object that we won't get very far if we start by choosing between a technical and an artistic evaluation. Tradition divides art from technology without any observational justification. In any case, if one is thinking formally, say, using a plotter, then form gains the upper hand over practice so that the saying from the first half of the century, "form follows function," is reversed and must read "function follows form."

If the object has been evaluated, the hands begin to "inform" it, to change its form. They violate it, they do not allow it to be as it is. They deny the object. They affirm themselves with respect to the object. That denial and this affirmation of the hands in relation to the object is the "gesture of producing." It tears the object from its surroundings. "To produce" means to take the object out of one and into another context, to ontologically change it. It means taking it out of a denied context (a world that is not as it should be) and putting it into an affirmed context (a world that is as it should be). The gesture of production is a gesture that denies the objective world, for it claims that the objective world is false, bad, and ugly. For the world keeps the hands from meeting. This is why our hands are monsters: they claim, through their gesture of producing, that the world in which they find themselves is false, bad, and ugly—unless something is being done with it. And just this monstrosity is our human way of being in the world.

In all the phases of the gesture of making that precede the gesture of producing, the object was just there, passive, quiet, mute, stupid, and "available to be grasped." This passivity and stupidity is just the way the objective world is there: it is the way it is as an object. But suddenly, under the pressure of producing, the object begins to react. It defends itself against being transformed into a product, it resists its own violation. It gets pesky. A "raw material." The hands detest it. The rawness of the object injures the hands that are violating it, and the gesture of producing changes as a result of this injury. The hands feel the resistance of the raw material and react with injury. That is the "gesture of researching." Through this gesture, the material is perceived, even penetrated, and the hands discover in the material a resistance to the value being imposed by it.

By observing the gesture of making, we discover the difference between understanding and research. We understand the world when we

compare objects, and we research the world when we penetrate it to compare objects with our values. To research objects means to provoke them into resisting the pressure of the hand and so to force them to reveal their inner structures. Researching the world is a later phase of the gesture of making. Comprehension must come first, making research possible. Hands at the surface of objects come to comprehend those objects; hands research objects from within them. So researching is more profound but also less objective than comprehending. In researching, one is inside, involved in the researched object.

It is true that in researching, one penetrates only objects one has made. But it does not follow that researching is just a function of practice. On the contrary, researching is an effort to make the internal theory of the object coincide with the practice. The gesture of researching is less free than the gesture of comprehending. It is a gesture that is constantly thwarted by objective resistance, constantly deflected from its intended course. As a result, researching is less objective than comprehending. However, in gestures of researching, the object shows itself to be more meaningful. To research, one must make something, and that implies a theory *and* a practice. We cannot grasp this by treating objects mechanically, without theory, or by researching them using "pure" theory disengaged from the work. Neither a factory worker, separated from his theoretical hand by the division of labor, nor a "pure" theoretician, his practical hand amputated, will research his object. That is "alienation."

The resistance of the raw material to the pressure of production varies in kind and degree from one object to another. Objects like glass break under the pressure; others, such as cotton, absorb the pressure; others, such as water, slip through the fingers; and others, such as marble, reveal hidden faults. Each object has its own tricks for disappointing the hands' efforts to impose a value. Each object requires a different strategy and method. There are objects that call for brutal treatment, there are others with which one must be tender, and there are still others that must be deceived. To the degree the hands are researching their object, they discover a strategy for imposing form. To the degree the object injures the hands, it gives up its weakness, its secret. And when the hands research this secret, when they grasp the way the object can be changed, they change their gesture once again. That is the "gesture of fabrication." The hands can

now impose a value on the object, they can penetrate it to its core, so as to meet and coincide with one another.

At this point in our description of the gesture of making, a new difficulty appears: the problem of specialization, the division of labor. Each object demands a specific strategy, so the gesture of fabricating is different for each object, and this to such an extent that the various gestures of fabricating do not appear to be comparable. But to perceive the *structure* of all gestures of fabricating, it is enough to observe one typical instance. The untold thousands of branches of the tree of specialization are present in every gesture of fabricating as a structure. To see the tree, there is no need to follow the hands as they strive for "wholeness," moving along countless numbers of branches. By looking closely, it can be seen as a negative condition of every gesture. For fabricating one object also means not fabricating any other. It is a gesture of "decision."

After they have researched their object and discovered its secret, the hands can also grasp their own secret, their own skills and destinies with respect to this object. We are familiar with such figures of speech as "that is something for me" or "that has nothing to do with me." For that is basically what it means to have researched and grasped an object. When the hands have grasped that the object is not for them, they let it go in a gesture of disappointment or even despair, so that other hands on another branch of the tree can grasp it. But when the hands have grasped that the object is suited to them, they are happy and begin to work with it. Every gesture of fabricating is proof that the hands have found their object by excluding other objects. The whole tree is negatively present as exclusion.

Underlying the gesture of fabrication is the idea of having heard a "voice," of following a "calling." That is another noble concept. Observing the gesture of fabricating has the advantage of demystifying this concept. A calling is not the plea of a mysterious voice from an unknown place, pressing on the ear to choose one particular object and impose a value on it. There is no one particularly distinguished object, such as, say, musical sounds or a painter's canvas. The discovery of a calling is the result of the hands' struggle against the idiosyncrasies of the object—any object. It is simply the discovery that each pair of hands is different from any other and that some hands are more capable of fabricating shoes, others of fabricating poetry, that fabricating shoes is as noble a profession as

fabricating poetry. Each pair of hands has its special ways and means of asserting itself in the world, and nothing about it is especially noble. The observation of the gesture of fabrication, having demystified the concept of a calling, also exposes the gesture's crucial existential significance. It is easy to see how lost hands are in the world when they fail to find "their" object. When hands find no object on which to impress a form, impose a value, the world literally has no value for these hands. They cannot meet, and their movement is absurd. Of course, they can grasp and understand and evaluate and produce and research, but they grasp and understand and evaluate and research only that the world is not theirs. But at the moment the hands find their object, their movement becomes meaningful, a gesture of fabricating. From now on, the hands are engaged in realizing a value. They have found their calling.

It is therefore entirely possible to describe the structure of any gesture of fabricating by observing just one. The object is to be understood as raw material suited to the hands and held firmly by the practical hand while the theoretical hand holds the value, presses on the object to in-form it. So the two hands press toward one another so as to coincide in the realized value. Of course, the object is changed in this process, but so is the value, the form, the idea. Facing the stubborn, recalcitrant defense of the unformed object, the theoretical hand feels the need to adjust the form it is imposing on the object to be shaped. The constant reformulation of the form under resistant pressure from the object is the "gesture of creating." In this way, the hands impose new forms on the objective world.

Observation shows that new forms are always developed under the pressure of a defensive object world. New forms do not arise from deep inspiration, as the romantic tradition would have it. They do not stride forth from the head of Zeus fully armed, as Pallas Athena did. They all arise from the disjunction between established forms and the resistance of a specific material. "To have original ideas" does not mean to be creative. Creating is a processing of ideas during the gesture of making. Nor are hands creative when they force finished ideas, that is, stereotypes, onto an "ad hoc" prepared material, as is the case with industrial production. Hands are only creative when, in the course of their struggle with a raw material they have just grasped, they need to develop new ideas, that is, prototypes.

Therefore there is nothing creative about the industrial manufacturing that is characteristic of our time and that is a violent assault on a material prepared "ad hoc" to be informed with stereotypes. In fact, prototypes produced in laboratories are not creative either, for they are virtual stereotypes. In industrial society, creative activity is in crisis.

The reason is probably a deep-seated prejudice characteristic of Western culture: the Platonic prejudice. For this is how Plato saw the gesture of making: the two hands move in two different places. In one of these two places (the *topos uranikos*), there are eternal, unchanging ideas. In the other place (the *physis*), there are changeable objects. In the gesture of making, one hand takes one of these unchangeable ideas, the other one of the changeable objects, and the two hands approach one another. The result is the reforming of the object and the idea. But because the "true" idea can never change, the idea that proceeds from the gesture of making is only a "false" idea. It is just an opinion *(doxa)*. So Plato, as a good property owner, rejected the dirty and vulgar gesture of art making *(technê)*. For him it was a betrayal of true ideas. And this judgment against the gesture of making, which is fundamentally a prejudice against creativity, is still with us today.

When we observe the concrete gesture of creating, we can see how thoroughly Plato, with his cultivated refusal to get his hands dirty, was deceived. We can observe that ideas are not stockpiled in heaven to be contemplated by philosophy but that new ideas are constantly appearing in the heat of theory's battle against a raw, resistant world. This observation is obvious, and yet the Platonic prejudice stubbornly persists. The Marxist analysis of work, for example, seems to have overcome it, but in fact even there one glimpses the ghost of a Platonic heaven being taken into account, this time in the form of "materialistic dialectic." Perhaps it is not possible to overcome this prejudice and set creativity free completely, for our own hands impose this "dialectic ideology" upon us.

Through the gesture of creating, then, the hands develop new forms and impress them on objects. That is a struggle. It can happen that the hands, being human and so weak, are sensitive and vulnerable and that the struggle threatens to destroy them. In this case, the hands can, of course, give up or surrender. It is a horrible gesture, and unfortunately, we know it well. Where there is disappointment with creative activity, the world's

brutal stupidity enters in. At the same time, there is a second alternative open to the threatened hands. They can withdraw from the recalcitrant object for the time being and look in the surrounding area for ways of reinforcing themselves, so as to attack again. This second alternative of further inquiry, in the vicinity of the object, with the purpose of returning to it, is the "gesture of tool making." This gesture makes something peripheral to return to the original object, an ambivalent and dangerous gesture.

In a certain sense, the whole problem of the gesture of making is concealed in this phase of its development. The hands turn away from their original, their "actual" object. They move around its surroundings, in the objective world, to find another object, made in a different way, an object that is somehow "like a hand," but not so vulnerable to injury, a stone, for example (that is like a fist), or a branch (that is like a finger). Obviously stones and branches are very much less complex than a fist or a finger, but for breaking or pushing through things, they are far more effective. The hands extract such objects from their objective contexts and then use them against the context. Objects used in this way are transformed into simplified and more effective extensions of the hands. For this purpose, the hands grasp, comprehend, research, and produce these objects so as to then use them against the original object. The gesture of making, interrupted by the intractability of the original object, can now proceed, for hands equipped with tools are less vulnerable to injury.

This excursion to the site of tool making involves ambiguity and danger because the process of making tools is itself a series of gestures of making. It is itself a movement in which the hands want to meet in an object, a movement through which the hands find their calling. In this sense, the toolmaker is exactly like any other creative person. He is just as creative as a shoemaker or painter. But in such a claim there lies a dangerous contradiction. For in its ontological status, a tool is not an object to be in-formed. It is an object that serves to give other objects a form. And more, to produce tools, other tools must be produced in a practically infinite regress. And still more, tools and tools of other tools occupy the hands and make such demands on them that they forget their original object. So the detour at the site of tool making can last hundreds of years (as in the modern period), and the original object behind the horizon of

the hands' field of activity disappears. That is the situation of industrial society today: its attention is trained on the production of tools and on tools for tools, and the original object of the gesture of making remains forgotten.

But why is this a danger? If the production of tools is like any other making one might choose, if the hands find their calling in this gesture and can come together through this gesture, why should a distinction be made between the initial objects and objects made in the detour? The answer is because hands armed with tools are not like naked hands. The tool is a simulation of the hands, and hands equipped with tools are simulations of tools. To grasp the effect of this metamorphosis of the hands through tools, we must return to the initial description of the gesture of making.

It is an imperious and imperialistic gesture that denies the world of objects. But there is nothing ethically false in the gesture. It is directed against the world of objects, and this world has no value. It only becomes "valuable" through the gesture of making. It is hands that impose value on this world. And naked hands can feel the difference between an object and a person with fingertips, on their surfaces and with their whole sensuality. An object is hard, passive, simply there, whereas a person answers the hands, hands that touch him on his own hands. The hands cannot capture a person, for a person answers the gesture of capture with a suitable gesture of his own. In this way, hands can recognize themselves in others, and the gesture of reaching a hand out is not the same as a gesture of making. Of course, hands can make mistakes and take a person for an object. They can objectify another person, they can use violence to bring him within their grasp. But in principle, naked hands move within the objective world through the gesture of making and adopt different gestures to move within the social world.

But hands equipped with tools do not possess the sensuality of naked hands. They cannot distinguish an object from a person. Everything can now be manipulated, made. People have become objects: they can be understood, researched, produced, and even turned into tools for producing other products. For hands with tools, having forgotten their original objects, there is no longer any social world. Their gesture of making is apolitical and unethical. In hands armed with tools, there reigns a strange solipsism: they are alone in the world and can no longer recognize other

hands. And that is dangerous, for if there are no others, making is an absurd gesture. So the danger in the gesture of making tools lies in forgetting the original object and, with it, the difference between an object and a person.

If the original object is not to be forgotten, the hands, now with their tools, return to it to break down its resistance. Now they can press into its core and reach agreement. That is a complex process. The tool presses the hands into the object. Under the pressure of the hands and the tool, the object changes. The form impressed on it, the value, changes not only as a result of the object's intractability but also through the form of the tool. The resulting product will be shaped less by hands than by tools. The form that is finally realized will be a mirror of the form that was first intended, the object's recalcitrance and the work of the tool. The result will therefore no longer be a work of the hands. Rather, a new, a "fourth dimension," will appear: the dimension of value. The two hands can coincide in this dimension. This gesture, in which the hands return to the original object to finally penetrate it after all, is the "gesture of realization."

Let us consider the result of the gesture of making: a work, two of whose aspects are obvious. For one, an object has become "valuable"; for another, the hands have "realized" themselves, a value has become objective. Yet there is a third aspect of the work: a defeat. Not only because the object has not become as it should have been and because the value originally intended has not been realized but also because the two hands have not come to "perfect" agreement. The first reason for the mood of defeat, in which the finished work is immersed (the reason Plato regarded it as a "betrayal of the true ideal"), is theoretical: the form that was originally intended was just ideology. But the second reason has real existential weight. The two hands come infinitely close to one another, but their perfect agreement is never achieved. This is a border situation. At no time can it be said that the work is complete. There is always a distance, however infinitely small it may be, that divides the two hands in the object. This integration of the hands in the object, the "wholeness," that is, is always elusive. In the sense of an ideal of being "wholly finished," the work is never perfect. The gesture of making is an interminable gesture.

And still it ends. It ends when the hands withdraw from the object, open their inner surfaces at a wide angle, and let the object glide into the context of culture. We know this gesture. It is the gesture of sacrifice, of

resignation and giving: the "gesture of presenting." This gesture is not made by the hands when they are satisfied with the work but rather when they know that to go on with the gesture of making would no longer have meaning for the work. The hands stop working when they are no longer able to make the work better. The gesture of presentation is a gesture of resignation.

But that is not all. Clearly it is the last phase of the gesture of making, and yet it is completely different from the other phases. The gesture of making is a gesture of hatred. It draws limits, excludes, overpowers, transforms. The gesture of presentation, conversely, is a gesture of love. It donates, gives something away, it offers itself and gives itself up. As they present their work, the hands offer themselves to another. They expose their work, making it public. The gesture of presentation is a political gesture. It is the gesture of opening. The gesture of making ends with the opening of the hands to others. Seen from its conclusion, the gesture of making is therefore a gesture of love with respect to another. The wholeness the hands seek in the object, without ever being able to find it, is a gesture of disappointed love. It is a specifically human gesture. It seeks to overcome the human condition and ends, beyond resignation, in love.

The Gesture of Loving

A phenomenology of the gesture of loving must negotiate two dangers, sensationalism and prudery. They probably cannot be avoided. In any case, they immediately immerse the inquiry in an atmosphere that is unique to this gesture. For they show that what conceals this gesture from view is not a cover woven from habit, as is the case for most other gestures, but from repression. We don't pay attention to most gestures because we don't pay attention to what is familiar, and so when we concentrate on them, they seem new and surprising. But we don't see the gesture of loving because social pressure demands that it be private, and private is by definition invisible, and if through some counterforce it becomes public, then it appears to be a controversial gesture, obviously changing its character, which has nothing to do with exhibitionism and ostentation. In the gesture of loving, we have one of those few gestures (other examples are flag waving and saber rattling) that appear on posters everywhere, in newspapers and television programs. It is the task of phenomenology to strip the appearance of exhibitionism away. Only the gesture of flag waving is motivated by exhibitionism. It is pornographic at its core, and the task of phenomenology is to expose the exhibitionistic core behind the exhibitionistic pose. Meanwhile, exhibitionism in the gesture of loving, to which we are currently far more exposed than we are to that of flag waving, makes the gesture seem strange. The task of phenomenology is to show that it is not pornographic and so to expose the core of the gesture, which is in danger of being lost.

Any observation of the gesture of loving must start from its ubiquitous depictions in our environment. We practically live among images of this

gesture, which is to say that our codified world is a sex shop, which differs from specialized businesses in its use of the gesture as a means of attraction and as a tool for selling nonsexual goods. This broadband sexualization of our codes (everything, even gasoline and cat food, has sexual connotations in posters and shop windows) conforms to a dialectic that in fact has little to do with the gesture of loving but of course affects the gesture through complicated feedback pathways. The sexualization of codes originated as a reaction to Victorian prudery. But it played itself out so quickly that both a constant expansion and a constant recoding were needed to keep it from turning into its opposite, a dreary desexualization. Unlike most other gestures, the gesture of loving allows few variations (despite there being more and more positions), a fact that surely affects our understanding of the gesture. For example, it is possible to write or swim or sing in diverse ways, but for loving, the diversity is not so great. And that is a problem for the sexualization of codes, for to avoid falling into their dialectical opposite, the codes continually need new variations of the gesture. This heightening and recoding of the gesture deflects attention further and further from the essential thing about the gesture, that is, away from the concrete experience and toward the technoimaginary. The messages we receive acquire sexual connotations that have hardly anything to do with love in a concrete sense. As feedback, that has an effect on the gesture of loving that should not be underestimated. The gesture itself becomes technoimaginary, which is to say technical, imaginative, and codified, an instance of scientific theories being linked to hands-on experience. One might even claim that the gesture of loving is one of the few gestures to which a vast majority of people apply both scientific theories and accumulated experience. And in this way the capacity to love is lost.

It is, of course, possible to bracket this entire complex of the sexualization of codes out of the observation of the gesture of loving so as to focus on the gesture itself, as it seems to be in actual experience. But this effort has to fail, because it is impossible to separate one's own experience from the social program. One is constantly reminded that the gesture of loving is to be clearly separated from that of reproduction, and that the pill has permitted women in particular to act on this separation, and so at last to be able to make a genuine gesture of loving. That is correct, but not complete. Equally important is the distinction between the sexual

gesture and the gesture of loving. Here the codified program by which
we live plays a significant part. To put it bluntly, one might say we are pro-
grammed for the gesture of reproduction and for the sexual gesture but
no longer for the gesture of loving. If we are nevertheless able to carry it
out from time to time, then it will be as an independent discovery, in stark
contrast to the broad-spectrum sexualization of the cultural program in
which we live.

The difficulty in releasing the gesture of loving from its entanglement
with sexual and reproductive gestures is not based solely in the complexity
of the concrete fact of the gesture itself but has above all a linguistic basis.
The word *love* is usually applied inexactly to all three of these gestures,
for we have lost, along with the capacity to love, the capacity to think
precisely about love. The Greeks, for example, made distinctions among
eros, philia, charisma, empathia, and many other concepts of love, while we
distinguish at best between sexual and nonsexual love and, in doing so,
start to water down the concept of love in earnest. For when it is said that
the sexual revolution permits "free love," or when "make love, not war"
turns organism rather than patriotism into a political program, sexuality
has been identified with love at a level that is not conscious. That such iden-
tification is an error is clear not only from concrete experience: there can
be sexual experiences without love experiences, and the reverse, perhaps,
love experiences without sexual ones. But the error in the identification
is also clear from observing the codified character of the sexual gesture,
which rules out almost any gesture of loving. For the sexual gesture has
become so technoimaginary that, for many, the phallus has become a
phallic symbol. In such a highly coded universe of sexuality, there is no
space left for love, and the gesture of loving has to assert itself against the
gesture of sexuality. This cultural situation may not be unique in history
(one thinks of the love poems of Catullus), but it is characteristic of the
current situation.

Although we must distinguish between sexuality and love, there is no
avoiding the close connection between the two contexts. For in doing so,
both sexuality and love are lost (and it happens from both sides, the moral-
izing, impotent side in Westerns as well as the pornographic, commercial
side in, for example, refrigerator advertisements). For sexuality, without
any love, turns into that ridiculous, tiresome mechanical movement,

reminiscent of hard labor, that is shown in pornographic films. And love, without any sexuality, becomes that saccharine sham that has as little to do with real love as the recitation of scripture has to do with real faith. So we should take it as a fact characteristic of our present situation that we can remove the gesture of reproduction from context but that things do not work in the same way with the gesture of loving, despite the recoding of the sexual gesture. In other words, to make authentic love, we must engage in sexual gestures, although in technoimagination, these gestures contradict the gesture of loving. And that is another way of saying that we are about to lose the capacity to love.

An objection might be raised that the foregoing deals with theoretical, not with phenomenological, observations and that there can be no doubt about loving in the gesture itself. The theoretically impossible division between love and sexuality is, one might say, experienced concretely, in fact, as sexual love. There is a pitched moment that has something to do with orgasm but that occurs at a different level of being, in which there is complete absorption in the other without loss of the self, and exactly this moment is love. At the existential level of love, the tipping over into another, which makes "I" and "you" into "we," appears as a climax, achieved by the organism, its sexuality, although it binds two people together afterward and beforehand with no sexuality at all. Seen in this way, the gesture of loving appears to be a gesture that makes use of sexuality, like the gesture of painting makes use of a brush. Not that the brush isn't critical for painting. It characterizes painting, and without a brush, painting is empty talk. And yet the brush does not occupy the same existential level as painting. That, as the objection might have it, is theoretically difficult but concretely obvious.

This objection is untenable. For if the performance appeared to be theoretical instead of phenomenological, this is due to the widespread theorization of the concrete act of the gesture of loving itself. When we make love, we watch ourselves, so to speak, as we do in all our other gestures. This theoretical, ironic distance is characteristic of gestures, of human existence in general. But this absence of naïveté has a particular character for the gesture of loving that is different from that of other gestures. There, it may provide a critical distance, a means of perfecting the gesture; here, with the gesture of loving, which is finally the gesture of merging

with another, it is destructive. Perhaps this critical distance toward loving is what is meant by "original sin." But in any case, a phenomenological observation of the gesture of loving must take this theoretical aspect into account above all others and so must take on a theoretical character of its own. So the gesture of loving could essentially be characterized as the gesture of overthrowing theory. It is the gesture in which a human being becomes most embarrassingly aware of his theoretical alienation and, at the same time, the one to which he is indebted for his most successful efforts to overcome this alienation. This is a roundabout way of saying that the gesture of loving would be the one in which a person is most concretely in the world and that therefore occupies a central position in life.

What is strange is that the gesture of loving cannot be described as a body movement at all. For if you try it, you suddenly notice that you have described the sexual gesture instead. Conversely, any attempt to describe the concrete experience of this gesture is equally doomed to failure. For if you try this, you suddenly notice that you have described a mystical experience instead. Of course, it is possible to circumvent this difficulty, as yoga books do, by saying the sexual gesture is a technology of mystical experience. But this sort of claim serves to reinforce mistrust of yoga books rather than to better understand the gesture of loving. For one comes no closer to love by acquiring the technique of the sexual gesture and probably moves further away. By analogy, one might conclude that enlightenment will probably not result from perfect yoga technique. Still, there is more in the impossibility of representing the gesture that is worth thinking about.

The problem probably looks like this: a human being has weak instincts, and so he can gesticulate, make movements for which he has not been genetically programmed. Obviously there is also instinctive behavior in humans, even if it has largely been culturally reprogrammed. The most striking among such behavioral patterns is the sexual one, so striking that many of our psychologists believe it to be the basis for all behavior. The sexual instinct in human beings is culturally reprogrammed as, among other things, the sexual gesture, and this gesture can be described mechanically. But beyond this, people build a whole program around this instinct, which we know from psychological, psychoanalytical, and similar writings. This program in turn leads to gestures of a completely different

sort, which also can be described mechanically. And still a human being is not completely programmed. He can let himself go and calmly escape all programming. Such serenity is not a gesture but passivity, not an activity but an omission. Obviously such a situation is difficult to describe mechanically. Such resignation and passion[1] take part, become active in the gesture of loving, and that is probably what makes it impossible to get at what is essential in the gesture through description.

If it is not possible to describe the gesture of loving either as a movement of the body or as inner experience without losing what is essential about it, it is still possible to use this impossibility of a means of recognizing the gesture. We could say, for example, that the essential quality about the gesture of loving is the sexual experience as mystical and the mystical experience as sexual. The mystical without the sexual is not love, and no sexualization of any kind, for example, on the part of Saint Theresa, can cover it up. We know from our own experience, however, that sex without a mystical dimension is not love. We can conclude that the panoramic sexualization of our world is just one aspect of the process of losing our capacity for love. The other side is the panoramic mystification of our world. The way to find concrete experience, then, would be through a mystification of sex and a sexualization of the mystical.

Of course, that's nonsense. For one of the distinctive qualities of the gesture of loving is exactly that one can't want it, for it involves surrender of will. One must, as the English language suggests, allow oneself to fall in love. The gesture of loving does not occur within a program but rather moves away from a program and so cannot itself be programmed. But strangely, it does not mean that the gesture is any more likely to follow from letting oneself go than it is from self-discipline. For the gesture of loving is bound up with limitations, with what is called "loyalty." However, a consideration of these limitations would lie outside the topic set out here.

The blurring of sexuality with love that characterizes our situation makes it difficult to see the authentically close relationship between the two contexts. Technoimaginary codes program us for sexual gestures, which we often confuse with gestures of loving. Because sexual inflation devalues sex, the gesture of loving, too, is devalued as a result of the confusion. And because we are steadily losing the innocence required for

serenity, becoming increasingly technical, imaginative, and critical, we have difficulty achieving the basics of the gesture of loving. It is individually and socially tragic. For the gesture of loving is the way we can lose ourselves in another and so conquer our alienation. Without the gesture of loving, any communicative gesture is an error. Or, as it should have been called earlier, sin.

The Gesture of Destroying

Gestures are movements of the body that express being. The gesticulating person's way of being in the world can be read in them. And in fact, that is possible because the gesticulating person is sure that he is making the movements of his own free will, although he knows that they are, like all movements, conditioned. He is not satisfied with reasons (causal explanations). Even if I could know everything about what makes me smoke a pipe, I would [not][1] be persuaded to chew gum instead. If I ask why I smoke a pipe, I am not asking for reasons (for causal, scientific explanations) but for what motivates me. Causal explanations "read" the world in which we exist; explanations of motives "read" the way we are there in it. Motives, and so decisions, lie outside scientific competence. The very fact that gestures cannot be adequately explained scientifically allows for existence to be "read" in them.

The gesture of destroying raises the question of evil. It is not the scientific question about whether there is such a thing as a will to destruction but an unscientific one about gestures in which the will to destruction has been freely chosen as the motive. The question is concerned not with "so-called" evil but with evil in the actual, ethical sense.

The fact that the question has arisen in the German language both helps and hinders the discussion at the same time. German is a Western language, to be sure, but not to the same extent as many others with Latin roots. *Zerstörung* and *Destruktion* do not mean quite the same thing, and the difference enriches and complicates our dialogue. *Destruktion* is closer to dismantling or displacement than it is to *Zerstörung*, and *Zerstörung* is closer to clearing away (an obstruction) than it is to *Destruktion*. For

Zerstörung negates *Störung* (disruption, annoyance), and *Destruktion* negates *construction*. Only if disturbing and constructing were the same could *Zerstörung* be translated as *"Destruktion."* The question whether and to what extent evil has anything to do with *Zerstörung* and whether and to what extent it has to do with *Destruktion* is to be examined here using two concrete examples.[2]

A prisoner bumps into the four walls of his cell when he walks around it in a circle. This bumping cannot be regarded as a gesture, even if it is violent. The same is the case for hitting the walls with a fist in despair, even if one of the blows should break through. With such movements, we are rather dealing with conditioned reflexes colliding with the wall. Should the prisoner decide to examine the wall for cracks so as to possibly break out, the movement must then be called a destructive gesture, even if it has no effect on the walls. It is not effectiveness that separates gestures from other movements but the fact that they express decisions, that they are phenomena at the ethical level of reality, expressions of being—in short, that they are "motivated."

This case concerns a decision: these walls disturb me, and although it is probably impossible, they should be destroyed. This decision is the motive for the gesture. Theoretically, it can be seen in the gesture. It is apparent that the disruptive gesture resembles work. Work is a gesture whose motive lies in the decision to make something different from what it is, because it is not as it should be. Both destruction and work decide that something is not as it should be. Unlike work, destruction decides not to make it differently but to get rid of it altogether. It negates not just the way the object is but the object itself. One could then suppose that destruction is more radical than work. That would be an error. It is less radical, for its decision does not get at the roots of the not-supposed-to-be. It has no model of obligation. Work is revolutionary. It replaces that which should not be with something that should be. Destruction is not revolutionary: it says no, but not dialectically. The being expressed in the destructive gesture is less radical in the world than one articulated in gestures of work.

In the example just given, *Zerstörung* (disruption) and destruction coincide. To destroy the walls, that is, the prisoner must move the stones that constitute the walls. The walls disturb him because they are assembled

from stones in such a way as to take away his freedom (or that of anyone else locked up between them). But although the prisoner's gesture is as much about disruption as destruction, there is no immediate sense of anything evil about it because the intention of the gesture points beyond disruption and destruction (namely, to an escape from the cell).

Here is the second of the two examples. Let's say there's a chess player who finds himself in a strategically hopeless situation. If he is so nervous as to tip the board over, that is not to be understood as a disruptive gesture. It is a movement conditioned by strained nerves. If, conversely, he decides to overturn the board to avoid an anticipated or customary defeat, the gesture must be called disruptive. It is characteristic of this gesture that it is a "move" in a chess game and not, as in the case of the nervous overturning, a random event with some bearing on the game, an "accident." The disruptive gesture is not a "systems failure" (as Nazism was not) but an ethical phenomenon: a "motivated" movement. Neither accident nor necessity (which we know lie on the same level of reality) but freedom is the framework in which ethical phenomena such as the disruptive gesture occur.

Overturning the board is a "move" in the chess game, one of the gestures that can be made within the universe of the game. But it is a "move" against rules. So the disturber is not someone who "no longer is playing" but someone who has decided to continue to play, against the rules. Only the decision explains that the rules are disturbing him. If he really were no longer playing, then the rules couldn't bother him. He decides to disturb the disturbing rules (to overturn the board and avoid the defeat to come) exactly because he was in the game when the decision was made.

In this example, *Zerstörung* (disturbance) and *Destruktion* (destruction) part company. "To disturb" means to get rid of the rules that put things in order and so cause these things to fall apart. Nothing of this sort happens with the overturning of the chessboard. This movement does not undermine the rules of chess but rather confirms them by not following them (it dis-turbs, as a thief confirms the law). Disturbers (barbarians) are not necessarily destructive spirits. On the contrary, they can have a constructive effect. As the Germans disturbed the Roman Empire, they transferred its rules (its structures) into other areas, for example, into the Church. If destructive spirits (e.g., cynics or Epicurians) had triumphed,

the empire would actually not have been disturbed, but it would have been destroyed. Disturbers disturb that which is disturbing; destroyers destroy structures. Disturbers are thieves and are unlike destroyers in that they do not deny the law. Disturbers are frustrated conservatives; destroyers are frustrated revolutionaries.

The player overturns the board because he is afraid he will otherwise lose. His motive is the avoidance of defeat through a rule-averse "move." His intention is to disrupt the game, to break it apart. He turns the board over "intentionally," and for exactly this reason, the gesture is not evil, not "diabolical," although it means *diabolical* (*diabolical,* from the Greek *diabolein,* "actively breaking up, dispersing"). Evil would be to overturn a board where two unknown players are sitting, whose game holds no interest. The motive for such a gesture would consist in a decision to disturb an uninteresting game. It would be a gesture with no intention. The motive would be "pure" (in a Kantian sense of disinterest, complacence). For what such a gesture disturbs, what provokes the gesture, is not a specific state of play, and not the rules of the game, as in the case of destruction, but the fact that this is a rule-governed activity. The decision does not mean "these rules are disturbing," nor does it mean "these rules are wrong"; rather, it means "this game is disturbing because it has rules." So, not "made, but disturbing," nor "badly made, and so disturbing," but "made, therefore disturbing." That would be "pure malice." It is rare, because it is inhuman, that is, unintentional, a gesture with pure motives.

A human being is in fact completely in the world, but in such a way as to stand apart from the world. To him the world as environment is an object. That allows him to gesticulate, to behave as a subject. The world is fundamentally entropic. As a whole, according to the second law of thermodynamics, it moves toward a state of increasing probability. It steadily loses form, becomes increasingly chaotic, for form is improbable, precarious, an exceptional condition. It is not the exception that proves the rule but rather the rule that is the exception, confirming the probable accident. This tendency toward probability (in which chance is necessary) is "objective time," and because of it (e.g., the decay of radioactive elements), we can measure segments of time "objectively."

As an entity that is part of the world, a human being is subject to this entropic tendency (e.g., he has to die). But as a subject, as an ethical

agent, he stands against this tendency. He denies it by setting up rules around himself and putting things in order: by "producing." The ordered alternative world ("culture") is improbable. What is called the "human mind" is this improbability. The produced framework is freeing because in it the necessities imposed on people by chance are pushed away, toward the horizon, and neither chance nor necessity permits decisions. But the produced framework is disturbing as well because the play of decision making must stay within the limits of rules. Because the produced context is disturbing, there are disturbers. And because the produced context is improbable and so could be produced differently, there are destroyers. That is human: the intention is freedom.

But the decision that something is disturbing because it is produced is inhuman. In it, the human mind joins the world's mindlessness and betrays the human mind's commitment to opposing mindlessness. In doing it, the human mind's motives are pure, for it cannot intend anything. Nothing is "foreseeable" outside what is made, within what is probable and what happens to be necessary. That is diabolical: pure evil.

Observing the gesture of destroying enables us to consider the question of evil. It lets us avoid the trap set by those who claim that disturbance and destruction are evil. Such moralists can be safely ignored. For their decision is "produced, therefore good." They don't defend the mind but rather the mind solidified into things produced, the corpse of the mind. They are basically saying "disturbance and destruction are evil because they disturb me." Disturbance and destruction are not evil, however, as long as they have an intention. Disturbance with intention is frustrated conservatism; destruction with intention is frustrated revolution. When they coincide, frustrated work is the result. From such gestures, we can read a frustrated, which is to say a superficial, un-radical, "disingenuous" existence. Such disturbance and destruction is "false" (inauthentic) but not evil. It becomes "true" if it turns into a phase of a genuine gesture of work. For to work also always means disturbing and destroying. It is a difficult but important task to distinguish apparent disturbance and destruction from genuine, revolutionary gestures of work, for example, to distinguish a ruin from a demolished house or a skeptic from a scientist who is advancing this thesis.

The observation of the destructive gesture also lets us avoid the trap

of rendering evil harmless, set by those who make everything relative. These immoralists, too, can be safely dismissed, for they themselves dismiss human dignity by misapprehending evil. Although they are rare, there are gestures of pure, pointless disturbance and destruction, the betrayal of the mind (of form, or freedom) with pure motives. The being in such gestures can be read as the presence of evil in the world—as authentic, radical evil. The devil exists.

When disturbance and destruction occur intentionally, when they are "pragmatic," their motive is impure and so not "pure evil." And what is not pure evil is none at all but rather the frustrated search for freedom. When they are without intention, however, when they occur with "pure motives," then they are evil, which happens rarely because it is inhuman (as is "pure good," regrettably). And then they are terrifying.

The Gesture of Painting

If you watch a painter at work, you seem to be watching a process in which various bodies (that of the painter, his tools, the pigments, and the canvas) move in some fundamentally obscure way that "results" in a painting. Still, you don't have the feeling of having understood the process. And so, behind the observed movement, you project a further, invisible movement of an invisible body, perhaps the "painter's intention" or his "idea of the painting to be painted." From such an approach to painting, which can serve as an example of the occidental approach to the world, come familiar attempts to explain the phenomena we seem to be observing, the difficulties with which arise at the point where "idea" is equated with "painting" or "subject" with "object" (or whatever one wants to call this spurious dialectical pair). But this looks less and less like a genuine problem. Rather, we are dealing with a question that has been improperly posed because the phenomenon to be explained has not been properly observed. The suspicion arises that in observing the act of painting, one does not actually see what he thinks he sees. That is a tricky assertion. Would observing the act of painting properly just once be enough to dispel the problem of "body–soul" or "mind–matter" that has been consecrated by centuries and by religions, philosophies, and ideologies? Yes, it would be enough, if it were successful. The question is just this: how can you really observe something properly? Can you observe anything without having some kind of point of view? Don't you always see what you believe you see? So if at first the demand to finally look at painting properly seemed banal, obvious, now it seems impossible. The truth lies in between. In fact, it is very difficult not to see things as the dominant point of view demands.

But it is not impossible. There are methods of bracketing out prejudices of observation, even if these prejudices lie very deep in the observer. It is symptomatic of the crisis in which the occidental perspective finds itself that there are such methods and that they are being applied everywhere.

What you see when you observe the act of painting are synchronized movements, that is, the "gesture of painting." At its most basic, "something" moves. But the moment you try to give "something" a name, you are in trouble. You do not see how the painter moves his body: you just think you see it. You don't see the body of the painter, still less the painter that's moving it. You see a moving body one could perhaps call "hand–brush" and another that one could call "right foot," and you see how these two movements are coordinated through their engagement with other bodies that can't be designated any more closely. We believe we see that hand and foot "belong together" and the brush came later, but we believe we see that because we believe we know it. In fact, we see that hand and brush "belong together" and that the foot moves as a function of the "hand–brush" connection, like a tool. We don't permit ourselves to see this because we believe we know better. We think we know that the brush, and not the foot, is the tool of the invisible painter. We believe we know the foot is an organ of the body. We get nowhere.

The first thing we must do to actually see the gesture of painting is to dispense with the catalog of moving bodies involved in the gesture. Such a catalog is in fact "metaphysical" in the sense of presuming bodies that are located somewhere outside the gesture and move only within it. This can be seen if we try to suggest some sort of catalog and then use it. For example, (1) the body of the painter, (2) a brush, (3) a tube of oil paint, (4) a canvas. The following phases of the gesture can be distinguished: (A) "The painter opens the tube." We see two hands, a stopper, pigment gushing out, and a number of bodies that are only indirectly engaged in the gesture. The hands, the stopper, the pigment were not anticipated in the catalog. (B) "The painter loads some pigment on the brush." We see a body called "hand–brush–pigment" that was not anticipated in the catalog and bodies at the edge of the situation that can at best be considered as surplus to what was anticipated. (C) "The painter dabs the canvas." The point where the tip of the brush touches the canvas is at the center of the situation, and around this center, we can see any number

of extremely complex movements that block any effort to identify bodies. The catalog suggested earlier is worse than pointless. It is pointless because it gets in the way of analyzing separate phases of the gesture (dispersing them into bodies). And it is worse than pointless because it projects elements into the observation that tend to force the observed gesture into forms that are not apparent in the gesture itself. It becomes clear that any list of bodies is a list of concepts that the observer sees in the gesture before he looks at it. A list of prejudices. Not only the invisible painter, his invisible mind, and his invisible intention but also his apparently visible body, his brush, and his canvas compose such ideological prejudices. To actually see the gesture of painting, one must abandon the effort to analyze the gesture according to the bodies that move in it—no easy task in the face of Western tradition. Only then can one begin to analyze the gesture according to its gestalt, that is, in phases that can actually be observed.

In doing so, one is surprised to establish that the gesture of painting is very obviously a meaningful movement, in the sense of a movement that points toward something. Of course, it seems that we know beforehand what it points toward, namely, the painting to be painted. Isn't that why it's called the "gesture of painting"? But close observation of the gesture shows that this understanding has not supplemented the observation the way concepts of bodies did but rather that the meaning of the gesture can be seen in each of its phases. Each separate phase refers to and becomes meaningful through the painting to be painted. The painting to be painted is what is meant by opening the tube of pigment as well as by moving the right foot. It is not necessary to wait for the completion of the painting to know that the gesture points toward it. The painting is, so to speak, contained as a tendency in each separate phase and contained as a whole in the gesture. We are sure of this not because we assumed it beforehand but because it stares you in the face, so to speak. And we are sure as soon as the observation begins rather than only after the gesture has been analyzed. So any analysis of the gesture must start from the fact that we are concerned with a meaningful movement.

This prescribes a method of analysis. Movements that point to something cannot be understood by listing their causes. Causal explanations that link the movement to previous movements, showing how one led to

the other, do not explain where the movement points. To understand this, one must know the purpose of the movement. One must have explanations that link the movement to its future. The meaning of the gesture, the painting to be painted, is the future of the gesture, and if one is to understand the gesture, it must be explained from this future. Causal (scientific) explanations help, but they are not enough. A causal (physical, biological, physiological, or sociological) explanation of the gesture of painting explains it as a movement (of a type such as "falling stone" or "crawling worm") but not as what it actually is, namely, as a gesture of painting. For as the meaningful movement that it is, the gesture can in fact be explained exhaustively, but not satisfactorily, by a list of its causes: it is a "free" movement, "free" in just the sense that a satisfactory explanation can come only through its meaning, its future. One must start here: we are dealing with a free movement, reaching from the present into the future, that is to say, with a gesture.

To account for what one actually sees, any analysis of a gesture has to be an analysis of meaning. Its methods must be those of decoding, a dismantling of the gesture into the elements of its meaning. One might say of a specific phase of a gesture that it means a brushstroke on the canvas, of another that it means the canvas resisting the stroke, and of a third that it means the overcoming of the resistance. Of course, it would also be possible to describe these three phases as movements of bodies, perhaps as movements of a brush, movements of the canvas, and of the foot moving away from the canvas. But such a description is like describing the letter o as a circle and the letter x as a cross in a textual analysis. An analysis adequate to the gesture consists of meaningful elements ("letters"), and the analysis is charged with deciphering (decoding) it. Such semiotic analyses differ from causal analyses primarily in the attitude of the analyst toward the analyzed. A phenomenon analyzed causally becomes, for the analyst, a problem that can be solved by enumerating the causes. A phenomenon analyzed semantically becomes an *enigma* for the analyst, a puzzle that is solved through deciphering. Yet, in the case of the gesture of painting, the gesture itself requires the one who is analyzing to take this position. He has to see the gesture as *enigma* because a causal analysis is insufficient to explain it. The fact that the gesture is not only problematic but also enigmatic, and that its enigmatic aspect is not just the result of

an observer's arbitrary attitude but rather is forced on him, indicates only that in this gesture, we are concerned with a free movement.

In starting to decipher the gesture, to solve its *enigma*, it will become clear that there are various levels from which it is "legible" and that these levels can be ordered hierarchically. For example, there is the level with the meaning "brush stroke," one below this with the meaning "color composition." The *enigma* of the gesture of painting can be resolved on various semantic levels, and each level produces another way of reading. The more levels the person analyzing is able to distinguish, and the more successful he is in coordinating these levels, the richer the meaning of the gesture will be. That is a characteristic of the semantic method: it permits a phenomenon to unfold its meaning in the course of the analysis. Through analysis, it becomes denser. That is also what distinguishes semantic from causal analyses. One analyzes problems to be able to see through them and so to get them out of the way. Problems solved are no longer problems. One analyzes *enigmas* to enter into them. *Enigmas* solved remain enigmas. The goal of an analysis of the gesture of painting is not to clear painting out of the way. Rather, it consists of entering into the *enigma* of painting more deeply so as to be able to draw a richer experience from it.

So an analysis of the gesture of painting is not itself a gesture that comes from outside, that is directed toward that of painting. It is rather itself an element of the gesture to be analyzed. The gesture of painting is a self-analyzing movement. It is possible to observe a level on which it analyzes itself. Specific phases of the gesture, for example, a specific stepping back from the canvas or a specific look, mean self-criticism, autoanalysis. Metaphysical concepts, such as a "the spirit of the painter" somehow hovering over the gesture, are not needed to explain this phase (as deeply as such concepts may be rooted in our habits of thinking, distorting our observations). The necessary concepts may be seen in the actual form of the gesture. The self-critical level of the gesture is so closely coordinated with all the other levels of meaning that the whole gesture is imbued with it. In this sense, each phase of the gesture is autoanalytic. The gesture not only reaches from the present into the future but also brings an anticipated future back into the present and returns it to the future: the gesture is constantly monitoring and reformulating its own meaning.

This is to say that the gesture shows the one who is analyzing it that he

must enter into the gesture if he wants to resolve the *enigma*. The under-standing of the gesture must be an understanding of self. This, too, tells us that the gesture we are dealing with is a free movement. For freedom can be understood only through one's own engagement with phenomena, not through external observation of them. To analyze the gesture of painting with the intention of understanding it, one must engage with it oneself.

Although a genuine analysis has to enter into the gesture to disclose it, and with it the self, from the inside out, such an analysis still has aspects that "transcend" the gesture. There are levels of meaning at which it would still be possible to read the gesture of painting in a wider context, namely, in that of all observable gestures, which in their totality constitute "history." Even this level is not really external to the gesture, however. For not only does the gesture exist in history but history exists in the gesture, and this not only in a causal but also in the semantic sense of the gesture having historical significance. If this is the case, then the analysis of the gesture, itself a historical movement with a historical meaning, imbues and is imbued by the gesture to be analyzed at this level of reading as well. One of the goals of this essay is to establish this: that to distinguish between "inner" and "outer" in the analysis of gestures makes little sense and leads to confusion, that the more promising strategy for understand-ing gestures is to abandon such distinctions.

At the beginning, I spoke of an occidental worldview. I meant that we have a tendency to see the phenomena of the world in which we are immersed as synthetic processes, as a combination of elements that somehow existed separately at one time: for example, water as a process in which oxygen and hydrogen come together; or human gesture as a synthesis of mind and body; or painting as a combination of a painter and his materials; or the analysis of the gesture of painting as a combina-tion of the analyst and the gesture. And I claimed as I started out that it was becoming increasingly difficult to continue in this way because it has become increasingly clear that the approach leads to intractable (and so in all probability false) dichotomies. Yet it is just as difficult to abandon this way of thinking: so deeply is it rooted in our patterns of thought that, in observing phenomena, we don't even notice it.

When we look at water, we don't see the interaction of atoms of oxygen and hydrogen, we see water. The atoms are the results of analysis

and so come "after" water. They are extrapolations from water. This does not rule out conditions in which it is possible to observe atoms on their own or as they synthesize water. But it does mean that in the concrete experience of "water," these atoms are a distant horizon, a supplemental "explanation" of the concrete phenomenon of water. This, our tendency to take a concrete phenomenon apart, and so abstract it, becomes much clearer when we turn our attention to phenomena such as a human gesture. What we see is not the interaction of bodies and mind but a gesture, and one may doubt whether there are situations in which we can actually see a body without a mind (with the exception of a corpse) or a mind without a body. Mind and body are extrapolations from the concrete phenomenon "gesture," explanations that come later, in fact, more evidently later with mind than with bodies. They form only an abstract, "theoretical" horizon for the gesture that is actually observed. But then we project this subsequent explanation onto the gesture itself and go on to believe that we actually see it.

In observing the gesture of painting, we are not seeing some sort of mysterious merging of painter and material in a process from which the painting emerges as a synthesis but rather the gesture of painting. "Painter" and "his material" are words we use to explain the gesture and not the other way around: we cannot see the meanings of these words coming together. "Painter" and "his material" follow from the gesture, but because we project them onto the observation, they turn into prejudices. That certainly does not mean that Mr. X could not actually be observed independently of the gesture of painting. It means that independently of the gesture, he cannot be seen as a painter. It does not mean that his brush could not be observed in other situations. It means that the object may be seen as "the painter's brush" only in the gesture of painting. Mr. X and the brush are hooks on which various names may be hung, according to the situation in which they are observed, to "explain" it. Outside these situations, they are "empty concepts," forms, ideas, virtualities, or however we may want to designate these prejudices. Only in an actual situation do they become real. Only in the gesture of painting does Mr. X actually become a painter and the brush actually become his brush.

Such a view is not easily reconciled with traditional Western worldviews. But it is easily reconciled with concrete experience. A painter would

probably say he feels himself to be a real painter only inside the gesture of painting. He is only really living, he would say, if he is holding the brush and facing the canvas (or if a brush is holding him and a canvas is facing him). And such questions as why he paints or why he chooses these colors will probably seem meaningless to him. For they could as well be turned around to ask why painting, why this color has chosen him. He has neither chosen painting, in the metaphysical sense of having had access to various possibilities prior to deciding to paint, nor is painting his "calling" in the metaphysical sense of a brush or canvas having somehow directed a call to him. For there is no such thing as a painter who could choose painting from outside painting nor a brush that could call a painter. Those are metaphors. The fact is simple (as all facts are, incidentally). There is a concrete gesture of painting, and in it, painter and brush are realized.

Such a description of the gesture of painting sounds mystical, if by "mystical" one understands a blurring of subject and object in concrete reality. It seems to resonate with what Zen Buddhists mean when they speak of "becoming one," whether of the archer, bow, and arrow in shooting; people and flowers in ikebana; or tea, cup, and drinking in the tea ceremony. In fact, Zen, like the phenomenological method, emphasizes the concrete experience of phenomena. And indeed, there is nothing mystical in the effort to exclude prejudices of abstraction from observations of the concrete world. The Far Eastern worldview is syncretic, aesthetic, and leads to, among other things, a mystical experience of the world. The Western worldview is analytical, rational, and leads to greater and greater abstraction, to a distancing from the concrete. The phenomenological method is an attempt to save Western thought from alienation by once again finding the concrete "ground" from which this thought proceeds. Such tracing of roots goes against the Western tradition. And yet, for this very reason, phenomenology remains firmly on Western ground. By using this method to examine the enigmatic atmosphere of freedom in which the gesture of painting actually occurs, the occidental character of the phenomenological method becomes clear.

Painting is, as mentioned earlier, an openly "intentional" movement, pointing from the present into the future. In it, Mr. X becomes real, and specifically a painter, because in the gesture, he turns into a reaching for a future, namely, for a painting to be painted. He becomes real. He "lives"

because he is indicating something. The painting is the meaning of his life. He actually becomes real for himself in this way, for the gesture of painting is a self-analyzing, self-conscious gesture. But he also becomes real for the observer. Because the observer, in the gesture through which he realizes himself, recognizes this kind of reaching. He also recognizes himself in the observed gesture of the painter, and this recognition is his way of knowing that a painter really is with him in the world. So the gesture of painting is Mr. X's means of becoming real, to himself and to others who are with him in the world.

What has just been said seems an awkward and complicated formulation of the fact that Mr. X is aware of being real and that others are aware that Mr. X really is there. The formulation is in fact awkward and complicated, but only because it must avoid such awkward, complicated and metaphysical concepts as "consciousness," "mind," and "soul" that block access to the simple facts. The facts are these: we are gestures. Through them, we come up against the events of the world in which we are gesticulating, the world that gesticulates through us, and that we "mean." But some of these events have meaning, point toward a future, which is to say toward us: for we are their future. These events are the gestures of others, in which we recognize ourselves. All this is simple and obvious but becomes complicated because we try to explain the obvious by way of metaphysical causes such as consciousness or mind.

We are not alone in the world, and we know it, because all around us, the gestures of others are pointing toward us. This pointing serves, but also presumes, what is given. Grammar makes it difficult to put it into words: the meaning of "to have" and the meaning of "to give" are in fact the same. But an observation of the gesture of painting circumvents this grammatical obstacle. The painting to be painted is a meaning the gesture "gives" by making it and "has" by presuming it. The painter realizes himself in the gesture because his life receives the meaning the gesture bestows and the gesture bestows this meaning through brushstrokes, foot movements, and blinking eyes, in short, through the movement of indication. The movement of indicating is not itself "work" but the sketch of the work. Still, the indicating movement seeks to change the world and results in such change. The painter becomes real in the gesture of painting, because in it, his life is directed toward a change in the world. It is

directed toward the painting to be painted and, through it, toward others who are there with the painter: toward the future. For what approaches the gesture of painting is the analysis of the gesture, which is to say, the antithesis of its meaning. This dialogue of gestures, this interweaving of concrete events, is a changing of the world, a being there in the world for others. For, of course, "the world" is not an objective context of "objects" but a context of interacting concrete events, some of which have meaning inasmuch as they give it. If, by observing such a gesture as that of painting, one can get free of the objective worldview of the West, one can see how "having meaning," "giving meaning," "changing the world," and "being there for others" are four formulations expressing the same state of affairs.

All this is only an effort to speak about freedom, however. To be free is to have meaning, to give meaning, to change the world, to be there for others, in short, to truly live. Freedom is not a function of choice in the sense of more options producing greater freedom. The painter is not freer in the gesture if he "knows" that he could also be a thief or a train conductor. "Free" is not the opposite of "conditional," in the sense of fewer internal and external conditions resulting in greater freedom. The painter is not freer in the gesture if he exceeds the limits set for him by his brush or his liver. Freedom is a self-analyzing indication of the future. The gesture of painting is a form of freedom. The painter does not have freedom, he is in it, for he is in the gesture of painting. Being free is synonymous with actually being there. The observation of painting allows us to see the concrete phenomenon of freedom. Only through subsequent efforts to explain it can its ontological, aesthetic, and political dimensions be distinguished. Freedom is actually indivisible: it is the way we recognize that others are in the world with us.

The meaning of the gesture of painting is the painting to be painted. This was not discussed very much in this essay because the intention was to pursue the gesture itself. Of course, the painting to be painted is assumed in the gesture, the painted painting is the stiffened, frozen gesture. If there were a general theory of gestures, a semiological discipline responsible for deciphering gestures, art criticism would not be empirical or "intuitive" and would not try to explain aesthetic phenomena away by assigning causes as it does today. Rather, it would be an exact analysis of gestures that have

solidified into paintings. In the absence of any such "choreographology," the better strategy may be to observe the gesture as it occurs before us and in us: as an instance of freedom. It means to try to look at the world with fresh eyes, without the prejudicial spectacles of objectification and abstraction that come with our tradition. Then the world would "appear" again, illuminated with the splendor of concrete phenomena.

The Gesture of Photographing

There is no doubt that the invention of photography should be called revolutionary, for it is a method that seeks to fix subjects that exist in four-dimensional time and space onto a two-dimensional surface. This method is revolutionary in that it, in contrast to painting, permits the subjects themselves to be imprinted on a surface. A photograph is a kind of "fingerprint" that the subject leaves on a surface, and not a depiction, as in painting. The subject is the *cause* of the photograph and the *meaning* of painting. The photographic revolution reverses the traditional relationship between a concrete phenomenon and our idea of the phenomenon. In painting, according to this tradition, we ourselves form an "idea" to fix the phenomenon on the surface. In photography, by contrast, the phenomenon itself generates its own idea for us on the surface. In fact, the invention of photography is a delayed technical resolution of the theoretical conflict between the rationalist and empirical idealism.

The English empiricists of the seventeenth century thought that ideas imprinted themselves on us like photographs, while their rationalist contemporaries believed that ideas, like paintings, were designed by us. Photography offered proof that ideas function in ways that confirm both ways of thinking. The discovery came too late to affect the philosophical discussion—given the fact that, in the nineteenth century, the multiple implications of the prevailing views on both sides were generally more or less accepted. That is an example of technology following theory. At the same time, the invention is revolutionary in that it permits the discussion of the difference between "objective" and "ideological" thinking only at the level of technology. Photographs qualify as the "objective" and

paintings as the "subjective" or "ideological" ideas we have in relation to the concrete phenomena that surround us. That is an example of technology stimulating theory. In fact, only now, more than a hundred years after the invention of photography, are we beginning to confirm the theoretical possibilities that arise from the comparison between photography and painting.

If we recognize that photographs are caused by phenomena, whereas paintings point phenomena out (i.e., they mean phenomena), we can analyze the difference between causal and semiotic explanation. So photographs are explained when we know the electromagnetic, chemical, and other processes through which they were produced, and paintings are explained if we are able to see in them the "intentionality" that is being expressed. But this essay is not about to enter into a discussion of this problem, fascinating as it is. The reason is the following: both photography and painting come from very complex and contradictory movements. There are objective phases in the act of painting and subjective phases in the act of photographing, in fact, to an extent that makes the distinction between objectivity and subjectivity more than problematic. If we want to distinguish between painting and photography—and we must do this if we want to understand our relationship to the world—we must first of all examine the two gestures photography and painting elicit.

The study of the gesture of photographing seems to be a preparatory step, essential both for the study of photography itself and its comparison with painting. And that is exactly the intention of this essay.

But the moment we try to describe the gesture of photographing to study it, we are startled by a strange phenomenon. What we are doing seems to be an attempt, if in a metaphorical sense, to "photograph" the gesture. Inasmuch as we understand "description" to be a translation from one context into another, a photograph is a two-dimensional "description" of a gesture. A photograph of a man smoking a pipe is a description of his gesture of smoking in that it transfers the gesture from four to two dimensions. Its elements are "manipulated" through the gesture itself (to put it more simply, through the light reflected by objects that move in the act of smoking). A typed description of a photograph, by contrast, is assembled from elements (the letters on the typewriter) that have no causal relationship whatsoever to those of the described gesture. We are

therefore mistaken if we allow ourselves to believe that when we write
about the subject of the photographic gesture, we are in some sense, if
only a metaphorical one, photographing it. Photography must be discarded
as a model for our description of the gesture of photographing. That is
worth noting, for it is an example of the way tools threaten to shape our
thinking. First we invent photography as a tool for looking "objectively."
Then we try to observe photography itself by looking photographically.
The tool exerts an inhibiting force on our thoughts at many levels, some
less obvious than others. We should not allow the tools to sit in the saddle
and ride us. In the case under consideration here, we should not try to
regard the gesture of photographing as though we were photographing it.
If we want to find out what is "really" going on, we must instead observe
the gesture naively, as though we knew nothing about it and were seeing
it for the first time.

Although this appears to be very simple, it is difficult. We have before
us an ambiguous situation. Let's say it's a social event. A man is sitting
in a chair smoking a pipe. There is another man in the room holding an
apparatus. Both are behaving in an unusual way, if by "usual" we mean
appropriate to the event. The man smoking the pipe seems not to be
doing it so to smoke but for some other reason. Although we might find
it difficult to say why, it seems to us that he's "playing" at smoking. The
man with the apparatus, conversely, is moving around the area in a most
peculiar way. If we set out to describe his path, then for us he becomes
the main point of the scene, and the smoker becomes the explanation for
the way he is circling around the middle of the image. That is noteworthy,
for it shows that the situation is determined not so much by the relation-
ships among the constituent elements as by the observer's intentions. So
this is not an "objective" description in the sense of being independent of
the observer's point of view. Quite the contrary, the situation described
here is "set up" by the observer. But "set up" is, of course, a photographic
concept, which proves how difficult it is to leave the photographic model
out of the observation. That implies that photographs are not "objective"
descriptions. Let's try to remember this image and to forget the photo-
graphic model once again.

The center of this situation is the man with the apparatus. He is mov-
ing. Still, it's awkward to say of a center that it is moving in relation to

its own periphery. When a center moves, it does so with respect to the observer, and the whole situation then moves as well. We must therefore concede that what we are seeing when we watch the man with the apparatus is a movement of the whole situation, including the man sitting on his chair. It is difficult to admit this because we're accustomed to believing that someone who is sitting is not moving. Because we believe it, we think we're seeing it.

In fact, when we turn our attention to the man on his chair, we see that the situation is still and the man with the apparatus moves within it; should we turn our attention to the man with the apparatus, conversely, the situation begins to move, and the man on his chair becomes the fixed element in a changing situation. This suggests, among other things, that the Copernican revolution was the result of a change of viewpoint and not a "truer" vision than the Ptolemaic system offered. In other words, the man with the apparatus doesn't move to find the best standpoint from which to photograph a fixed situation (although that may be what he thinks he's doing). In reality, he is looking for the position that best corresponds to his intention to fix a changing situation.

Nevertheless, the following problem appears: the man with his apparatus is the center of the situation only for us, watching him, not for himself. He believes himself to be outside the situation, for he is watching it. For him the man on the chair, at the center of his attention, is the center of the situation. And we, too, are located in the space, watching the man with the apparatus. We are part of the situation for him. That could mislead us into supposing that there are two different situations, one in which the man with his apparatus, whom we transcend, is at the center and another in which the man on his chair is at the center and in which we are involved. The two situations are different yet bound up with one another. But there is actually only one situation. We can confirm this because we are able to step away from our observer role and look at the situation from within it, which the man with the apparatus can do as well. By looking at his gestures, we can actually notice that he himself is not aware of some of his movements.

This view of ourselves in a situation (this "reflexive" or "critical" vision) is characteristic of our being-in-the-world: we are in the world, and we see it, we "know" about it. But to say it once more: there is

nothing "objective" about this. The gesture with which we release ourselves
from a particular role and which is just as available to the man with the
apparatus remains bound to a "place" from which we can assert that we
are experiencing the same situation twice. This "place" is the basis for a
consensus, for intersubjective recognition. If we encounter the man with
the apparatus on this basis, we don't see the situation "better"; rather, we
see it intersubjectively, and we see ourselves intersubjectively.

The man with the apparatus is a human being, which means that he
is not only in the situation but also reflectively apart from it. We know
that we are dealing with a human being, not only because we see a form
we can identify as a human body. But equally and more characteristically,
we know it because we see gestures that very clearly "indicate" not only
attention directed toward the man on the chair but also a reflective distance
from that attention. We recognize ourselves in this gesture because it is
our own way of being in the world. We know that we are dealing with a
human being because we recognize ourselves in him. Our identification
of a human body is a secondary element of this direct and concrete rec-
ognition. If we trusted in this identification alone, we could be wrong.
We could be seeing a cybernetic machine simulating human gestures. But
we can't be wrong about recognizing a gesture, just because recognizing
ourselves in it is a human gesture.

Because the man with the apparatus is a human being and there are
no instances of "naive human beings" (a contradiction in itself), it follows
that there can be no "naive photography." The man with his apparatus
knows what he is doing, and we can tell this from watching his gestures.
That is why it is necessary to describe his gestures in philosophical (reflex-
ive) terms. Any other manner of description would be useless because it
would not grasp the reflective and self-conscious essence of the gesture.
That is the case for any human gesture, but for the photographer's gesture
in particular. The gesture of photographing is a philosophical gesture, or
to put it differently, because photography was invented, it is possible to
philosophize not only in the medium of words but also in that of pho-
tographs. The reason is that the gesture of photographing is a gesture
of seeing and so engages in what the antique thinkers called "theoria,"
producing an image that these thinkers called "idea." In contrast to the
majority of other gestures, the point of the photographic gesture is not

directly to change the world or to communicate with others. Rather, it aims to observe something and fix the observation, to "formalize" it. The oft-quoted Marxist argument that philosophers have restricted themselves to explaining the world (he should have said to observe it and chat about it), whereas the point is to change it—this argument is not very persuasive when applied to the gesture of photographing. Photography is the result of something new—a look at the world and simultaneously a change in the world. The same is true of traditional philosophy, although the ideas that arose from it are not so easily grasped as photographs are. Photography's comprehensibility gives it an indisputable advantage over the results of traditional methods of philosophy.

What the man with the apparatus is doing is probably too complex a gesture to be dissected into its separate aspects. This is not at all my intention in any case, because for my purposes, it is enough to say that three aspects can be distinguished but cannot be separated from one another. A first aspect is the search for a place, a position from which to observe the situation. A second aspect is the manipulating of the situation, adapting it to the chosen position. The third aspect concerns critical distance that makes it possible to see the success or failure of this adaptation. Obviously there is a fourth aspect: the release of the shutter. But this process lies in some sense outside the actual gesture, for it proceeds mechanically. Beyond this, there are complex electromagnetic, chemical, and mechanical technologies inside the apparatus and the whole process of developing, enlarging, and retouching that together culminate in an image. But although these technologies have a decisive influence on the result of the gesture and are fascinating to analyze, they lie outside the situation we are currently observing. We did not set out to analyze photography, for which an analysis of those technologies would be indispensable. Rather, we are concerned with observing the gesture of photographing as it appears at a social event.

The three aspects of the gesture just mentioned cannot be observed in the same way and do not have the same meaning within the gesture. The first aspect of the gesture, the search for a place, is the most obvious. It could seem as though the other two aspects were subordinate to it. But an attentive examination shows that the second aspect, the manipulation of the situation under consideration, is more characteristic as a gesture.

Although it is not so obvious as the first aspect and not so readily acknowl-
edged by the photographer, it is the manipulation that governs the search
for the position. As for the third, the self-critical aspect, it can't appear
critical to the observer, and yet the "quality of the image" is judged by
criteria based on this aspect.

What has just been said about the gesture of photographing can, with
a few adjustments, be said just as well about the gesture of philosophizing.
Were we to examine this gesture, we would probably discover the same
three aspects, related to one another in a similar way. This is to say that
photographing is a gesture that translates the philosophical attitude into
a new context. In philosophy, as in photography, the search for a position
is the obvious aspect. The manipulation of the scene to be illuminated
is not always readily admitted but nevertheless characterizes the various
movements of philosophy, and the self-critical aspect is the one that allows
us to judge whether the manipulation has been successful. We get an even
stronger impression that the gesture of photographing is a philosophical
development in the context of the industrial age when we observe the
three aspects as precisely as possible.

The search for the position is apparent in the body movements of the
photographer. But in watching the way he manipulates the apparatus,
another, less obvious dimension appears. The place the photographer is
looking for is a point within the time-space continuum. The photographer
asks himself from what point and for how long he must illuminate the
subject he is trying to fix on a surface. In our example, that subject is a man
sitting in a chair smoking a pipe at a social gathering. This sentence is itself
a description of the situation as seen from a certain point of view, namely,
that of an observer held over the space and out of the time in which the
event is taking place by means of some metaphysical crane. The gestures
of the photographer show that he doesn't believe such a position to be
attainable, and even if it were, it would take some clandestine evidence to
show it to be superior to any other position. In fact, these gestures show
that he does not know the best position with respect to this situation and
thinks that each situation permits a variety of positions whose "quality"
depends as much on the situation itself as on the intention of the observer.
If I am intent on the photographic moment, given that smoke from the
pipe is rising, one particular angle of vision must stand out, impressing

itself on me through the "gestalt" of the pipe. Conversely, if I want to fix
the impression of enjoyment the taste of the tobacco produces on the
face of the smoker, there must be a different ideal angle, although it, too,
would be determined by the "gestalt" of the situation. Before he can look
for a good position, the photographer must therefore have a goal so that
he can perceive the situation. Of course, it can be seen from his gestures
that this view is theoretical, for in the course of his search, he can change
his goal at any moment. He sets out to photograph the smoke rising from
the pipe, and as he is looking for a suitable angle, he is surprised by the
face of the smoker. In fact, there is a double dialectic in play: first between
goal and situation and then among the various perspectives on the situa-
tion. The gesture of the photographer shows the tension between these
intervening dialectics. In other words, the gesture of photographing is
a movement in search of a position that reveals both an internal and an
external tension driving the search forward: this gesture is the movement
of doubt. To observe the photographer's gesture with this in mind is to
watch the unfolding of methodical doubt. And this is the philosophical
gesture par excellence.

The movement continues in what we normally call the four dimensions
of time and space. In the first dimension, the photographer approaches
the situation and distances himself from it. In the second dimension, the
photographer observes the situation among various horizontal angles, and
in a third, among various vertical angles of vision. In a fourth dimension,
the photographer wields his apparatus to grasp the situation in various
lengths of illumination. The four dimensions overlap one another in very
complex ways; the temporal dimension has a character that holds it apart
from the others in that it includes the use of the apparatus.

The four dimensions intersect—the photographer's search appears
to be an indistinct, unfathomable movement in time and space. And yet
a detailed observation shows that within this continuum, there are such
things as barriers the photographer must cross, as if time and space were
divided into separate fields, by situation—one of them for birds, another
for the frog perspective, one field for looking out of the corner of the
eye, one for the completely archaic, wide-eyed observation of things. It
looks as though there is no smooth gliding from near- to panoramic shot
but rather only a transition from one to another of the separate fields.

That separates the photographic gesture completely from that of the cinematographic; the still camera does not "travel." The gesture rather consists of a series of leaps over invisible obstacles and consists of decisions. The photographer's search is a series of abrupt judgments. The photographer passes through a space-time consisting of diverse areas of vision, that is, of diverse *"Weltanschauungen"* and the barriers that divide them. The quantum character of the gesture of photographing (the fact that this concerns a *clara et distincta perceptio*) gives it the structure of a philosophical gesture, whereas the gesture of filming dissolves this structure. The reason for this difference is apparently technical: just like the philosopher, the photographer looks through a "categorical" apparatus and, in doing so, pursues the goal of grasping the world as a series of distinct images (definable concepts). The filmmaker looks through a "processual" apparatus, with the goal of capturing the world as a stream of indistinguishable images (indefinable concepts). This "technical" difference between the two apparatuses is responsible for the difference in the structuring of the two gestures. The assertion that the photo apparatus is an extension and improvement of the human eye is therefore just a figure of speech. In the photographic gesture, the human body is so enmeshed with the apparatus as to make it pointless to assign either one a specific function. If one designates the instrument as a body whose movements depend on those of a human body (if, within the relationship "man–tool," we make the human body the constant and the tool the variable), it becomes almost pointless to define the apparatus as the photographer's tool. It would be no better to maintain that in the search for a position, the body of the photographer becomes the tool of the photo apparatus. By observing the gesture of photographing, it is possible to actually see the reversibility of this relationship in a specific para-industrial context. In the automobile industry, the worker's condition as a function of the machine actually implies a loss of self (his value as a free being). With the gesture of photographing, conversely, the photographer's adaptation to the photographic apparatus, for example, the need to adjust his position to suit the timing of the apparatus, implies no alienation of self. On the contrary, the photographer is free exactly because of the temporal determinants of the apparatus rather than despite them.

Whoever sets out to name all the tools of "culture" will have to admit

that the gesture of a worker in a factory and the gesture of a photographer play out in different contexts. What the socialist revolution should have set as its goal is the removal of all gestures of the worker type from our cultural environment. There is no doubt that the aspect of the photographic gesture examined so far, the search for a position, would require an extremely thorough investigation to be fully grasped. For the present purposes, it is enough to say that we are concerned with a series of theoretical decisions in relation to the test situation, that the situation is therefore a movement of methodical doubt, and that its structure is determined as much by the observed situation as by the apparatus as by the photographer, so that any separation of the named factors must be ruled out. We can add that it is about a movement of a freedom, for the gesture is a series of decisions that occur not despite but because of the determining forces that are in play.

To examine the second aspect—manipulation—we need to forget any objective knowledge we may have regarding the act of photographing. According to such knowledge, there are objects, among them a man sitting on a chair and smoking a pipe. These objects are "phenomena" in the sense that, for the purposes of experiment, they can be optically documented, for they reflect the rays of light that fall on them. The man with the apparatus would, then, be trying to catch the light rays to effect specific chemical changes in a sensitive film material. Such an objective description, which could be called a "scientific observation," reduces the gesture of photographing to a laboratory operation. It must be forgotten, not because it is "wrong," but because it does not include what we see in the gesture.

The man with the apparatus is not hunting for reflected light but rather selecting specific rays of light within the parameters of those available to him. Nor does he select passively, like a filter (although one may doubt whether a filter is passive). He takes an active part in the optical process. He excludes some groups of rays, for example, by closing the curtains a bit. He turns his objects in the light so that they reflect some rays and not others (e.g., he says "laugh!"). He introduces his own light sources (e.g., flash.). He immerses the situation in colors of his choice. He manipulates the apparatus with special filters. He chooses a suitable film that accepts some kinds of rays and rejects others. The image that results from these

operations will not be the effect of rays as reflected by the object had the photographer not been there. Still, it will be the effect of rays that were reflected by the objects and, in this sense, will be objective. One could ask oneself whether this is the only true meaning of the concept "objective." For all things considered, what is happening in the laboratory operation (during the scientific investigation) is not very different from what is happening in the gesture of photographing, and in this sense, we do not doubt the objectivity of photography; we doubt a certain meaning of the concept of objectivity in science.

Of course, the problem in photography is more complex than in science (except perhaps in anthropology), especially when we're concerned with photographs of people. The object reacts to the manipulation, for it isn't a real object but someone sharing the same situation with the photographer. A complex mesh of actions and reactions (of dialogue) is established between the photographer and his pictorial motif, although the initiative rests with the photographer, and the person photographed is the one who waits patiently (or impatiently). For the one who waits, this doubtful dialogue leads to that mixture of reserve and exhibitionism (produced by an awareness of being the center of an objectifying attention) that leads to "affected behavior" (betrayal of the motif). On the active photographer's side, this leads to that strange sensation of being witness, plaintive, defendant, and judge all at once, a sensation of troubled conscience that is reflected in his gestures. He tries to surprise his motif in an unguarded moment so as to turn it into an object. To the extent that photographing appears to be dialogue, he, too, betrays the motif. The gesture of photographing is an art form.

But the fact that the photographer manipulates the situation and betrays the motif does not mean that the photograph cannot be an objective image. Still less does it mean that the image would have been more objective if the photographer had refrained from manipulating the situation. Nor does it mean that the objectivity of the photograph is affected in any way if the motif reacts to being manipulated by the photographer. On the contrary, it means that to observe a situation is to manipulate it, or to put it another way, observation changes the observed phenomenon.

To observe a situation is, to the same extent, to be changed by it. Observation changes the observer. Those who observe the gesture of

photographing need neither Heisenberg's uncertainty theory nor psycho-analytic theory. They can actually see it. The photographer cannot help manipulating the situation. His very presence is a manipulation. And he cannot avoid being affected by the situation. He is changed simply by being there. The objectivity of an image (an idea) can only ever be the result of manipulation (observation) of one situation or another. Each idea is false to the extent that it manipulates what it takes into consideration, and in this sense, it is "art," which is to say fiction. Nevertheless, there are ideas that are true in another sense, namely, in really grasping what is under consideration. That may be what Nietzsche meant when he said that art is better than truth.

The photographer cannot help manipulating the situation, for his search is tightly bound up with this manipulation. Search and manipula-tion are two aspects of one and the same gesture. But the photographer does not always readily admit it. He will say that some of his photographs reproduce situations that neither were nor could be manipulated, for example, landscapes. He will concede that photographic portraits are always the result of manipulation because the subject to be photographed senses the presence of the photographer and responds to it (with at least surprise, having known nothing of this presence beforehand). He will insist that landscapes don't notice the photographer's presence. But he is wrong. Photographs in the field of archaeological research may serve here as an example. It's perfectly obvious that the use of infrared rays to bring the forms of an archaeological layer into view is a clear and unambigu-ous manipulation. Yet it is a fact that photographs taken at sunset reveal forms that are imperceptible in the light of midday and that seem not to be a manipulation. Midday and sunset appear to be components of a given situation. But the decision to favor sunset over midday represents a manipulation of the fact of the landscape, for through this decision, the landscape serves a purpose. Every photograph is a portrait in the sense that every situation shows itself to be "aware" of being photographed. From this standpoint, too, photography resembles philosophy: one can-not take up a position without manipulating the situation, despite some philosophers' reluctance to admit it.

The third aspect of the gesture, self-criticism, relates to what is called in philosophy "reflection." That is a concept evidently borrowed from

optics and so closely bound to photography. The camera has a mirror, and when the photographer looks into it, he sees how his image might be. He sees possible images, and as he looks in this futurological way, he chooses his own image from those available to him. He rejects all the possible images, except this one, and thereby condemns all the other possible images, except this one, to the realm of lost virtualities. In this way, the gesture of photographing permits us to see, concretely, how choice functions as a projection into the future. This gesture is an example of the dynamic of freedom. For it shows that criticism (the use of standards to measure possibilities) embodies this dynamic of freedom.

But to be a mirror to judge the possibilities of the future is only one of the meanings of the concept "reflection." In another meaning, "reflection" is a mirror for looking at ourselves as we make decisions. I don't know whether there are cameras with such mirrors, but it would be easy to build them. For some of the photographer's movements give an impression that he is looking at himself in such a mirror. Using this mirror (whether material or immaterial), he sees himself photographing. In this way, he draws himself into the situation.

The gesture of photographing is concrete evidence of what kind of seeing is involved. It is not to be confused with the view obtained by using the timed shutter release. The gesture of photographing does not show the photographer to be a passive object (as in the anthropological sciences). It mirrors an active subject (the goal of some philosophies). Such mirrors must—should they exist—permit monitoring not only of the photographer but also of the gesture of photographing itself. Self-control is another form of freedom.

In the Western tradition, and especially since Kant, we are warned (with good reason) about reflection as pure speculation. For the mirror I'm speaking about permits the construction of other mirrors that reflect one another in an infinite series, setting up a void with no foundation. This void can exert a suicidal attraction yet would not be able to check the gesture of photographing. The gesture loses its meaning when it loses itself in the void. In contrast to other cultures, and for reasons that have to do with, among other things, the way we set up our mirrors, we occidentals are interested in photography. So our problem is not continuous reflection; it is about deciding when to stop reflecting so as to be able to switch over

to action. Although we know the void ("nothingness"), we examine it not for itself but only to be able to photograph better. For us, reflection is a strategy and not surrender of self. The moment the photographer stops looking into the reflecting mirror (whether real or imaginary) is the moment that will define his image. If he stops too early, the image will be superficial. If he stops too late, the image will be confused and uninteresting. It will be penetrating and revealing if the photographer has chosen a good moment to stop reflecting. Reflection therefore forms part of the photographer's search and his manipulation. It is a search for himself and a manipulation of himself. In fact, the search for a position belongs to the search for himself and the manipulation of the situation to the manipulation of self, and vice versa. But what is the case for photography is also the case for philosophy, and very simply for life. But in photography, it is tangible, clear: we can see it by observing the gesture of photographing.

These considerations are not a detailed phenomenological description of the gesture of photographing. They merely suggest that such a description could be useful. But at least they raise certain questions in a specific context, for example, the one that comprises the ontological and epistemological difference between photography and painting. What effect—if there is one—did the invention of photography have on painting, and what influence will it have in the immediate future? What effect—if there is one—did the invention of photography have on philosophy, and is the movement called "hyperrealism" artistic or philosophical? Couldn't one actually claim that the distinction between art and philosophy has become blurred, thanks to (but not always for the sake of) photography? What effect has the invention of photography had on scientific thought (and not just on scientific method)? What sort of relationship does photography have to newer and related methods of seeing (such as slides, films, videotape, and holograms)? To sum up, the observations stated here are sufficient to formulate those questions about photography that reach the heart of the problem: photography as a gesture of looking, of "theoria."

The Gesture of Filming

In investigating the gesture of filming just after that of photographing, I face a methodological problem: I have the opportunity to observe photographers far more often than I do filmmakers. I can make a photograph myself, if necessary, but have hardly ever even held a film camera in my hands. Conversely, I have looked at films far more attentively. I have been intellectually engaged with certain individual films and believe that film must be regarded as the contemporary artistic medium par excellence. Because many share my position as a photographic amateur and critical receiver of film, I will make a methodological exception to my usual effort to grasp the gesture by observing it from the standpoint of the one who is gesticulating. I will try instead to uncover the gesture of filming by observing its reception.

It is banal to regard the cinema as the archetypal womb, that windowless cave that means both birth and death, even though the similarities between cinema and Plato's cave, with the moving shadows on the wall, are so striking that it's impossible to read Plato's myth without thinking of films. Banal as the archetypal connection may be, then, the thought that Plato was the first film critic is a provocative one.

Less banal but just as significant is the comparison between supermarkets and cinemas. Both are basilicas of the type of the pantheon in Rome and in fact recall the twofold function of the basilica as market hall (supermarket), on one hand, and church (cinema), on the other. The market hall has a wide-open entrance and a narrow, difficult exit and so is a trap, whereas the cinema has a narrow entrance before which people form lines, while its exit is periodically opened wide. Another difference

is the pseudo-plaza-like atmosphere of the market hall and the pseudo-theatrical atmosphere of the cinema. The supermarket is not a market-place because it lacks the leisure for dialogic exchange, and the cinema is no theater because the scene is two-dimensional, permitting no feedback between the drama and the audience. And still it is very important for the reception of films that they are shown in basilicas—false theaters that resemble churches, standing near false marketplaces, requiring a sacrifice to be brought to enter, and periodically expelling people.

One sits in a dark cave on Cartesian, that is to say geometrically or-dered and arithmetically numbered, seats and watches huge shadows that speak loudly and swagger about on an illuminated cave wall. High over the heads and far behind the backs of the audience is a machine throwing these shadow gods on the illuminated wall. This *Laterna magica* is known through its occasional malfunction, through its miniature version—slides—and through a very widespread familiarity with film technology. Still, no one turns around, as Plato's prisoners did, toward the truth. We are pro-grammed, by the cinema program and by other programs that comprise mass culture, to take the semblance of gods on the wall to be probable. The fact that film is the contemporary art form is not to be explained only from film itself but rather by our being programmed by our whole culture to accept film as the appearance of truth.

It is not enough to say that shadows of scenes can be seen on the screen as in Malaysian shadow theater. Rather, four-dimensional scenes are visually reduced to three dimensions on the screen (the two of the surface and the third of the rolling film), while the loudspeaker provides the sound dimension. The expression "audiovisual" masks the fact that, in the cinema, one is immersed in sound but face-to-face with the im-age. But this is not what is critical and radically new in film. It is rather the "technoimaginary": the temporal dimension of the depicted scene is represented by the unspooling of the filmstrip. That is what lets us see the essential thing about the filmic gesture. It is the gesture that makes strips intended to represent historical time. So the gesture that propels the camera from place to place is preparatory and provisional, in a sense prefilmic. Its intention is to fill long strips with photographs and sound traces. These strips constitute the material with which the actual filmic gesture, the gesture of cutting and pasting, is engaged. The gesture can

be defined as follows: it works with scissors and glue on strips that contain the traces of scenes so as to produce a strip that represents history, that is, historical time, in cavelike basilicas.

Accordingly, we need to direct our attention to this gesture rather than to the manipulation of the film camera. It is not as if that manipulation didn't matter; on the contrary, it is important because it provides the raw material of filming. All the problems of the photographic gestures are there, if recognizable in a different way: the problem of the point of view, of the manipulation of the scene, and self-reflection. Only the choice of standpoint turns out to be less quantitative, that is, less "clear and distinct," because the film camera permits vacillation (it *travels*[1]). The manipulation of the scene is more complex and so more conscious, which means that film understands itself as an art form more readily than photography does. For this reason, self-reflection through a division of labor becomes more collective and dialogical. In general, however, one can still say that despite the differences, the manipulation of the film camera is just the photographic gesture in the service of the filmic gesture, which has changed only inasmuch as it is now serving something else.

In this way there come to be long strips of photographs, each with a sound trace, which can, in a projection apparatus, trick the eye and, in a baroque fashion, conjure Elysian shadows on the screen. That is, for film, a given. What the filmic gesture produces from it is a story, not in the sense of an "anecdote" (although it can do that as well) but in the sense of an "event." With scissors and glue, the gesture produces a strip that is synchronically a whole, a thing, yet as it runs, diachronically, a process. The filmmaker stands apart from the material strips and composes, from this transcendent position, things that will appear in the cinema as processes. For him, as for God, beginning and end coincide, but he can reorder single phases of the process better than God can, speed up or slow down the process, let phases or the whole process run backward, even make the whole process dissolve in eternal return as a circular loop. He not only decides, as God does, between formal transcendence (creative composition) and existential immanence (the experience of duration) but he can, as God cannot, himself redirect the process to run in temporal directions other than radiating linearity.

History has a double meaning: "events" and "giving an account of

events." It appears that there is nothing especially new about the filmic gesture: it gives an account of events. Always, or at least since Homer and the Bible, the narrator has composed a string of events, as the editor of every newspaper still does today, and the filmic gesture only shows what is essential about this recounting more clearly. But that is an error: the filmmaker does not give an account, and the word *erzählen* (French: *raconter*; English, *to tell*) shows this. *Erzählen* means to count again what has been arranged in the past, and in doing so, of course, to possibly arrange things another way. The filmmaker can, of course, do this as well, and then there really isn't anything new about his gesture. It is just Hollywood kitsch or the evening news. But the filmmaker can also combine phenomena that have never been there before in ways that have never been there before and then let them run. That is not to recount what has happened or what might have happened but to cause what might have happened to happen *now*: to preempt the future, not as utopia or science fiction but as events in the present. He therefore can make history not only in the second sense but also in the first, not only to recount what has happened (possibly and really) but also to bring events about (as trompe-l'oeil on a cave wall, of course).

There has never been such a gesture before. For historical people (Jews, Romans, and Greeks—in short, Westerners), history can be changed only from the inside, by engaging with it. That is why the Romans called history *res gestae,* "things done." And historical telling is itself such an engagement, a thing done. But in the filmic gesture, history is made from above and beyond itself. It is therefore not "things done" but "things in progress." A film that has been produced in this way may itself be regarded as a "thing done" and so taken as an engagement with history, and yet the gesture it comes from, formally transcendent in relation to history, is a meta-historical gesture such as "historical materialism," Nietzsche's "eternal return as the will to power," or neo-positivist and structuralist historical analysis. Only the filmic gesture is far more concrete than such analyses, for its tool is the filmstrip and not the concept, and its works are not a discourse of ideas but of shadows thrown on a screen.

This raises a question about how the filmmaker is able to do this when the epic poet, historiographer, or science fiction writer cannot. It is a question about the difference between linear and two-dimensional

codes. Linear codes are read, meaning that their meaning is grasped. Surface codes, by contrast, are deciphered with the imagination. Traditional surfaces, including photography, are motionless, "anecdotal," and in this sense prehistoric. Linear codes consist of particle-like elements, for example, letters or numbers. They analyze events through a process and are therefore historical. The film is the first code in which surfaces move, a discourse of photographs, not of numbers. Because it "happens," it is as historical as numbers are, and because it consists of surfaces, it is as imaginative, as prehistoric, as traditional surfaces are. In this way, a new kind of deciphering arises: the images of a film do not mean a scenic reality as those of traditional images do. Rather they mean concepts that mean scenes. What a film depicts is not, as in the case of a traditional image, a phenomenon. Rather, it depicts a theory, an ideology, a thesis that means phenomena. So film does not give an account of events but imagines events and makes them imaginable: it makes history, if always three steps removed from the concrete phenomena.

There are two levels of history: the four-dimensional one of daily life and the three-dimensional one of the Cartesian basilicas. Complex feedback links the two levels, but the tendency is to prefer the three-dimensional level, trompe-l'oeil as it is, over the four-dimensional, which resists, presents obstacles. We cannot dismiss the possibility that in the future, existentially significant history will play out before an audience on walls and television screens rather than in time and space. That would be authentic posthistory. That is why film is the "art" of our time and the filmic gesture is that of "new people" with whose being we are not entirely in sympathy.

The Gesture of Turning
a Mask Around

A whole range of gestures are connected with masks, for example, the gesture of mask design, the one of choosing among available masks, the one of masking, of wearing the mask, and of taking the mask off (and indeed of taking someone else's mask off as well as one's own). Each one of these gestures deserves to be studied carefully because masks are materializations of the roles we play to one another, and at the same time of the roles we play to ourselves (because we see ourselves mirrored in others). And yet, in comparison to turning the mask over and looking at it from the wrong side, all of these gestures are ancient phenomena that have long had explanations that are to some extent satisfactory. Mask design has, for example, been researched repeatedly by students of mythology, the choice among available masks by pedagogues, masking by psychologists, mask wearing by sociologists, removal of the masks of others by social critics, and the removal of one's own mask by penitents, and these studies accompany the masquerade of history as attempted demystification, themselves performing a sort of second-degree masked dance. But the gesture of turning a mask over is one of those that were not examined, probably because studies of it appear only in relatively recent literature, and then only as implication. To approach a mask from the "wrong" side is to observe a phenomenon from a point of view that was not taken earlier.

We can try to illustrate this thesis, that the turning over of a mask is a gesture that is characteristic of the present time, using the carnival in Rio as an example. In this example (noteworthy in many respects, incidentally), there are roughly three types of gesture: that of the participants, that of the critical observers, and that of the mask turners (although, of course,

anyone is in a position to carry out all three types). The participants dance, masked, on the street and transform the city into a giant mask. The critical observers sit in the bleachers and distribute the prizes for the best masks and dancers. The mask turners are on vacation, for during carnival the ministries for planning, communication, and tourism, in which the carnival is programmed, are closed. So the mask turners are either in Teresopolis in the mountains, getting away from the confusion of carnival, or, as may be more significant for the future, they are using their holiday from turning the mask around to dance along a bit themselves.

The relationship of those in mask to the critics has, as mentioned earlier, been studied for thousands of years. It is the relationship of the actor to the public, of practice to theory, of politics to contemplation, in short, the historical relationship. Of course, a masked dancer dances as a function of those in the bleachers during carnival: he is a prince or an Indian or a Martian for the prize-distributing critics, and not Kanguru for himself, as a prehistoric dancer would be. And yet the dancer's motivation is not primarily the prize, and in dancing, he forgets the critics. It's true that he won't identify himself with his mask as a prehistoric dancer would, but he will take the critic's role over only inasmuch as the critical distance between himself and the mask is part of the dance itself. As for the critic watching from the bleachers, he must resist the temptation to be drawn into dance rhythm, to step down to the street and to take part in the carnival dressed as a critic. This complex dialectical relationship between dancers and critics has an especially baffling effect because the masking here happens at the border between prehistory and history (between Africa and Europe, between religious festival and theater) and yet fundamentally retains the "historical" bearing with which historical materialism, for example, is concerned.

But the relationship between the mask turners, on one hand, and the dancers and critics, on the other, cannot be grasped in such historical categories. A bureaucrat in the Ministry of Communication is not in the space or in the time of carnival. For example, he is just now holding off programming carnival for the coming year until he gets feedback from this year's event. For him carnival is over long before it begins, and not because he foresees what will happen there. Obviously, he doesn't know which masks will get the prize or whether the bleachers will collapse. But

such information doesn't interest him. The mask turner is no futurologist. Carnival is over for him as soon as it is programmed—not "past" in the historical sense of "happened" but in the sense of "accessible." So the mask turner is there neither for dancers nor for critics: he stands outside their horizons. Both know that their carnival was programmed, that it neither occurs spontaneously nor follows a cyclical rhythm, but that it has been appropriated by a system, that it is "animated," and both complain if the programming doesn't work out and money is short or the buses aren't running. But they complain because the program becomes visible: it should remain invisible. For the mask turner, conversely, critics and dancers are not there as conversation partners, as "others," but as elements of the reversed masquerade called "carnival." The mask turner does not influence the dancer in his gesture but grants him so-called historical freedom, for he is no producer of masks. And he does not influence the critic in his judgments, he grants him so-called freedom of conscience, for he is not one to strip a mask away. He grants historical freedom to the one in mask and freedom of conscience to the theoretician because he has no interest in either: they are both "over" in the sense of "accessible." If a carnival program intrudes on the freedom of the dancer or of the critic, it is a program error and must be corrected. For if a dancer's or critic's freedom is restricted by the carnival program, controversy will follow, and it can only interfere with the mask turner's programming.

The gesture of turning the mask moves from outside toward the mask, but not like a hand moving toward a glove to slip it on, nor like the hand of an artisan toward glove leather. The glove is turned inside out not to use the glove but to see its inaccessible side. When we are dealing with masks rather than gloves, one might object that use of a mask should not be regarded as a mask itself but as a function within a system, as a gesture of unmasking: it shows what carnival is when it is demythologized. One might further object that, in such a gesture, the system is masked so that it can itself be unmasked in turn. But such objections contribute little to an understanding of the gesture. For they are observing it from the standpoint of the masquerade and not from the standpoint of that which is carrying it out. Of course, from the standpoint of the masquerade, it is a theatrical and probably very effective gesture to turn a mask around, and the one who turns it is an actor, assuming it is happening on a stage.

But the fact that the official in the communication ministry plays some kind of role there, and that a reversed carnival becomes an exposed mask in this masked dance, gets us nowhere with the gesture of programming. For the distance from which the carnival is programmed is exactly the one from which the communication ministry is programmed, and from which the program is programmed, within which ministries are programmed. It is not a critical distance but a remove from the historical event. For this reason, it is not necessary to step back any further to see it. Once one single mask has been turned around, all of them become accessible as no-longer-masks, regardless of the way the hierarchy may look. That is to say, in trying to grasp the gesture of turning a mask around using historical categories for action of a stage (e.g., to explain it using political, economic, or cultural motives), what is lost is the essential thing about the gesture, namely, what is not theatrical about it.

Another example illustrates the difficulty. I wear a paper mask. Through its holes I see others. If I take the mask off and look at it from the outside, I see how others have seen me. In this sense, the removal of the mask is self-recognition. But if I take it off and look at it from the inside, I see a gray surface that extends back at various points into a third dimension. The political, cultural, and aesthetic aspects of the mask are all located on its other side, now invisible. What I see now is the mask in its negative aesthetic aspects, so to speak: it should not be seen in this way, and this "ban" can be seen on the inside of the mask. Only the view destabilizes my aesthetic categories. I see the "wrong," prohibited side of the mask, and as I do, the other, "right" side becomes the false face in which others think they are seeing me. So the "wrong" side of the mask is the genuine one, for it exposes the fraud. And yet this dialectic of the mask is a "negative dialectic," for the gray surface of the mask I am seeing is only its negative side, after all. So in turning the mask over, I am able to gain political and ethical insights, but in a sense that exceeds ethics and politics: in turning the mask over, I find myself beyond good and evil. The gesture is fundamentally a move beyond theater, past the stage, the act, the plot, and it is one of the very few gestures in which the untheatrical, posthistorical form of being finds expression.

There will be an objection that the inner side of the mask is not seen for the first time when it is turned, that the mask designer not only sees

it as well but is the very first to put it in place. And this mask designer is not only a historical being (such as the designer of the Harlequin in the Renaissance or of Superman in the present) but even a prehistoric one (such as African mask carvers or Oriental storytellers). So how can mask turning still be seen as a posthistorical gesture? But the objection is unsound. The mask designer, whether he is a carver, dramatic author, stage designer, or legislator, does indeed put the inner side of the mask in place, but he does it as a function of something external to himself and therefore does not direct his attention to the inner side, even when he is looking at it. This side of the mask becomes visible as such only when it is turned over. Although the mask designer has a technique for finishing the inner side of the mask (e.g., brought nearly to perfection in Shakespeare), and one might suppose that the inner side would be very familiar (he would know exactly how, say, Falstaff would appear from the inside), he doesn't become aware of this side at all. What he sees, if he tries to examine his technique of mask design, is not the inner side of the mask he has made but the outer side of his own role as a mask designer. He doesn't see Falstaff from inside but Shakespeare the playwright from the outside. And that changes nothing about our seeing Falstaff and Shakespeare as superimposed masks for one and the same person.

This strange inability to step back from the mask, which can be addressed only by turning it over, can be demonstrated in another example. When someone is elected president of the fifth French republic, he slips on a relatively loose-fitting mask, for it is new, and known to have been stitched together from older masks, from the mask of the president of the fourth republic, for example, or of the American republic, or of remnants of various classical masks. Old masks, whose makers have been forgotten, such as that of the family patriarch, fit much more tightly. So the president can, for example, speak of his mask in the third person ("The president has decided . . ."), as the patriarch cannot. But although the presidential mask is new, and although it is a collage, like an African mask, through whose cracks we can see the other masks that lie behind it, its inner side is invisible, not only to the public and the actor but even to its designers, scattered among the public and on stage. For as they were designing the masks, they were wearing masks themselves, those of, for example, legislators, which would not permit them to fall out of their roles to see the

inner side of what they were doing. The presidential mask's gray inner side can only be seen by turning it around, and in fact not so much with respect to what it was made of and for but above all in what program it was designed. Turning the mask around reveals not only its function within the drama and its origin (the mask designer, too, sees these aspects as part of his practice) but above all what is called, elegantly, its "structure." But as soon as the structure is exposed, the function and origin of the mask become uninteresting, they are "over," for we are suddenly outside the theater and outside history. Not "outside" as if we were pulling the strings in a marionette theater (for we would then in fact be participating in the performance) but outside in the sense of someone who wants to recycle the puppets, to use them for some other purpose, such as papermaking.

When the mask is turned over, it ceases to be a mask and turns into a manipulated object. One could, of course, claim that this ontological transformation has occurred as a result of the semantic dimension of the mask having been excluded, but it is easier to continue the phenomenological study of the gesture. Turning the mask over changes its location: it is no longer in front of the face but in the hands. In all traditional gestures associated with masks, the mask either is, or is supposed to be, or not be, in front of me, and so between me and others. In this sense, the gestures are historical: they concern the future. In making the gesture of turning the mask around, however, I stand over the mask, I have surpassed it, it is over, and that means that the gesture preempts the future, turns it into the past.

The gesture is therefore posthistorical in an even more radical way than the gesture of filming is. The gesture of filming cuts and pastes a history to bring it about. The gesture of turning a mask preempts all history by showing it from its "wrong" side, namely, from the side that reveals it to be meaningless. But not like Solomon or Diogenes or Buddha, who saw through all masks and were then persuaded of the "vanity" of all history. Solomon, Diogenes, and Buddha are disappointed actors and directors, all the more so in that the gesture permits all realized and even possible histories to be programmed. With the gesture of turning a mask, one is no longer playing a role in history but playing with history.

Of course, that does not mean that, in making this gesture, we have stopped wearing masks or playing roles. All the dramatic rules of the

economy, sociology, and politics remain valid onstage. But they are valid in a different way, namely, as rules of a game, and no longer as laws. The masks we wear over and under masks no longer fit as they did before: as masks that can be turned around. For example, the question of so-called identification changes, as does the question of body and soul, idea and material. "What am I under all the masks?" that is, the so-called onion question, is no longer at issue. Rather, it appears that what was once called the "I" is now that ideological hook for hanging masks by their inner sides. The negative dialectic between the inner and outer sides of the mask has become the real identification problem. This means, in turn, that although we will continue to wear masks and play roles, although history and stories play on, the historical form of being-in-the-world is coming to an end. We do go on suffering from history and acting in it, but we can no longer engage with it as we once did, because we can turn all its roles around: we can play with it.

With the gesture of turning the mask around, history loses all meaning, but life does not, necessarily. On the contrary, playing with history can itself become a way of lending meaning. For the moment, there isn't much evidence of such meaning being generated in the ministries that program the carnival. But close examination lets us see the gesture of turning a mask around as a gesture of making meaning.

The Gesture of Planting

Contrary to superficial first impressions, we are dealing here with an unnatural gesture, "perverse" in a radical sense: for in it, being turns into its opposite. This perversity, and the way the so-called ecological movement has inverted it, effectively demands that we consider this gesture just after having examined the gesture of turning a mask around. The thesis I want to advance here is that the ecologists' standpoint is the same one as the one from which one turns a mask around: a standpoint outside history.

As with most of the gestures we encounter daily, there is no appropriate strategy for recognizing this gesture, for remembering it. For it is covered up by habit (although we city-dwellers hardly do any planting ourselves), and this familiarity blocks our memories' access to the essential thing about the gesture. Another thing about planting is that it is laden with myths, allegories, and metaphors to a greater extent than other gestures are, so that familiarity is enveloped in "hyperfamiliarity," hiding the essence of the gesture that much more effectively. So it is appropriate to try to enter into the conditions in which the gesture was new, to the situation of the Neolithic planter, not only because its contemporary novelty could reveal the essential thing about the gesture but also because this study's thesis is that new gestures express a new form of being. There is hardly another critical point in history that could support this thesis as effectively as the emergence of the gesture of planting in the late Mesolithic.

In trying to think oneself into the situation in which a hunter-gatherer decides to dig holes in the ground, to press grass seeds into them, to close up the holes again and then wait for months to see what happens, one can hardly grasp the perversity of this gesture. To have this experience, one

must obviously try to forget what later "normalized" this gesture, that is, all of history. The perversity, the turning of existence into its opposite, can only be experienced by observing the gesture in its original context, by bracketing out all economic, social, and political explanations, by observing the gesture not from the twentieth-century point of view but from that of the Paleolithic. This is possible because a posthistorical standpoint, or more exactly, one of its aspects—the ecological standpoint—has now become accessible.

The hunter-gatherer, as we encounter him in perhaps a decadent form in the Amazon region, and perhaps in a depressed form within ourselves, is a setter of traps, a "capturer." He builds structures for containing ponies, reindeer, or primeval beasts and baskets for catching berries, roots, or eggs. Looking at this basic gesture more closely, it becomes clear that it is about weaving nets, for traps and baskets can be seen as stitches in a net that people cast about themselves. All other gestures of work, the making of weapons as much as the sharpening of flints, of painting as well as burying, can be understood as variations of net weaving, that is, hunting and gathering. The state of mind that underpins the form of existence expressed in this gesture is a lying in wait. Hunters, like gatherers, live on the run, poised to jump on their prey, and the difference between hunting and gathering, between the capturing of animals and the capturing of plants, which counts as the original division of labor between man and woman, appears to be a difference in the rhythm of waiting and acting. It important to keep in mind that humans stalk prey in a way exactly opposite to the way predatory animals do. The predator animal stalks its prey so as to surprise it. A human being sets a trap and lets himself be surprised by the prey. The predator waits in nature and as nature and waits, too, for human beings, because from its standpoint, humans are no different from any other prey. A human being waits for nature because he himself is not in it, and so, from outside it, as the traps are being set, distinguishes among deer and cows, berries and eggs. To set traps, that is, to exist, he must categorize, that is, "ex-ist."

Over almost the entire time people have been on earth, it has a been characteristic pattern for men to lie in wait, by category, for animals, and for women to lie in wait, by category, for plants. An existential philosopher of the Paleolithic would perhaps have suggested the following analysis of

being: human beings are entities that, unlike any others in nature, lie in wait from outside, and this in two ways—the masculine, that of zoology, and the feminine, that of botany. What such an existential philosopher cannot know is that such a human existence is only possible when and as long as nature can be lain in wait for, as long as it is tundra. Humans are perverse beings. They exist because, in the tundra, they stand apart from the tundra. As "human" presence draws to a close, about ten thousand years ago, as the trees in the environment become more numerous and the tundra begins to change into taiga, a human being cannot, and no longer needs to, "ex-ist." He can no longer do it, for in the forest, it is difficult to make nets, to classify. And it is no longer necessary, for in the forest, a human being can feed himself without having to lie in wait for nature. It is the ambivalence of trees that, on one hand, permits a return to the lap of nature but, on the other, not to the nature with respect to which a human being is a human being. Existentially, nature is grass and human beings are grass eaters, a situation insufficiently appreciated by nature philosophers, existentialists, and ecologists.

This is exactly the reason for emphasizing the situation of Mesolithic thinkers. The appearance of trees in the world opened three strategies we are only now beginning to evaluate. (How can we hope to recognize, so soon, which strategies are opened by the entry of machines in the world?) The first strategy: to live with the tree, in the tree, and from the tree, and so to turn back to a preexistential condition (paradise). The second strategy: to submit to the tree, to follow the animals in the disappearing tundra, and so try to go on existing. The third strategy: to oppose the tree, to burn it or cut it down, to allow for grass to grow and existence to continue. None of these strategies was successful, but the defeat took three different forms. Recognition of the tree did not lead to paradise but to so-called primitive cultures. Submission to the tree did not preserve hunting but led to the rearing of animals by shepherds. And resistance to the tree didn't preserve hunting either but rather led to agriculture, that is, to our own form of existence. How the gestures of tundra hunters were transformed into the gestures of fishermen on the Amazon and shepherds in the taiga is a fascinating question. But the point here is how these gestures are reversed to become the gesture of planting.

The gesture of planting is, as the ancients knew but we forgot, the

overture to the gesture of waiting. After covering the seeds with earth, a person sits back and waits. The Latin *colere,* from which *cultura* is derived, does not mean only "harvest" but equally "care for," that is, to wait attentively, to protectively anticipate, and *agricultura* is not only planting and harvesting but above all greedily and jealously watching. That appears to be lying in wait, as in hunting and gathering, but it is a perverse reversal of that gesture. For this is not about tying nets and setting traps to be surprised but about instigating a process that leads inevitably to an intended result. A good hunt is unforeseeable good luck; a bad hunt is the norm. A bad harvest, conversely, is unanticipated bad luck. The inversion of stalking into waiting, tension into passivity, mortal fear into caution, which is to say the inversion of the unforeseeable into the inevitable, is what is essential about the inversion of hunting and gathering into planting. And as we know, planting is the root of ownership and the waging of war, that is, of waiting in the sense of persevering in one's ownership.

To be able to plant, it is not enough to have watched "randomly distributed" grass seeds beginning to sprout around the hunting grounds, as soothing explanations maintain. The decision to reject the forest, to clear it, must already have been made. Among the tools of planting are not only spade and plow but also axe and fire, at a minimum. It is noticeable in the tropics (and perhaps in the Siberian taiga), but even taking hypocrisy into account, it is forgotten in those areas where forests are no longer enemies. To plant means to dig holes, to force nature to become unnatural ("cultural"). These holes are the places where trees once stood. In short, to plant means to uproot trees so that grass can grow in the spaces that are then available. The later planting of not only grasses but even of trees changes nothing. It only shows to what an extent the essence of planting was obscured through habit and myth. The Romans knew what agriculture is: domination of nature by absorbing the forest into the house *(domus),* that is, by expanding the circumference of the earth *(orbis terrarum).* For the Romans, then, synonyms for planting include not only culture, imperialism, and domination but equally the gestures of ordering *(legis-latio),* for the orderly rows of planted grasses transform the unexpected into the inevitable, stalking to waiting. The true planters are legionnaires (as the colonial powers still knew in the nineteenth century, for colonization was synonymous with cultivation and planters with legionnaires). The gesture

of planting has many sexual, mythical, economic, social, and political con-
notations, but it is more important that we recognize its basic orientation,
namely, the digging of holes to turn the unpredictable into the inevitable.

Planting accordingly inverts not only hunting and gathering but also
nature, and this in such a way that the so-called laws of nature that came
later were reversed to correspond with human intention. It is a miracle
that, since the Neolithic, wheat has been growing successfully according
to botanical laws for the bakery's purposes and airplanes have been flying
successfully for decades according to aerodynamic laws for the purposes
of tourism. In the course of the last millennium, planting obviously
became more technical, because the theoretical distance to it increased.
Planting is done mechanically, fertilizing chemically, alteration of plants
biologically, and the rhythm of ripening (waiting) is controlled artificially,
for example, by using artificially lit rotating boxes for planting, as in Japan.
But the original Neolithic gesture of planting is essentially preserved in
all of this, that is, the decision to turn nature's own regularities against
nature itself and so not only to assert human existence over nature, as in
hunting and gathering, but to force nature to deny itself. The gesture of
planting is a powerful and violent gesture.

The gesture of planting has enabled human beings to live in an artifi-
cial world since the Neolithic, that is, to stay in a taiga forced by its own
laws to be a tundra. It exists in and against the tundra, and to exist, it
transforms taiga into tundra. It is no simpler to replace the words *tundra*
and *taiga* with the words *nature* or *art,* for such is the gesture of planting's
perversity with respect to the world and existence, so completely has it
inverted man and world, so confused have ontological concepts become
as a result, that we can no longer distinguish between what is given and
what is made, between nature and art.

The ecological movement, that is, the tendency currently pressing into
the political domain with an eye toward confusing it, but in the foreseeable
future to breaking it apart, should be seen in this context. This posthistori-
cal movement appears to be trying to rescue nature from the pestilence
of technology (i.e., history) and so keep human beings from suffocating
in their own excrement: to turn history around in the opposite direction.
But because we no longer can grasp the concept of "nature," because it no
longer makes any sense to consider stone more natural than concrete, or

mineral water more natural than Coca-Cola, for example, this movement does not refer to itself with the romantic phrase "back to nature" but more structurally as "the science of relationship" *(oikós)*. What it actually is can be judged from such slogans as "Have Mercy on Our Forests" and "Save Our Seas." It advocates the planting of trees and the eradication of red algae. Neither biological nor economic arguments are therefore adequate for a radical understanding of this movement. Rather, it is necessary to try to grasp its existential position.

It is a movement against the transformation of taiga into tundra, against the attempt, underway since the Neolithic, to fell and burn trees. Since the essence of the gesture of planting has been forgotten through habit and myth, it is not easy to see that the ecological movement means an inversion of the gesture of planting. The planter wants to grow grass rather than trees, not because he prefers culture to nature, but because he wants to recover that nature he faced in the Paleolithic. Ecology, conversely, wants to grow trees instead of grass (or other technical products), not because it prefers culture to nature, but because it wants to recover that nature the Neolithic used to fight against nature. The planter fells trees to plant grass, so as to cut the grass and harvest it: he exists face-to-face with grass and needs grass to exist. Ecology tears grass out to plant trees and views the circulatory pattern tree–grass–tree–grass from a distance, as an entity that no longer exists face-to-face with grass but with its own eating of grass.

That gives us a glimpse of the transcendence that is expressed in each of the gestures. Hunting and gathering are gestures that transcend human beings' physical surroundings. They are gestures that catalog the world through nets so as to capture it. Planting is a gesture that transcends hunting and gathering by manipulating the world into allowing itself to be gathered. And ecology is a gesture that transcends planting by viewing it from the outside, imposing a "strategy" on it. The planter is an inverted gatherer, the ecologist an inverted planter. The farmer is an inverted nomad, the ecologist an inverted farmer. The hunter is prehistoric, the farmer a founder and carrier of history, the ecologist posthistorical. The hunter makes a catalog of the unforeseeable world (nets). The farmer forces the world into an order (tilled fields). The ecologist views the world as relationship (as *oikós*). Transcendence is the content of the hunter's gesture,

the form of the farmer's gesture, the strategy of the ecologist's gesture.

The gesture of planting is the historic gesture. It is dramatic, an action, an agitation. That is why the Romans called a field *ager* and planting *agricultura* (controlled agitation). This gesture has changed repeatedly in the course of history, and so greatly that we can hardly recognize its original form any more. But it is now beginning to change into its opposite, namely, into tree planting, into ecology. An *oikós* is the opposite of an ager: it is a field not of agitation but of acting and reacting. In this inverted gesture, a human being is no longer a subject (actor) facing an object but a programmer of a context of relationships. The gesture of one who asks us to sympathize with rather than hate our forests is the gesture of exceeding history. It is therefore one of the gestures that permits us to draw a conclusion about an existential crisis: an ecologist exists differently from a planter. In a word, he no longer exists politically but rather ecologically.

The Gesture of Shaving

A barber's tools are gardener's tools in miniature, and so a barber's gestures can be compared with those of a gardener. When you do this, certain questions arise that could, under close examination, press deeply into the existential problems of the present time. For example, is gardening a type of cosmetic care, a beautification of an extended human skin, or is it the other way around—are cosmetics a kind of gardening, an artistry applied to human beings' natural environment? In other words, is grass a kind of beard or a beard a kind of grass (in the understanding that it would be perfectly possible to give a positive answer to both questions)? Another example: is the gesture of gardening with respect to the grass a gesture that alters nature (i.e., is the grass the same for the gardener as the client is for the barber?), or is it the opposite, that the barber's gesture with respect to the beard is a rectifying gesture (i.e., is the client the same for the barber as grass is for the gardener?)? Last example: because both gestures are subject to the extremely problematical phenomenon of fashion, can cosmetic fashions (e.g., the length of hair or beard) derive from urbanizing tendencies (e.g., from those toward suburbanization and second homes), or the reverse, that is, do urban fashions follow those of cosmetics? Or should one look for some *tertium comparationis,* for example, a "zeitgeist" or a "materialist dialectic"? This kind of question, which arises in light of the similarity between electric razors and lawnmowers, or between the gestures of propping up beards and bushes (and a whole range of such questions can be formulated), comes down to the questionable concept of the skin, that indefinite no-man's-land that is used to mark out a zone between a person and the world. The fact that shaving and gardening can

be understood as *dermatological* gestures shows how permeable the skin is from both sides and how, despite its permeability, it represents an obstacle between man and world.

One can hardly stave off ontological reflections at the sight of beard hairs, as they are caught in the apparatus after shaving. During the gesture of shaving, beard hairs change their ontological location; they were part of my body before, now they are part of my apparatus. Now changing ontological location is characteristic of a gesture of work. "Work" means to make something out of something else, for example, to make something artificial out of something natural. Accordingly, the gesture of shaving would be a gesture of work. But the gesture is related not to a thing but to the one gesturing—so it must be designated work on oneself. But once that's done, it becomes clear that we have missed the essential thing about the gesture. On one hand, any gesture of work could be said to change the one gesticulating, for example, the gesture of the shoemaker makes the gesticulator into a shoemaker. But the gesture of shaving is not concerned with this type of self-alteration. On the other hand, there are gestures that seek to change those making them, for example, the gesture of reading or of travel. But the gesture of shaving is neither about changing a thing in the world nor about changing the one who is gesticulating; rather, it is about a change in the skin between the one gesticulating and his world. So it is neither a gesture of work in the narrow sense nor a ritual gesture. It could be called the dermatological gesture—or a cosmetic gesture, should the root *cosmos* still be discernible in this word.

In shaving, beard hair that was formerly part of my body has become part of my shaving apparatus. But because this is a dermatological gesture, that is, one that occurs in the no-man's-land between man and world, the ontological change of the beard hairs by shaving becomes problematic. On one hand, it is open to question whether the beard hairs actually ever were part of my body or whether they weren't expelled from the body without having fallen off, and that shaving isn't aimed directly at completing the separation. On the other hand, the shaver could be understood as an extension of the body (defining tools as artificial body organs). From this standpoint, the beard hairs' ontological location has not changed in shaving but has simply transferred from one place on the body to another place, the whole body thereby being regarded as an apparatus that is

manipulated by the gesticulator. Finally, one might contend that the way the beard hairs have changed during shaving consists in their having been moved from the organic world (body) into the mechanical world (shaver), which raises the unsolvable problem of defining the organology of beard hairs from their structure, their function, their ontological position. All these difficulties show that, in the gesture of shaving, we are concerned with an indefinite, intermediate area.

To resolve these difficulties, we must let the gesture itself speak. Only then can we do away with ideological prejudices of the type "I have a body" or "I am a body." Because the gesture is directed toward the gesticulator himself, because in it, he is both agent and object, both the one who performs it and who suffers it, it offers an unusual, and in fact not a dialectical experience. One feels how the hand guides the apparatus over the skin and how the skin is scraped by the apparatus, without sensing conflict between the two experiences in a relationship between subject and object. That is what is called a "liminal experience" (mystics try to speak of this in a completely different context). It would be easy, but also unproductive, to go on to explain this double experience physiologically (e.g., neurologically). For the crucial thing about this gesture is not the biologically explicable movement but the existential ambivalence of acting and being acted on at the same time. In taking the aspect seriously, we encounter the phenomenon of pain.

There is a temptation to say, simplistically, that when it hurts, one stops shaving. That is, a balance must be maintained between acting and suffering, and this would be the experience of the intermediate realm called the "skin." We know that such a claim is false. First, shaving is different from tattooing or from plastic surgery in that it does not, in principle, cause pain, because it doesn't penetrate deeply enough into the skin. Shaving is an epidermatological gesture that takes place at the surface of the skin, and the pain involved is not a boundary that can be monitored but an accident. Second, however, the motivation for shaving, as for having oneself tattooed or undergoing plastic surgery, takes pain into account as part of the bargain. Although there is some risk of pain, one shaves nevertheless and normally avoids pain. So the phenomenon of pain cannot play a defining role in this gesture. Still, it is clear that shaving and pain are somehow related.

To shed light on this situation, it will not do to resort to the intensity of the pain and say, perhaps, that the more intense it is, the more deeply the gesture has penetrated from the world into the interior of the one who is being acted on. In other words, to say that shaving is a superficial self-analysis, the evidence being that it does not, in principle, cause pain. This is not a valid claim for various reasons, and the neurological ones are, again, among the least interesting of them.

It is more interesting that shaving is exactly the opposite of self-analysis (this despite the shaving mirror into which one looks), that one does not shave to recognize oneself but to change oneself (to become other than one is), and that it can cause pain, not because it can accidentally penetrate deeply but rather because it does not penetrate; it essentially covers up.

We come closer to the phenomenon of pain in shaving by thinking about blood. If blood appears in shaving, even if only in the form of irritated skin, one has the feeling of having achieved the opposite of what one set out to do. The pain of shaving, that is, is not like other pain. Normally pain is avoided as the opposite of the intention of all gestures (of what is called "happiness"). In shaving, pain is not being avoided (it is accepted as part of the bargain), but bleeding is avoided. In fact, all technical progress in shaving is directed at avoiding not pain but bleeding. Pain in shaving is a symptom of bleeding, a sign that the shaving has gone wrong. It is not the opposite of the intention of the gesture but only a symptom of the opposite of this intention. If there is pain, one stops shaving in fear, not of pain, but of bleeding, and in this sense, pain sets limits to shaving.

With that we can see the essential thing about the gesture of shaving. Obviously, it concerns a gesture of removing beard hair from the face, but not to make the face visible beneath the hair. It does not mean an opening of the face toward the world. Nor is it a gesture that attempts to make the world more accessible to the face, to, say, make it easier to feel the wind. For if that were the gesture's intention, the goal of shaving would be an irritated facial skin, a skin that brought the interior closer to the world. Shaving is, on the contrary, a removal of beard hair to emphasize the boundary between man and world. Shaving makes the skin, and not the face, visible, and that means it makes the boundary between man and world visible. The beard hair is removed, not because it covers the face and so obstructs communication between man and world, but because

it obscures the difference between man and world. The goal of shaving is not to make a connection with the world but to distance oneself from it and assert oneself in it. That is achieved by uncovering the skin that divides man from world. When young people grow beards, it is not to hide themselves but just the opposite, to cast doubt on the difference between the self and the world. Beards are rejected attempts at identification.

What has just been said opens a wide field for the study of various forms of beards that should be considered in this context not as masks but as holes in masks. The area is fascinating because it opens an unfamiliar entry into the philosophy of history and of fashion (the shaved Caesar and the bearded Jesus) and because it permits the study of parallels between beards and breasts (i.e., of "women's lib"). The field is unfortunately too broad to be surveyed here. But we should not lose track of the ambivalence expressed in any gesture emphasizing a boundary, an ambivalence that is especially clear in shaving.

If I emphasize skin, that is, the difference between myself and the world, I am defining world and self, and that means I am standing above and at a distance from both. For "to define" means to negate, that is to say, what something isn't. In shaving I go against the self, make it smaller, and not actually because I remove hair but because I am emphasizing the difference with respect to the world. The shaver is an instrument for reducing the self, by definition. That is what the skin feels as it is being shaved. And yet, in shaving, I also go against the world, make it smaller, even though I am transferring beard hair into it. I make it smaller because I am extracting me—all except the hair—from it. That is what the shaving hand is feeling as it cuts the self out of the world to define the world. Each morning, as I shave, I cut through the "umbilical cord" that tried, the night before, to grow hair to erase the difference between the world and me.

The ambivalence of shaving consists in our dealing with a gesture that in fact clarifies and distinguishes (seeks a *clara et distincta perceptio* of people and the world) but, for exactly this reason, also diminishes both people and the world. To put it the other way around, the ambivalence of shaving lies in being engaged with the skin, which is to say, with no-man's-land. Such an engagement is possible because the skin is permeable, which means it can be experienced as agent and as object from the inside or outside. But this permeability of the skin is not dialectic (in shaving, there is no

difference between the experience of the hand and of the skin). So the engagement with the skin is a static and, in this sense, reactionary adherence to dissociating structures. The gesture of shaving is the gesture of formalist rationalism, a classic, unromantic, and antirevolutionary gesture. Of course, one can't claim that anyone who shaves is a fascist, but one could claim that a fascist could not possibly wear a full beard.

From here we can resume the comparison between the gestures of barbers and gardeners, of cosmeticians and city planners, and (why not?) of social engineers and ecologists. They are gestures that have the intention neither of humanizing nature (producing culture) nor of naturalizing human beings (preserving nature for people) but of emphasizing and expanding the border area between man and world, the "skin." These are dermatological gestures. The gardener, the planner, and the ecologist work on the skin, in the skin, and for the skin, for the garden, the suburb, and the forest "reserve" are skin between man and world, skin that keeps growing and thickening. Gardeners, planners, and ecologists are cosmeticians. They are not pursuing humans' being-in-the-world but a "cosmetic" form of being, an aesthetic being in the bad sense. They are barbers who shave off weeds, pollution, and concrete construction so as to broaden the gap between man and world.

One might claim that we are about enter a cosmic, which is to say a cosmetic, age, an epoch in which man and the world keep getting smaller and the skin between man and world, the so-called environment, takes on ever more cosmic proportions. But one might just as well claim that there are already tendencies to oppose this shaving off of every connection between man and world, like so many beards and their equivalents. The cosmetic world is the world of fashion, that is, the modern. That is why there is nothing more modern than ecology, environment, quality of life, in short, than shaving. But this modernity, that is, the modern era and the gesture of shaving, may be reaching a crisis. This essay is not claiming it but rather is presenting it as a suggestion.

The Gesture of Listening to Music

The gesture of the seer has been so thoroughly stylized through myth and tradition that every day and everywhere, in television and in advertisements, we can watch it becoming a pose. The pose of the statesman, gazing with determination at the stars, for example. The gesture of thinking has, by way of Rodin, become a cliché. The gesture of the listener, conversely, does not seem to have been stereotyped in the same way, although it is related to seeing and thinking inasmuch as it involves not a movement but a positioning of the body. Looking back at medieval iconography with gestures in mind, however, one finds the gesture of listening to be one of the central themes. It is Mary's demeanor at the conception, the demeanor of being fertilized by the word *(logos)*. Mary "receives," which is to say she hears a voice. It is instructive to observe the way the gesture changed with the coming of the Renaissance. In the Gothic, the gesture was one of surprise, of being called, in the Renaissance, that of a resolute, attentive Mary. If we are concerned with hearing music, if it is the Renaissance gesture that is of interest, we should look to Ghirlandaio and not to Giotto.

And yet we must pause for thought almost immediately. Music is heard differently from speaking voices *(logoi)*. With speaking voices, one hears as one deciphers, one "reads," which is the reason the deaf can read lips. They cannot do this with music. Mary hears, reading, and that is exactly what "conceive" means: she receives, understanding. There is actually a deciphering in hearing music as well, for music is codified sound, and so a musical message is just as logical as that of the *logoi*. But it is no "semantic reading," no deciphering of a codified meaning. Despite centuries of discussion, there is still no agreement about what is being deciphered

when we hear music. But we really should be able to recognize this in the gesture of listening itself. Mary's gesture of reception, as it is seen in Renaissance painting, can serve as a starting point, for to listen to music is to pay attention. But it is important to remember that Mary is not hearing music, even when the message is supposed to be received in the company of violin-playing angels. At best, one could say that Mary represents a musical borderline case, namely, that she is hearing a "song."

If one agrees, the confusion begins. Let's say that, at the conception, Mary is hearing a song. Then the gesture of listening would depend on the song to which one is listening. A gesture of listening to "La Marseillaise" is different from one of listening to a Rolling Stones song, after all, and different again from Mary's gesture. If "La Marseillaise" was heard as Mary heard, or Mary was marching at the conception, the musical message would have somehow been received incorrectly. But what applies to hearing songs must be potentially applicable to hearing music in general. The gesture of listening varies according to whether we are listening to chamber music or a film score, electronic music or the sound of harmonicas. But if we have admitted that the gesture depends on the message being received, something like catching an object that has been thrown, then we begin to wonder whether it makes any sense to speak of a gesture of listening to music in general at all.

On reflection, this confusion will be resolved, however. For the gesture of listening's deep dependence on the message (in fact, not only on its content but on what is called its "channel") simultaneously permits and encourages us to look for a core that all these gestures have in common. Exactly because one listens differently, depending on whether one is hearing opera or Indian ragas, and opera differently, depending on whether the opera is on television or on vinyl, we must ask how we can justify putting these particular forms of listening together into something like listening to music in general. For something significant seems in fact to separate the gesture of listening to an opera on television and a raga on a vinyl record from other gestures of listening, even if these gestures appear to lie in the vicinity of listening to music. Listening to an opera on television is closer to listening to a raga on a record than it is to listening to a sportscast on television or a political discussion on tape. We need to focus our attention on the core—common to listening to any music—

and not on the prominent differences among specific forms of listening.

Considering that the gesture of listening to music depends more completely on the message being received than is the case with almost any other gesture (listening to opera on television is far more different from listening to "La Marseillaise" at a political rally than reading a novel is from reading a political pamphlet), the following hypothesis may come to mind: listening to music is a gesture that conforms to the message received, and it is this very changing of form from message to message that all these forms share and that makes them gestures of listening to music. The Renaissance gesture of Mary receiving confirms this thesis: Mary pays attention, and that means she attends, she adapts herself to the received message.

That raises at least two objections, however. First, as pointed out earlier, the gesture of listening to music is a positioning rather than a movement of the body, even if the positioning is not fixed. So it is not about actively entering into the process of reception, as it was in the case of catching an object. Of course, we do occasionally see listeners' feet tapping in rhythm or lips seeming to whistle, but these, like the movement of the lips in reading, represent a naive discharge of an essentially internal tension. So we can't speak of an adaptation to a message in the usual sense, as in catching an object or dancing. Second, however, it is characteristic of acoustic messages that they are not actually received but passed along. The human body is permeable to sound waves, and in such a way that these waves set it in vibration, affect it. The body does have specific organs of hearing that convert acoustic vibrations into other, for example, electromagnetic, vibrations, but music sets the whole body, and not just the auditory nerve, in vibration. We cannot speak of adaptation to the message when the message itself imposes its form on the listener.

Despite these two objections, the hypothesis is still supportable that the gesture of hearing is essentially an adaptation of the body to an acoustic message and that it differs from other gestures in this respect. And this not only because neither objection is grounds for refuting the hypothesis, but also, oddly, because it is only through these two objections that we can tell what listening as an accommodation to sound waves is all about. These two objections will therefore be examined somewhat more closely now.

Listening to music is a posture, that is, an inner tension that relaxes,

which is to say opposes itself, when it is expressed as movement. In this respect, the gesture of listening to music is comparable to standing at attention or to a boxer's defensive position. Just as the guardsman cannot sneeze without sacrificing the correct position, the listener can only listen well when he concentrates, that is, somehow turns his muscles and nerves off. The difference between the guardsman and the boxer, on one hand, and the music listener, on the other, is that the guardsman and the boxer are not focused on reception but on action. That is, they concentrate from the inside toward the outside. Someone listening to music, conversely, is not actually concentrating on himself but—within his body—on the incoming sound waves. That means that in listening to music, the body becomes music, and the music becomes a body.

The gesture of listening to music is, accordingly, a posture that incorporates music (in listening, it is characteristically no longer possible to distinguish the plot from the passion, action from suffering, so the music from the body). So the objection that the listener cannot adapt to the message because he is in a passive position is refuted. Because the listener, in listening, is himself what he is hearing, adapting oneself to the music means becoming the music. What is at issue in this case (and what will not be romanticized here in any way) becomes apparent when we come to the second objection.

The human body is permeable to sound waves, but not in the same way it is to X rays. Without going into the physical details, it is clear that sound waves and Roentgen rays have different effects as they pass through the belly. They can be felt, one is aware of being subjected to them. In Greek, this knowing subjection is called *pathein*. The reception of music in the belly (and chest, sexual organs, head—all body parts disposed to oscillation, in short) is *pathos,* and its effect is empathy with the message. The acoustic message alone literally has this pathetic character. In all other messages the effect is only metaphorical. In listening to music, a person is "touched" by a message in an entirely physical (not a metaphorical) sense; he is empathizing with the *pathos* of the message (Pan and Orpheus come to mind readily, but so does aerodynamics).

But the matter is not so simple. For one thing, the liver probably oscillates differently from the sinuses; for another, the liver and the sinuses are connected to the nervous system in different ways; for a third, there is an

auditory nerve specializing in the reception of sound waves. So empathy with the message is a complicated matter, complicated above all not only by the cybernetic feedback that arises between the separate oscillations of the body but also, and primarily, because verbs like *feel, wish, dream,* and *think,* substantives such as *joy, love, longing,* and *beauty,* are the words that name this complex pathetic experience in everyday language. In short, the matter of the human body's permeability to sound waves is not so simple because it is experienced as happiness, mathematical order, and beauty.

No experience demonstrates as forcefully as listening to music that *mind, soul,* and *intellect* are words that name physical processes. And yet listening to music is not a so-called borderline case. We cannot say that listening to music is some sort of massage (like diathermy) for stimulating some aspect of mind. On the contrary, one of the highest, if not the very highest, form of mind, soul, intellect is received in listening to music, in this acoustic massage, and in fact in such a way that one's own mind and the mind of the message's sender come together in this acoustic massage. For this reason, a study of listening to music from a physiological and neurological point of view would probably be a good way to understand the physical aspect of such processes as "logical thinking," "creative imagination," or "intuitive understanding."

To sum up the two objections to the thesis that listening to music is essentially a gesture in which the body adapts itself to the message, we could say that the two objections show what "body" and "adaptation" mean in this context. In listening to music, the body becomes music, and in fact the position the body takes at any one moment corresponds in its internal tensions to the music it is receiving. And it can take this position because it is disposed, in an extremely complex way, to resonate with the *pathos* of this music. In other contexts, the body's complex way of resonating is called "feeling," "thinking," "desiring." To put it differently and more radically, listening to music is a gesture in which, through acoustic massage, the body becomes mind.

This intellectualization of the body by acoustic means (a process that cannot be compared to any other physical event) is perfectly opaque in its details: it is, to speak cybernetically, a so-called black box. It is therefore impossible for a composer to set out, say, to do the following: I will make the listeners' salivary glands vibrate in such a way as to think and feel the

geometric structure of the fugue and so a logical aspect of the world as a whole. Or, I will make the listeners' oral cavities oscillate in such a way that they mentally experience unconditional, all-embracing love. But although neither Bach nor Beethoven was able to compose in this way, it was their intention to produce such an effect in the listener. They acted cybernetically: they manipulated the input and output of the black box "body." They fed in vibrations that have love and logic as outputs, without troubling themselves about what happens in the body's interior. So to describe listening to music as an acoustic massage is no desecration of the intellect. On the contrary, it lets us see the mystery of the intellect in general and of music in particular clearly for the first time, namely, the mysterious darkness in the interior of the black box. Only by taking music back to sound and the intellect to nerves and muscles do we glimpse the secret of *pathos,* the orphic mystery, the Pythagorean "theorem": music and mathematics in harmony, as "peri-*pathein*" and "em-*pathein,*" become the art *(technê)* that leads to the wisdom of beauty and goodness, to *sophia* of *kalokagathia.*

Listening to music is a gesture in which the body tunes in to the *mathesis universalis.* This is possible because the acoustic vibrations don't just penetrate but also set up a resonance with the body's skin. The skin, that no-man's-land between a human being and the world, changes from boundary to link. In listening to music, the division between man and world dissolves, a person overcomes his skin, or conversely, the skin overcomes its person. The mathematical vibrations of the skin in listening to music, transmitted on to the intestines, to the "inside," is "ecstasy," the "mystical experience." It defeats the Hegelian dialectic. In listening to music, a human being finds himself without losing the world and finds the world without losing himself, by finding himself as the world and the world as himself. For he and the world do not appear as a contradiction between subject and object but as "pure relationship," namely, as acoustic vibrations. Only in listening to music does one experience, physically, concretely, psychically, literally what science means when it speaks of a "field" and of "relativity." As in an acoustic field (which is a special case of a gravitational field), one experiences man and world relationally, that is, relative to one another, becoming one, "pure intentionality," as Husserl put it. This is why listening to music is the "absolute" experience, namely, the experience of the relativity of subject and object in the field of *mathesis universalis.*

Listening to music is the gesture that defeats the skin by transforming it from a boundary into a connection. It is the gesture of ecstasy. It is possible that there are other ecstatic gestures. For example, it is probably possible to force the body to overcome itself chemically, through drugs, or mechanically, through yoga. And there are certainly techniques of autosuggestion that provoke physical responses leading to ecstasy. St. Theresa is probably an example of this. But listening to music is different in kind. When I tune in to Radio France to listen to France Musique,[1] I am performing a perfectly profane, perfectly technical, and perfectly public (unconcealed) gesture. And if I am really attentive, I can have the ecstatic experience. It is exactly because the gesture is so profane, so technical, so public, because there are schools of music and musical animations and happenings, it is for this very reason that music is the very greatest, most sacred mystery. It does not need to conceal itself, for in its magnificent, supercomplex simplicity, in mathematical simplicity, it is obscure. Like death and life. For it is life in death and death in life. One need not have read Schopenhauer to know it. To know it, one need only have tried to really listen to music.

The Gesture of Smoking a Pipe

Pipe smokers differ most fundamentally from those who do not smoke pipes in their extraordinary dependence on pockets. At a minimum, one is needed for the tobacco pouch, one for the pipe, one for the lighter, one for the tool for cleaning the bowl, and one for the wire to clean the stem. But it is good to have additional reserve pockets, for example, for a second pipe, for matchboxes, and for wires of varying strength and flexibility. The pockets cannot have just any shape and cannot be situated just anywhere. The tobacco pouch, for example, should be in a deep trouser pocket, for it needs warmth; the pipe has to be in an outer breast pocket, for its head must be turned downward and the mouthpiece in the light; and the lighter needs to be readily available in a right inner coat pocket so that it can be grasped easily with the left hand (the right is holding the pipe). Pipe smokers are distinguished most fundamentally from those who do not smoke pipes, then, by their extraordinary dependence on certain clothing. It would nevertheless be incorrect to speak of work clothes and to suppose that we could recognize a pipe smoker by his clothes. For the gesture of smoking a pipe is not work but rather, as we shall see, the opposite of work, namely, leisure. And the clothing of the pipe smoker is not recognizable as such because it is in the nature of pockets to hide and be hidden. So the following question arises: if smoking a pipe (1) increases the smoker's dependence on circumstances and in this sense reduces his freedom; (2) is a complex gesture that does not "accomplish" anything, as work would; and (3) does not "distinguish" the smoker (except at the moment of smoking itself, by the pipe held in the mouth), why do some people smoke pipes? This question has the paradigmatic form of a whole

class of questions. In it, for example, we could substitute "painting" or "playing the violin" for "smoking a pipe." This "class character" of the question, which shows that smoking a pipe belongs to a class of gestures, in fact, to a very questionable class, also explains why the gesture of smoking a pipe was chosen as the theme of this investigation.

The question can be approached from various standpoints. One might try to explain it historically, for example, and perhaps begin with the discovery of America. Or one might try to move ahead sociologically, and perhaps work with such concepts as "social level" or "cultural environment." Or one can draw on concepts from neurophysiology, such as "effect of alkaloids on the nervous system," to explain, although psychological concepts such as "phallus and vagina symbolism" would work equally well. All of these explanatory efforts (and there are as many of them as there are disciplines of the natural sciences and humanities) share the need to give a cause for the pipe smoking. But causal explanations don't get to the essential thing about the gesture. When I ask why I smoke a pipe, I am not talking about the things that condition me to smoke a pipe. I mean the motive for my smoking. For I am convinced that I could just as well not smoke a pipe, and it is this conviction that makes me ask why I smoke. This difference between cause and motive, between conditioned movement and gesture, deflects causal explanations, correct as they may be, from what is meant by the question. If we are to get at what it means, the question must be answered from the standpoint where a choice was made and a decision reached. For the question means, why have I decided to smoke a pipe, of all things, instead of, say, chewing gum, which I could do just as well? What is needed to answer the question, then, is not scientific research but sympathy with the "essence" of the gesture.

Having taken such a standpoint, we can see right away that only a complete misunderstanding of this gesture would to lead to any attempt to "rationalize" pipe smoking. Obviously pipes can be constructed that do not get blocked, or pipe cleaners that serve multiple functions and are easier to use, or pouches in which pipes, tobacco, and cleaners can be comfortably and economically stored. All these gadgets and more are available for purchase, by the way. But they would literally nullify the gesture of smoking a pipe. That proves that the motive for smoking a pipe cannot be the actual smoking, that is, the breathing in of tobacco smoke alone,

as may be the case with cigarette smoking, and that the pipe smoker does not have the same relationship to nicotine as the cigarette smoker. One might even suppose that the actual inhalation of tobacco smoke is in part just an excuse for the complex gestures that precede and follow it, and that the motives for smoking a pipe are at least as likely to lie in these complex gestures as in the actual smoking. This begs a comparison. Isn't the difference between smoking a pipe and smoking a cigarette comparable to the one between drinking tea at breakfast and drinking tea in the Japanese tea ceremony? To the extent it is apt, the comparison raises a suspicion that pipe smoking is largely a ritual gesture. Of course, pipe smoking is not done at the same "sacred" level as the tea ceremony (to say nothing of ritual gesture in the Roman Catholic mass or rain magic). And yet, the fact that it can't be "rationalized" without nullifying it suggests that we are dealing with a ritual gesture.

Still observing from this sympathetic standpoint, if we next try to describe the rite of smoking a pipe (which is, as we now know, a gesture whose motivation cannot be addressed using any causal explanation because it is a gesture, which is nullified by any rationalization because it is a ritual), we are surprised to realize that there is no overall norm governing the behavior of pipe smokers. This is to say not only that each pipe smoker has worked out a characteristic way of handling his pipe but also that each pipe smoker is prepared to confirm and defend his style in discussion with other pipe smokers. The observation is surprising because it appears to contradict the first observation. For isn't it the mark of a ritual gesture that it is stereotypical, that is, prescribed and rigid, so that anyone performing it must make the same movements, always and anywhere? And doesn't their readiness to discuss and confirm their own style mean that each pipe smoker believes himself to have "rationalized" his gestures, which the first observation concluded was impossible without nullifying pipe smoking? Could the first observation be wrong and pipe smoking be no ritual act after all?

On reflection, one gets the feeling that the contradiction that has come to light here does not block the way to our understanding of pipe smoking (and ritual in general) and may actually open it up. For what we have before us in this contradiction is the insoluble fusion of theory and practice, as it occurs in ritual and in no other activity. What characterizes

gestures such as pipe smoking is, on one hand, that they are completely impractical, in the sense of having no intention of achieving anything, and on the other hand, that they are completely practical in the sense of having no theoretical basis. So with this kind of gesture, there is no dialectic between theory and practice of the sort that came to light in the analysis of gestures of work. Rather, there is that insoluble fusion, exposed in the contradiction we encountered. Pipe smoking's complete impracticality appears in this contradiction as a struggle between opinions *(doxai)* regarding the best way to smoke a pipe, in which all the contestants realize that the issue is subjective, for when there is no intention of achieving anything, there can be no objective best method of smoking. And pipe smoking's complete practicality appears in the contradiction as a variety of smoking styles, that is, aesthetic rather than epistemological variations of the same theoretically incomprehensible activity—stereotypical, after all. In other words, the discussion is completely theoretical and has no effect on the theory-free gesture of smoking, nor, strangely, does it want any. It arises nevertheless, wherever and whenever pipe smokers meet, because the absence of theory for smoking, in light of its complete indifference to practice, presents a kind of scandal for the smoker himself.

As mentioned earlier, pipe smoking is a profane gesture. So the completely ineffectual theoretical discussion between pipe smokers regarding differing styles of smoking is enveloped in an atmosphere of smiling mutual tolerance. Because smoking is profane, which is to say it has no bearing on the essentials of existence, each smoker lets another achieve bliss in his own way. Of course, he remains convinced all the while that his is the right way, for the only reason that applies here, namely, that is it the one that makes him happy. Turning from this entirely ineffectual theoretical discussion of a gesture that cannot be theorized to other rites (e.g., to those of the Jewish kashruth), which are concerned with existentially foundational, namely, sacred matters, the atmosphere changes. We then face that bitter and intractable difference of opinion illustrated in many Talmud commentaries. So, exactly on the basis of its profanity and so its pervasive harmlessness, pipe smoking may serve as a model for the understanding of the discussion of rites within orthodoxy. Whether the tobacco should be pressed into the bowl firmly first and then lightly appears as a question of the same type as one about whether one should

eat an egg that has been laid on a Saturday. They are at once completely theoretical questions in the sense of being completely free from any intention of achieving anything, and not theoretical at all in the sense of being directed only toward practice. It shows that such discussions cannot and don't want to "rationalize" the rite but rather are "aesthetic" in the etymological sense of the word, namely, that they are concerned with experience. And it shows that the kind of reasoning that comes into play in such discussions is neither theoretical nor practical but rather a kind specific to discussions of rites. In the Jewish context, it is called "pilpul." This indivisible union of theory and practice in ritual, in which theory is no longer theoretical and practice is no longer practical, rather than theory becoming practical and practice theoretical, as is the case with work, already came into view in the contradiction between the first and second observations regarding the gesture of smoking a pipe.

Although pipe smoking is a stereotypical activity because it cannot be "rationalized" and does not try to achieve anything, each pipe smoker smokes in his own characteristic way. The question it comes down to is, of course, what the concept "stereotype" means. If, by "stereotypical behavior," we understand a gesture whose every separate phase is more or less "preplanned," then it is clear that with pipe smoking, we do not have a stereotypical form of behavior. But in this sense, no gesture is a stereotype, for inherent in the concept of gesticulating is the typically human belief in acting of one's own free will, and this belief instills a plasticity within the structure of the gesture. Stereotypical behavior in this narrow sense is more readily observed in animals than in people (e.g., in the dance of bees, in the way male fish court females, or in the nest building of birds), and when such behavior is observed in people, it often has a pathological, obsessive character. Pipe smoking is not like this, and it would be an ontological error to call the dance of bees or an obsessive handling of pillows a ritual. Stereotypical behavior in the narrow sense is a phenomenon on a level of being for which natural science is competent, and rituals are a phenomenon of another level of being beyond the competence of the natural sciences.

If by "stereotypical behavior" we rather understand a gesture whose general structure is stable and that is performed so as to realize this general structure, without pursuing a purpose that refers to things outside

the structure, then pipe smoking is stereotypical behavior. For now, the word *stereotype* means that there are gestures that are made largely for their own sake and for which we have models. When we gesticulate in this sense, we don't do it to change the world as we do with work, or to convey a message to someone else as we do with communication, but to perform movements within parameters established by a model. And that is what we do when we smoke a pipe. It does not exclude the possibility of changing the world (e.g., burning tobacco) or communicating something to others (e.g., the smell of the tobacco). But it would be an error to suppose that changing the world and communicating, aspects of any gesture, "explain" stereotypical gestures such as pipe smoking, and this error blocks access to an understanding of such gestures. Rain magic is not "explained" by considering it a means of producing rain or by claiming it is a particular community's method of communication. One only gets closer by recognizing it as behavior that incorporates a particular model. Nothing essential is said about rain magic by comparing it with other methods of producing rain or other means of communicating but only by drawing other stereotypical gestures, such as pipe smoking, into the comparison. For then it becomes clear that we are basically dealing with a question of style, an aesthetic question. It becomes clear that ritual is an aesthetic phenomenon.

What has just been said is a daring assertion, for it contradicts almost everything that has been said so far in the subject literature. The risk must be taken anyway because an observation of pipe smoking almost demands it. For in trying to enter into the gesture of pipe smoking from an ethical angle, the characteristic thing about the gesture is lost, and that characteristic thing is the ritual aspect. So the crucial aspect of a rite cannot be its "ethical" aspect (e.g., making rain or transforming the host into the body of Christ), and the announced intention of the rite when it is being performed (e.g., success in hunting or purification) must conversely be considered something that covers up the essential thing, as a rationalizing pretense, which is incidentally immanent in most rites. When someone says he smokes a pipe to inhale tobacco smoke, he "believes" what he is saying, and the same is the case for the claim of taking Communion to savor the body of Christ, and washing one's hands to keep them clean. But despite the plausibility of such claims, they are mistaken. In fact, pipes

are smoked and Communion taken and hands ritually washed to perform
a gesture within an available behavioral model. This can be seen more
readily in pipe smoking than in other stereotypical gestures because it is
a profane gesture and so relatively free of ideology.

This leads to the following consideration: the less intentional a gesture
is, the less it pursues a goal outside itself, the "purer" is the ritual. The
intention, which transcends the ritual gesture, could be called its "magic"
aspect. The magical element in rain magic is the intention of producing
rain and, in the rite of Communion, is the intention of transforming the
host into the body of Christ. When the question is put in this way, magic
does not appear inherent to the rite, but conversely as a debasement of
"pure" ritual. Then it becomes clear why the Jewish prophets opposed all
magic so violently: they wanted a "pure," purposeless rite, an unpractical
practice. And Judaism then appears as a partly failed attempt to develop a
model for gestures of "pure" ritual, a life of impractical practice.

Even with this, however, we still have not come to the essential thing
about smoking a pipe and about ritual life in general. It only comes into
view when we reflect that we are dealing with an essentially aesthetic phe-
nomenon. The assertion that pipe smoking and ritual gestures in general
are aesthetic phenomena is risky primarily because it puts the question
of art in an unfamiliar light. It's not that we're unfamiliar with emphasiz-
ing the ritual aspects of so-called artistic creation. In a certain sense, the
romantic conception of art and any *l'art pour l'art* treats artistic activity
as a kind of rite. What is unfamiliar about the assertion is not the claim
that art is a kind of rite but just the opposite, the implication that ritual is
a kind of art. This does not imply that there is a ritual form of being that
expresses itself in specific gestures and in an artistically active life, among
other things, as was the case in the romantic era or in *l'art pour l'art*. It
rather implies that there is an aesthetic form of being, the artistic life, and
that this life expresses itself in various gestures, including ritual ones. It is
not art that is a kind of rite but a rite that is an art form. It is not that there
is, for example, a Jewish art that expresses itself in literature or music but
also in ritual, and a Jewish philosophy and ethics in addition, but just the
opposite, the whole of Judaism, understood as a ritual form of life, is an
art form among other ritual forms of life, and Jewish philosophy and ethics
are aspects of this art form that threaten to obscure the essential thing,

namely, the aesthetic dimension of Judaism. The assertion is unfamiliar and risky because art is usually understood to be a category of being within which such phenomena as rites, music, painting, and poetry come about. This is not the usual claim that the artistic life is a life-form along with the political life, the scientific life, or the religious life, or even that the artistic life is aligned under the religious one (Kierkegaard). It is rather the unfamiliar claim that religious life, inasmuch as one understands it to be a ritual life, is one kind of artistic life-form. This unfamiliar claim does not mean a sanctifying of the artistic life, but conversely, the desanctifying of ritual, for it was reached through the observation of profane pipe smoking.

Obviously what has just been said assumes that such words as *art* and *religion* are to be questioned. For it may be that the whole difference between the risky assertion that religion (as ritual life) may be a kind of art and the more common assertions regarding the relationship between art and religion lies in the definition of these two concepts. Whether we are concerned with a verbal difference only or with a difference in meaning can only be decided when the gesture of smoking a pipe, which offered the starting point for the risky assertion, is illuminated by observation. For through such observation, it should become clear what is meant by *art* and *religion*.

Let's turn back to our original question, then: why do some people smoke pipes, despite its being a gesture that neither "achieves" anything (like work) nor "distinguishes" in any way (like communication)? To move closer to an answer, we should turn our attention to the way the question is framed, implicitly distinguishing among three kinds of gestures, namely, gestures of work, gestures of communication, and gestures of the type "pipe smoking," which were defined as "ritual gestures." Assuming that being expresses itself in the world as gesticulation, the question's framing implies that it would be possible, based on gesticulation, to distinguish three life-forms: working, communicative, and ritual being. Such a classification conforms neither to Kierkegaard's, which I just mentioned (aesthetic, ethical, religious life), nor to Plato's (economic, political, theoretical life), as it was elaborated by Hannah Arendt. Still, the divergence should not be taken too seriously. For we are not concerned with a phenomenal classification, and any one of us constantly performs gestures of all three types, and each type possesses aspects of the others. We are there, in other words,

in simultaneously stylizing ourselves with respect to the world (work), to others (communication), and to ourselves (ritual). So the classification implied in the way the question was framed is not a thesis to be defended but a working hypothesis.

The question about the reason some people smoke pipes is a special case of the question about why ritual gestures are performed and further contains the question about the reason these gestures, rather than others, are ritually performed. The answer to these two aspects of the question seems obvious: for "pure pleasure." Many people smoke pipes because they take pleasure in this particular gesture. It pleases them to interrupt other gestures, such as writing an essay or talking to a friend, to take their pipes apart, clean the bowl with an old nail scissors, then run the stem through with a hairpin, put the two parts back together, pull the pipe pouch out of a pocket, crumble the tobacco between the fingers, push it carefully into the bowl, take the pipe between the teeth, get the tobacco to glow with a slow rotation of a specially constructed lighter, draw the tobacco smoke into the oral cavity, and then resume the interrupted gesture of writing or conversation. It pleases them to share their attention between the gesture now resumed and that of pipe smoking, and it pleases them to have their attention to the gesture of writing or conversing immersed in the specific mood of pipe smoking. It pleases them that smoking a pipe, a gesture subordinate to the other one, demands that they interrupt the writing and the conversing repeatedly. It pleases them that when they have finished smoking, they must clear the pipe out, blow through the stem, and rock the pipe between the hands so as to cool it, so that it can be stored in the breast pocket. They take a kind of anticipatory pleasure in being able to choose among various forms of pipe and various qualities of tobacco in specialty stores, and it pleases them that they can prefer a particular shape of pipe (e.g., short, curved) and a particular kind of tobacco (e.g., bitter, cut fine). They are pleased that they can build a pipe collection, designate some pipes for daily use and others for special occasions. The list of these joys, all "small," could continue for a long time, and the length explains why, despite its joys being small, pipe smoking is one of the pleasures that many people would not want to give up.

This somewhat long-winded answer to the question (long-winded because it tried to describe my own style of smoking a pipe) is completely

inadequate, however. For instead of actually answering the question, it opens a whole range of new questions. Just for example, what is pleasant about cleaning the pipe bowl, when it is in fact a distinctly unappetizing procedure? Or, why is it a pleasure to interrupt writing and conversation, when there is greater interest in continuing to work and communicate? And basically, what is meant in this case by the word *pleasure,* when we seem to be dealing with a burdensome gesture, a kind of vice? Isn't the essence of vice passion, that is, suffering? And isn't there suffering when the pipe is blocked up or one runs out of tobacco? To say nothing of the fact that pipe smoking is detrimental to health. Don't people suffer from any vice, according to one rather utilitarian moral standard (the official one, as is typically the case)? It would be futile to try answer the bundle of questions that have arisen here without being tripped up by causal explanations that have been eliminated from the discussion because they are not competent to deal with the gesture of smoking a pipe. The matter must therefore be approached in an entirely different way if we are to get a result that is more satisfying than the completely inadequate answer presented here.

The pleasure in smoking a pipe does not have one or another specific cause and does not come from resisting one or another argument against it; rather, the pleasure comes from the gesture, from "acting oneself out." This phrase, in everyday use yet difficult to grasp, touches the essence of pipe smoking. In this context, to "act out" does not only mean to expend superfluous life energy to no purpose, although it means that as well. This "as well" can be observed in pipe smoking. But to act out also means to project an existence that is one's own, very particular, and comparable to no one else's. This meaning of the phrase "act out" can be observed in the gesture of pipe smoking. It is important to note that the verbs "to act out" and "to let oneself go" are not synonyms but antonyms. In letting go, the self is lost in unstructured movements that no longer constitute gestures because they are not performed "freely." In acting out, the self is recognized as if from the outside and so asserts itself, for it is then perform-ing a gesture specifically for itself. This antimony between "acting out" and "letting go" can be observed in pipe smoking, for in smoking a pipe, a person moves as a function of specific, "freely chosen" objects, that is, within boundaries, in a manner that bears witness to his own existence. That is what brings pleasure: to bear witness to oneself, freely and without

purpose, within explicitly chosen parameters; to recognize oneself by one's style, and then to immerse all other gestures (e.g., that of writing and that of conversing with a friend) in this style. From this standpoint, perhaps, we can appreciate the familiar saying about style making the man. In other words, pipe smoking is a gesture that permits us to act out, that is, to find ourselves in the world through our own style. And that is what is meant by the answer, "It is a pleasure."

This kind of pleasure can only be defined as "aesthetic," and so we can now say what was meant by the word *art* when we were discussing ritual gesture as a phenomenon of the artistic life. The word *art* means the gesture through which existence "acts itself out," freely and purposelessly bearing witness to itself, within appropriate parameters. The "artistic life," then, is the life-form that depends on the style in which gestures are performed. So the "artistic life" is not about changing the world, or about being in the world with others, but about finding itself in the world. The gesture of pipe smoking is a nice example of this sort of life, because in most other examples of "artistic life" (e.g., dancing or praying), issues of changing the world or seeking others weigh in the balance, but in pipe smoking, they play hardly any part at all. As we will see, the gesture owes its aesthetic purity to its profanity.

What comes to mind in speaking of the artistic life is not likely to be the gesture of pipe smoking but rather such gestures as making sounds, photographing, or writing poems. Why, actually? If the artistic life is that form of life in which people act themselves out, then shouldn't it be such gestures as pipe smoking that come to mind when it is under discussion? Our misrecognition of what is essential about the artistic life goes back to the way the concept of "art" has developed in Western history. In the West, "art" has become a kind of work aimed, as all work is, at producing something—a work. It has even become the highest kind of work because it is expected to be "creative," that is, to produce "new" works. At the same time, however, "art" in the West has become a means of communication that shares something with another person, as does all communication. It has even become the highest form of communication because it is expected to be "original," that is, to share new information. Because of these developments, the essential thing about art, namely, the "aesthetic" acting out, has been suppressed, and so when talk turns to art, thoughts

do not ordinarily turn to such gestures as pipe smoking. In other words, the historical development of the West has caused the essence of artistic life to be forgotten. It can be recalled to memory, however, for example, by looking at the art of black people.[1]

One could claim, namely, that the gestures considered expressions of artistic life in black Africa and America—drumming, dancing, and mask carving, that is—recall our pipe smoking far more readily than our painting does. What happens when a mask is carved can be described as follows: to perform his gesture, the carver has specific materials, specific tools, and a specific model available. In this sense, his gesture is "stereotypical." Now he does not attempt to work with a new material or experiment with new tools or "exceed" his model, as a Western sculptor would. Rather, he tries to express his own specific character within the framework of the materials, tools, and patterns that are given. This art is therefore not, as we sometimes tend to think, a static, inflexible repetition of forms but a context in which individual styles come to expression, perhaps more often than in Western art. And this may be because the models for the gestures are accepted as boundary parameters. Exactly because this art is not "historical" in our sense of the word, it permits the realization of individual style rather than changing the world or communicating. In this sense, it is a "purer" art than that of the West.

Now it is often claimed that African art is an aspect of religious life. One drums so as to move the gods to enter human bodies, one dances to drive spirits out of bodies, and one carves masks to make these dances more effective. Here we are dealing with a misunderstanding. It is in fact true that drumming, dancing, and mask carving can be used for magic, that is, for "religious purposes" as well. But it is not true that these gestures serve such purposes exclusively. It is not true that African art serves magic; what is true is the opposite: magic is one of the possibilities African art offers. African art is its own purpose: one drums because one finds oneself in this gesture. The fact that this drumming causes a god to enter a human body is in fact a result of the drumming, and is impossible without the drumming, but if the drumming was done solely to achieve this, then it was not "pure." African art opens its space to magic, but magic is a result, not a cause, of the artistic life. That permits us to come closer to what is meant by "religion."

To drum to invoke a god is to carry out a gesture of the artistic life, for within the set boundaries of drum, sticks, and rhythm, it expresses an individual style. Apparently drummers recognize one another across the hilltops of Rio de Janeiro at night just by the way the drum is struck. That is to say, a person finds himself in his own drumming as it flows out from the self into the world. But it is exactly this self-recognition in the world that challenges the god to descend. In the final analysis, the god does not appear in the rhythm of the drum but in the self-recognition achieved by means of the aesthetic gesture. The god is an "aesthetic" phenomenon, meaning that he is one of the experiences one has when acting oneself out. In drumming, a person experiences himself in "ecstasy" (from beside oneself), as rhythm, sound, oscillating nerves, as an ordering principle, dominating the environment, and also as a god. Those are various kinds of experiences in the artistic life. One can, of course, concentrate on one of these kinds, on rhythm, on sound, on the god. Each of these forms of concentration will result in a variation of the gesture of drumming: if I am interested in rhythm, then I will drum differently from the way I would if I were interested in the god. But the variations overlap, for the god is an aspect of rhythm, and the rhythm is an aspect of the god. But if we call the interest in God a "religious" interest, then we are obliged to see the religious life as a variant of the artistic one. That was what was meant by the word *religion* in the context of claiming religion to be an art. It meant that only in the artistic life does a space open for the religious life at all. I don't have religious experience in the gesture of work because, in this gesture, I experience the world, that is, I experience "knowledge." And I don't have religious experiences in the gesture of communication, for in this gesture I experience society, which is to say I experience "values." Only in the aesthetic experience can I have religious experience, for in this gesture I experience myself, that is, I experience "revelation." Science is a possible result of work, ethics and politics are possible results of communication, and religion is a possible result of art. This assertion can be backed up theoretically, derived from many biographies, and documented in history and prehistory. But the crucial thing is that it can be seen in the gestures themselves. Observing the gesture of pipe smoking, we can see that a space within the artistic life opens up to the religious life. And it is possible for us to see it because we are dealing with a profane gesture.

The gestures of smoking a pipe, carving masks, and drumming are all stereotypical and therefore depend on style. They are "aesthetic" gestures. The gesture of carving a mask differs from the other two in "achieving" something, namely, the mask. This, the gesture's extension into the area of work, makes the gesture of carving a mask into an aesthetic gesture of the type "artwork." The gesture of drumming differs from the other two in sharing something with others, in "signaling" some information. This, the gesture's extension into the area of communication, makes it into an aesthetic gesture of the type "message." The gesture of smoking a pipe differs from the other two in having no intention outside itself. The purity of the gesture of smoking makes it into an aesthetic gesture of the type "ritual." The fact that mask carving is directed against a material, drumming toward others, and pipe smoking toward nothing should not disguise the aesthetic character of all three gestures, for all depend on style, that is, on "acting out." And yet the mask carving and drumming, by extending themselves into areas that are not aesthetic, to change the world and society, so transcend the two gestures as to present something of a distortion of the pure artistic life: a distortion toward the magical. Mask carving and drumming are magical aesthetic gestures, that is, they are geared in part toward changing the world and conveying messages. "Magic" can be defined in this way: it is the extension of the artistic gesture into areas that are not artistic. Real work is not magic because the aesthetic moment is not decisive in it, as it is in magic. Real communication is not magic because it is not primarily a question of style, as it is with magic. Pure ritual is not magic because the ritual gesture does not extend beyond the area of the artistic life. So there are gestures in the artistic life that are not magical, namely, gestures of pure ritual. In the life of the African, there are many magical gestures, because Africans lead largely artistic lives. In our lives, there are relatively few magical gestures, because we suppress the artistic life in favor of the lives of work and of communication. We have "defeated" magic by subordinating the artistic life to work and communication and, in doing so, obscured the concept of art.

But it is possible to "defeat" magic in other ways as well, namely, through a purely ritual life, which is to say an artistic life that does not transcend itself. The gesture of smoking a pipe, among other things, demonstrates this.

The gesture of smoking a pipe is not magic. But this is not the reason it is profane. It is profane because although it is an aesthetic gesture, it opens no space to the religious life. It is in fact pure ritual, but not a ritual that permits "the god" to be experienced in it. The magical gesture of drumming permits it. One might think it was the magical aspect of the gesture that opens the religious space. But the god appears in the drumming not because it is evoked (because of magic) but because drumming is a gesture in which the drummer finds himself as a god. It is not the magic dimension of the drumming that opens the religious space but the purely ritual. But why does this space not open in the pure ritual of pipe smoking? Answer: Because pipe smoking is a ritual in which the smoker does "act out" but to which he does not give himself completely. So the pipe smoker does recognize himself in the gesture but only insofar as he expresses himself in it. That is not enough to have a religious experience. The religious level lies so deep that it can only be experienced if the ritual gesture mobilizes one's entire being and not just one of its aspects, as is the case with pipe smoking. Drumming is sacred, not because it is magic, but because in it, being is expressed completely. And pipe smoking is profane, not because it is not magic, but because it is too superficial to express being completely.

When he is smoking a pipe, a pipe smoker is living aesthetically. But his smoking takes place within a life of work and communication that is not aesthetic (while writing or conversing). That is what makes pipe smoking profane: it is a pure ritual that takes place within a "meaningful" life. It's true that in itself, pipe smoking is meaningless and cannot be rationalized, that any attempt at a rationalization actually ruins it. But this, the absurdity of pipe smoking, is not part of the pipe smoker's existential foundation. That is why pipe smoking is a profane gesture. Drumming is sacred, but not actually because it is "meaningful," that it means to evoke a god. It is sacred because it is fundamentally absurd and because the drummer is fundamentally absurd in it. Magic only appears to be work and communication: fundamentally it is an absurd way of working and communicating. The magic aspect of drumming disguises its absurdity, but it is the absurdity that makes drumming sacred. Pipe smoking is not sacred, although it is absurd, because its absurdity expresses only an aspect rather than the whole of the smoker's being.

If you try hard enough to find your way into it, you can tell from the gesture of smoking a pipe that the absurdity of the ritual almost requires you to open up to religious experience. If you observe the way pipe, tobacco, and smoking tools are manipulated, with what kind of consideration the separate moves are performed, and the way the smoker remains aware of the absurdity of these moves all the while, you feel as if you are moving along the outer edge of what is meant by religious experience. A small step would be enough to go beyond this edge and fall into the void, a small step as it is taken in the tea ceremony or, better yet, in pipe smoking in an Umbanda ceremony. The structure of the gesture of the tea ceremony is almost identical with the structure of the gesture of smoking a pipe, and the gesture of smoking a pipe while one is writing cannot be distinguished at all from the gesture of smoking a pipe during the Umbanda. In other words, in smoking a pipe, one gets the feeling that a very slight impulse would be enough to transform it from a profane into a sacred gesture. So we can see, just because the gesture is profane, how any ritual gesture opens a space for religious experience. You can tell that the rite is a sacrament exactly because the tamping, cleaning, and lighting of the pipe have nothing whatsoever to do with religious experience. You cannot recognize the sacramental so readily in sacred rites, such as in folding the hands, crossing oneself, or turning toward Mecca to pray, because the view is obscured by a rationalizing ideology. The various religious ideologies idealize their rites, deny that they are absurd, and in this way hide what is essential about them. Pipe smoking exhibits its absurdity openly, because it is still just barely profane, and so permits us to recognize the absurd as the essence of the sacramental. By way of pipe smoking, we can recognize the essence of ritual life: to be open to religious experience through purely aesthetic, that is, absurd gestures.

It will be apparent to anyone who has ever made such a gesture that we recognize ourselves in them, and only in them: only in piano playing, only in painting, only in dancing does the player, the painter, the dancer recognize who he is. It is a founding principle of Zen Buddhism that self-recognition can be a religious experience, if the recognition is of the "whole" self: its rituals (tea drinking, flower arranging, board games) are therefore sacred rites. Certainly the greatest discovery of Jewish prophesy is that religious experience is an experience of the absurd, the groundless,

that "God" is manifest as that which is inexplicable, indefensible, "good for nothing else": hence its battle against magic and its insistence on the absurd rite, with no aims that make any sense. But all these noble insights, those of the artist, the Zen monk, and the prophets, can be gained in a modest and profane way by watching such everyday gestures as pipe smoking with sufficient patience. For then it becomes clear how each of us is a virtual artist, and a virtual Zen monk, and a virtual prophet. For each of us performs purely aesthetic, absurd gestures of the same type as smoking a pipe. What also becomes clear, of course, is what sets most of us apart from real artists, Zen monks, and prophets, namely, the complete renunciation of reason (in the sense of explicability and purpose) and the unconditional surrender in the gesture and to the gesture essential to the real artist, the real Zen monk, the real prophet.

The question at the beginning of the essay was, Why do some people smoke pipes, when it limits their freedom, accomplishes nothing, and shares nothing? The first answer that was offered was for the pure pleasure this gesture affords. Now it is possible to make this answer somewhat more precise. Some people smoke pipes for the same reason some people are artists, others monks, and still others prophets, namely, to act themselves out and find themselves. It's just that pipe smoking is far less demanding than a gesture of art, and even less demanding than the artistic gestures of Zen monks or orthodox Jews. This also makes it far less "open." So some people smoke pipes as a kind of substitute and caricature, which is to say a profanation of a ritual life.

The Gesture of Telephoning

Its appearance has changed frequently in the course of its history and can serve as an illustration of the way design has developed. But despite the difference between a telephone mounted on the wall, with its iron crank, and the row of colored plastic telephones on the manager's desk (to say nothing of the red telephone), it has undergone only one functional modification in its long history: automation. The telephone has retained an archaic, paleotechnical character in comparison to the discursive mass media. This matters to an understanding of our current state of communications. One of the possible definitions of freedom (and not necessarily the worst) describes it as having the same parameters as dialogue. In keeping with such a definition, freedom in a given country could be measured by the coverage and efficiency of the telephone network, and the relatively paleotechnical character of the telephone in all countries would permit us to conclude that no country is overly concerned about the freedom of its citizens.

To describe the function of the telephone, two completely different approaches are required: one from the position of the caller, the other from that of the recipient. The apparatus presents itself as a completely different object depending on which position is taken, which is a nice example of the phenomenological thesis that any object can exist only in relation to some kind of intentionality. From the standpoint of the caller, that is, the telephone is a mute and passive tool, patiently waiting to be used; and to the person called, it is a hysterically whining child that must get its way on the spot before it will quiet down. It makes people dream, in their most secret fantasies, about owning a telephone that can make, but not receive,

calls. Such a dream shows what omnipotence (divine or sexual) is about. Very powerful people in all societies (not only dictatorships) actually possess such telephones, incidentally. It's proof of the stupidity of any utopia that attempts social contact with the omnipotent being: a telephone net consisting entirely of apparatuses that can make but not receive calls cannot function. Or, without responsibility, there is no freedom.

From the caller's point of view, the telephone presents itself as a tool from which many wires extend, at the other ends of which countless people are waiting to be called. The tool permits the user to call all of these people one at a time but never two at the same time.

Such a structure permits anyone who has mastered it to demand individual answers to his call, whether this be an order, a cry of despair, or a question. From the standpoint of the receiver, then, the tool's purpose is to produce the dialogic communication it has instigated.

The wires behind the telephone, whether material or immaterial, open a parameter of choice. To be able to choose among the people one could call, the caller must have access to an index that gives a numerical sequence for these people. The index is stored in two places: in his brain and in the telephone book. That shows how archaic the telephone is: it would be more effective to have the numbers stored in the telephone itself (Minitel has, incidentally, recently attempted to do this). The numbering is a code without redundancy, that is, each of the digits that make up the number is meaningful, as is their order—dial a single digit incorrectly and you get the wrong connection. The telephone code is one of the nonredundant linear codes. Another is the banks' checking code. Calculation codes are not of this type, for their hierarchy introduces redundancy. For example, if you calculate in francs, the thousands in the left-hand side of the row of numbers must have very close attention, while the centimes in the right-hand column can be neglected. Within the communications revolution, there is a tendency to eliminate all redundancy, that is, to make all aspects of codes informative. There is another tendency to do just the opposite. If the first tendency continues to have the upper hand, if the society of the future is made up of numbers of equal value that are not interchangeable (and that is the brotherhood and equality cybernetics must have), then the telephone code, with all its errors and disappointment, is a more significant precursor of this society than the prisons and barracks

that are so often mentioned. Cybernetic society is numbered like a telephone, not like a prison, which is not necessarily a comforting thought. In large cities, there once were telephonic letters within the telephone code, and some apparatuses, like melancholy witnesses, retain evidence of it, for the alphabet has been eliminated from the code as incompatible with the calculation process. It shows that not only literature but also algebra, symbolic logic, in short, every alphabetic notation must yield to the code of calculation, for such notations are incapable of transmitting the information we need.

Before dialing the number, a piece of the apparatus must be taken off and held to the ear. In general, one then hears a codified sound that means a number can be dialed, although there is no general consensus with respect to this sound code: there are geographical variations in it. It also often happens that there are sounds that have no discernible meaning. In such cases, it is wise to begin again. The ensuing disappointment is not only that of a faulty omnipotence but also that of not knowing the solution to a puzzle. We don't understand what is happening in the telephone, and so it becomes a black box, with all the black magic that implies. But the occurrence has another, even more distressing dimension. The anthropomorphic character of sound codes is often stronger than that of visual codes. They are "voices." The sound heard in telephone acoustics is derisive, and the worst of it is that we are not dealing with an ontological error, for in fact this derision is the reification of another person, and static on the telephone line actually does turn flawed omnipotence into a fragment of shoddy installation in the telephone network.

Only when the right dial tone is heard does it become possible to choose a number, according to variations that depend on the automation level of the apparatus. If it is completely automatic, the selected number will be assembled from digits that form a line whose length reflects the distance between the caller and the recipient (which suggests the possibility of drawing land maps that are coded in lines and can be produced with calculations). In dialing, the series of digits is interrupted by whistling, whispering, and stuttering that surround the caller's ear. We are dealing with a sound code that regulates the rhythm of the choice of digits, and it is very rare not to have to understand it to be able to follow it. This opens a broad field for the study of the function of codes in a future

cybernetic society. When all is well (an eventuality inversely proportional to the length of the chosen number), a mechanically repeated sound is finally heard, a pulsing we interpret as the sound of the apparatus at the other end of the line.

In the process of choosing the digits, the more imperfect the automation, the sooner a human voice (usually female) will break into the code-cracking noises. At this point, it comes to a dialogue between the voice and the caller that has no parallels in human history or in the other media. The caller reads out numbers, begs, becomes angry, demeans himself, lies, whereas the voice repeats the numbers—the wrong numbers, often enough—mechanically and patiently, and, without warning, falls silent. Because its mechanical courtesy is so much more derisive, the human voice is far less human than the dial tone. The sole instance of such a dialogue outside the one on the telephone is the one between man and God in Kafka, although at the end of this incessant pleading, if all is well, one hears, at least on the telephone, sounds at the other end of the line: it shows that the telephone network functions better than Kafka's God.

At this point in our overview, we must change standpoints and take up the position of the recipient, for at this moment, mechanically repeated and idiotically insistent sound begins to pierce the life world of the recipient, sound he cannot escape, even if it is gentle, melodic, rather than shrill and metallic as usual. Of course, the effect of this interruption depends on the structure of the life world that is being pierced. It will differ depending on whether we are dealing with a bank or a hospital room, but the imperative of this idiotic call will always be categorical and so, once again, comparable to the divine call in Kafka. To grasp the effect of a call, couldn't the situations pierced by the sound of the telephone be divided into four types of waiting, of hope, in short, of faith?

In the first situation, a particular call is awaited with impatience, fear, or hope, and the mute telephone is at the center of the life world. The sound evokes a tension that in extreme cases can lead to real existential crisis if the caller is not the one who was expected or if there is a bad connection. In the second situation, the ring interrupts the concentration on an object or a person, and in this case, we are dealing with an intrusion of the public into the private space (i.e., with a break-in). In the third situation, the sound is aggressive, hitting a relaxed person, sleeping or listening to

music, like a knife in the stomach or heart, and so. In the fourth situation (in an office or a station), the ring is an organic part of the life world it pierces, and that is the only situation open to the call. Clearly the four classes of situation correspond to theological categories; there is nothing surprising about it: the call itself is such a category as well.

Dialogue on the telephone, following on such sounds, is therefore immersed in an existential climate rich in variation and dependent on the level of disappointment of the caller and the surprise of the recipient. But there is always a mutual recognition of this dialogic tension. The caller, for example, may be provocative and the recipient patient, but both partners compensate for this relationship "attacker–attacked"; that is, the attacker chooses the time for aggression (e.g., the time of the call, especially if there are geographical time differences involved) in consideration of the attacked—he puts himself in the other's place. In fact, this mutual recognition precedes the actual dialogue. It is demanded by the structure of telephoning, and without it, dialogue is impossible.

Dialogues begin with such ritual words as "hello," "who is there?" that is, with telephone-specific words, but pass quickly over to extratelephonic language. This raises not only the problem of so-called linguistic levels but also the new problem of the mechanization of speaking. The voice that speaks these words is not only a human voice but also recognizable to the listener as an individual. So he can answer on a first-name basis, but there is equally a specific telephone quality that arises from the telephone itself, not from the other person. An effort must be made to identify the medium with the other person (as one identifies him with his own rib cage) so that the telephone dialogue can become an intersubjective relationship. Despite such efforts, however, the dialogue remains existentially inadequate for the time being. Communication theoretical analyses give the impression that this is a result of the telephone's narrow linear sound code. So one might suppose that if the telephone network were opened up to richer codes, for example, to two-dimensional visuals, as in the case of dialogical TV (the original intention of TV, as the concept "tele-vision" suggests), or if video were used dialogically, the problem of low existential satisfaction would be resolved. Far from it. Telephone codes' poverty certainly figures in the medium's limitations, but there are deeper reasons for the lack of satisfaction.

Each medium has its own dialectic with respect to communication: it connects and separates those who communicate through the medium. This dialectic is, by the way, the exact meaning of the concept "medium," yet there are media whose presence is forgotten in the communicative process (the so-called face-to-face media). In a dialogue around a table, for example, the presence of the table is forgotten and, beyond this, the presence of air, through which one speaks. One gets the impression—always wrong—of unmediated communication, even when the bodies don't move. The impression is always false because there is no unmediated communication (except in mystical union, which resists all analysis), yet despite being false, this impression renders the communication satisfying. The telephone is a medium whose presence will not be forgotten in the foreseeable future. The issue is not a technical one: the TV is far more technical, and its presence is nevertheless forgotten, making the TV's discourse, regrettably, satisfying. The dialogue in the telephone network could only be satisfying if it were possible to make the medium existentially invisible. That is not only a technical challenge but also, in the actual sense of the term, a political one.

Nevertheless, the poverty of the telephone code is a key factor. This lies not only in its limitation to linear codes but also in a reduction of the acoustic coloration that lends linguistic symbols most of their connotative force. Semantic analysis can show that the telephone, as a medium, is restricted to announcements of lived experience. We are not concerned here with a medium that would be appropriate to what is called "art," for example. Still, with so few dialogic media available, the telephone is quite often forced to transmit inappropriate messages. Independent people (e.g., youth and women) commit this error, and that is one of the explanations—perhaps the saddest[1] one—for the overburdening of the telephone networks.

The technical structure of the telephone networks permits a gesture no other dialogic medium permits: it is possible to silence the other by hanging up the receiver. The brutality of this gesture is all the more effective in that it is new and so not fully exploited. And there are certainly other typical telephone symbols whose meaning cannot be translated and cannot yet be fully grasped. Think, for example, of the tapes that answer on behalf of an absent recipient and open a whole parameter for

dialogue of a nontraditional type. From the telephone, we are learning to substitute telepresence for face-to-face presence. There is pedagogical significance in the telephone as a means of teaching telepresence and in the prefix *tele-* in *telephone*.

The description of the telephone suggested here does not claim to be exhaustive. It is to be understood, conversely, as a recommended point of departure for the analysis not only of the telephone but also of dialogic media in general. The following should be kept in mind: the description contains all the elements that mark a bivalent dialogue (the call, the response, the recognition of the other and of oneself in the other). And all the elements that mark a circular dialogue are there as well (the announcement, the exchange, the search for new information). This description of the telephone, that is, permits us to think out future dialogic media that would sustain a utopian political life.

But the description also confirms that it is technically possible to build the telephone network into existing broadcast networks. It allows us to imagine that, in the future, we will enter into dialogue with one another only through such centralized structures. In television, for example, steps have already been taken in this direction. So there are two possible diagnoses: either the telephone network will serve as a model of a network that keeps branching out, for example, for reversible video networks and computer terminals, and in this case, we are moving toward a telematic society of self-recognition and the acknowledgment of others; or the second alternative is a centrally controlled and programmed mass society. Although current signs point toward the second alternative, it is too repugnant to face squarely. In such an apparently harmless tool as the telephone, both possibilities are visible. Which one will become reality depends in part on us.

The Gesture of Video

According to the hypothesis under examination here, the observation of gestures allows us to "decipher" the way we exist in the world. One of the implications of this hypothesis is that modifications we can observe in our gestures allow us to "read" the existential changes we are currently undergoing. Another implication is that whenever gestures appear that have never been seen before, we have the key to decoding a new form of existence. The gesture involved in manipulating a video camera represents in part a change to a traditional gesture. According to the hypothesis just presented, then, one way of deciphering our current existential crisis is to observe this gesture.

"Video" is a relatively new tool. A "tool" is an object produced to serve a particular purpose. It is "good for something." Such a tool reveals its purpose in its form. But it does not stop being an object, that is, a problem. "Problem" is the Greek word for the Latin *obiectum*. So it is possible to ignore the tool's informing purpose and ask, "What is it, and what can be done with it?" With traditional, familiar tools, this "problematic" aspect is obscured by familiarity. A bed no longer raises any such questions. We know what it is and what it's for. It is a place on which to sleep, under which to store suitcases, and in which to hide money. But if the tool is new, its problematic side shows. This is the reason new tools are so fascinating.

There is a double attraction about new tools. They are immediately fascinating because the purpose that gave them form has not yet played itself out. We don't yet know all the virtualities inherent in artificial satellites, laser beams, or computers. They are "dangerous." We are further

fascinated because the formative intention can still be deflected in a different direction. Tools are imperatives that shape our behavior. The bed says, "Lie down!" The purposes of the tools that surround us are not necessarily our own. They are the purposes of those who made the tools. To change their direction means to be free. The new tools are fascinating because they, more than anything else, conceal unknown virtualities within themselves and because they permit acts of emancipation.

The purpose of video is to serve TV. Those responsible for the decision to produce it had exactly this intention. It is a tool for developing a program that is to be broadcast, for assembling and censoring it. Video removes the surprises of live broadcast. It is a tool that serves the purposes of the TV system, which in turn is a constituent part of the cultural system that defines us.

Videotape is a memory. It stores scenes on a linear surface. So it has three dimensions: the two of the surface and the dimension of the rolling tape. It reduces four-dimensional space-time to three dimensions. In this respect, it is still comparable to sculpture, for example. But the three dimensions to which it reduces scenes are structured differently. There is a further, ontological difference: sculpture depicts scenes; videotape plays them back. Videotape belongs to a different level of reality from sculpture: its dimensions are set up differently, and it is related in a different way to the scene it stores.

Videotape is like a filmstrip. But film is made up of photographs. Its temporal dimension depends on an optical illusion. With videotape, conversely, playback and scene overlap. It, too, involves tricking the eye, but the tricks have other possibilities for manipulation that lie closer to the threshold of the scene's reality.

The tape is a linear code like the alphabet. To receive its message, one must follow its line. But with tape, the line rolls along, and with the alphabet, it doesn't move at all. Reading a tape is more passive than reading the alphabet, where eyes move. Because the tape is not one-dimensional, but three-dimensional, reading it is more complex than reading the alphabet.

The gesture of videoing resembles the gesture of photographing. But here, too, there are differences. The photographer is required to choose a position. He must decide from what point the scenes are to be stored on the surface. He feels obliged to make clear, firm, and final decisions to

transform the scene into photographs, which is to say objects, of which he is the subject.

The video maker, too, stands in front of the monitor as if before the scene about which he is making decisions. It follows that his decisions will not need to be so objectifying as those of the photographer. They can be made in relation to the scene as well as within the scene. A photographer needs to be "objective"; a video maker can be intersubjective, but must, in any case, be phenomenological.

That brings us back to the comparison with film. Unlike film, videotape can be "read" by the participants in the stored scene immediately after recording. Within the scene, they need not be actors only, as is the case for film. They are subjects and objects at the same time, those who store and those who are stored. The tape opens a dialogue between itself and the scene, whereas the film is a discourse about the scene and forbids any immediate dialogue. Videotape is a dialogical memory.

At first glance, the monitor seems to be a mirror, but many differences can be established between it and a "classical" mirror. The monitor emits sounds. It does not reverse right and left and so is in this sense exactly the opposite of a mirror. It does not reflect the light coming from the scene but has its own cathode luminescence. It presents a completely different image from that of the classical mirror, new in such a way as to be revolutionary. For in its sound, angle of reflection, light, it reverses all our traditional concepts of a reflected, speculative reality. It puts the person watching the monitor in a space for which there are no coordinates. He loses orientation.

Like a mirror, a monitor is a glass surface, but in turning the mirror around, it is more like a window. In this respect, it is like TV, as distinct from the back of a painting or a film, which is a wall. With respect to its origins, the projection of slides and of film is a further development from painting, with its beginnings on the cave walls of Lascaux and Altamira. The monitor, like TV, is a further development of the reflective and transparent surfaces whose origins lie in the surface of water, watched by "primitive" people. Video and film occupy different branches of the tree of image genealogy. In comparing them, we are able to see it, setting video and TV free from the control exerted by the model of film.

Genealogically, film can be traced to the line fresco–painting–

photography; video can be traced back to the line water surface–magnifying glass–microscope–telescope. In its origin, film is an artistic tool: it depicts; video, conversely, is an epistemological tool: it presents, speculates, and philosophizes. The contrast is not necessarily functional. Film can present (e.g., in documentary), and video can represent (e.g., in video art). Nevertheless, the origin of the tool "video" gives the impression of a whole series of epistemological virtualities that have not yet unfolded.

A video maker manipulates the linearity of time. He can synchronize diachronic time. Any tape can be used again to synchronize varying temporal segments on the same surface. So it is about a composition comparable to that of a musician. But there is a difference. The musician synchronizes the diachronic time of sounds: he forms chords. Such a synchronization of sound can be called a *symphony*. The video maker synchronizes scenes: he superimposes them. Such a synchronization of scenes can be called a *symsceny*. The video maker moves toward the work along a sequence of events, whereas the musician moves along a sequence of sounds. The raw material of the video makes history in the strict sense: a sequence of scenes. Not only does it happen in history but it also affects history. In this sense, it is a posthistorical gesture. It aims not only to commemorate the event (a historical engagement) but also to compose alternative events (posthistorical engagement).

This is exactly the reason video, as a tool, fascinates us. It permits us to discover potentialities unknown either to those who invented it or to those who paid for its production. And it permits us to steer its development in another direction. Of course, video may engage the same gestures that were foreseen when the intention was modeled. In this case, analysis will show that we are under the control of the power behind the apparatus. Behind the gestures of the video maker working in and for the system, we will be able to discover the ways and means the system has of programming us.

But video can also be manipulated with gestures borrowed from other media, for example, gestures from films, texts, musical compositions, sculpture, or philosophical speculation. They will have a new quality, however. This new quality will come from the dialogic structure of video. To put it briefly, we will be dealing with a gesture that no longer attempts to produce a work whose subject is the maker but rather with one that

attempts instead to produce an event in which the maker participates, even if he is controlling it.

To summarize, we are dealing with a gesture whose coming can be read as a new way of being-in-the-world. It is about a way of being that challenges traditional categories (e.g., those of art, historical action, and objectivity) and proposes new categories that aren't yet clear enough to analyze. To understand these new categories, we must start analyzing gestures, such as the gesture of videoing that was just lightly sketched here. Perhaps a name such as *dialogic speculation* would apply to this understanding, forming a great arc to Plato: it raises a suspicion that if the ancients had reflected in video rather than in words, we would have video archives rather than libraries, and videotic rather than logic. But these are anachronisms.

The Gesture of Searching

Our gestures are changing. We are in crisis. The following essay, which also serves as the last chapter of our attempt at a phenomenology of gestures, will claim that our crisis is basically a crisis in knowledge,[1] a crisis in our "gesture of searching." Visual evidence does not support this thesis. On the contrary, it appears that the gestures of researchers in laboratories, in libraries, in classrooms, are more or less the same as they were a hundred years ago, although other gestures, such as those of dancing, sitting down, or eating, are structured differently. The thesis presented here claims that all our gestures (our actions and thoughts) are structured as scientific research and that if our gestures are changing, it is because the gesture of searching is about to change.

It is obvious that technologies initiated through scientific research (i.e., the results of research, the positive discoveries) penetrate deeply into our way of life and our gestures. The technical manipulation of things in our environment (under way for the last two hundred years), like the technical manipulation of people and society (just beginning), seems to have been the cause of a thoroughgoing transformation of gestures since the Industrial Revolution. Still, gestures of technology are not really the models for all our gestures. For they themselves are modeled on the gesture of "pure" research. The gesture of searching, in which one does not know in advance what one is looking for, this testing gesture known as "scientific method," is the paradigm of all our gestures. It now holds the dominant position that religious ritual gesture did in the Middle Ages. At that time, every gesture—in art and politics as in economics and science— was shaped by religious ritual gesture. Every act (but also every thought,

147

desire, passive experience) was steeped in a religious atmosphere, in the structure of the religious gesture. At present, every gesture, including every ritual one, is shaped by the structure of scientific research. So much for the thesis of this essay.

Scientific research took up this central position without really trying, so to speak. There was never a struggle between rites and research (between religion and science) for the power to monopolize the modeling of gestures. Little by little, in the course of the sixteenth and seventeenth centuries, ritual gesture was simply abandoned, and the gesture of searching established itself in the empty place left behind. Actually the gesture of searching can't be the model for other gestures. It is not a search for anything that has gone missing. It searches for who knows what. It has no goal, no "value." It can't be an "authority." And yet it has become one. The position scientific research holds in our society is in conflict with research itself.

The gesture of searching is the gesture of the revolutionary bourgeois. The bourgeois works with his hands: he engages inanimate objects. He tries to do something with them. He does not consort with plants and animals; that's what farmers do. Nor does he manipulate people: that's what nobility and clergy do. The "practical" knowledge of the bourgeois is confined to inanimate objects. That is why modern research begins with astronomy and mechanics, disciplines that try to understand the movement of inanimate objects. That's obvious and yet surprising. For from an existential standpoint, these movements are not very interesting. The bourgeois revolution, which marks the origin of scientific research, is a revolution of interest.

Medieval interests were directed toward the life and death of human beings: toward the "soul." Augustine said, "Deum atque animam cognoscere cupisco. Nihil—nec plus? Nihil." (I wish to know God and the soul. Nothing more? Nothing.) This was the dominant interest for millennia. The structure of interests that controls the revolutionary bourgeois is different. He wishes to know "nature." Which nature? Neither the Judeo-Christian creation nor the Greek *physis*. Neither the "Holy Work" in which His will is revealed nor that of a cosmic organism in which each thing finds its place according to its fate. The research field of the revolutionary bourgeois is inanimate movements.

A field of little interest, then. What is being sought? Of course one can say that the search was for ways to manufacture tools and machines to subordinate inanimate objects to our will. That would be of interest because it would allow us to work less and to consume more. But to say it is to commit an anachronism. The revolutionary bourgeois did not set out to produce the Industrial Revolution. Those were conditions that arose, unexpectedly, two centuries later. His research was "pure" and disinterested. He turned his back on the interesting problems, leaving joy and suffering, injustice and war, love and hate, to such extrascientific disciplines as religion, politics, and the arts.

To turn away from problems that interest people so as to be involved with uninteresting objects is the "humanistic" gesture. For objects that are not interesting (with which human beings do not "engage") remain "at a distance." They are just objects, and a human being is their subject. He is in the realm of "transcendence" with respect to such available objects. So he can know them "objectively." Compared to things like stones and stars, a human being is like a god. Compared to things like cathedrals, diseases, and wars, he is not, for he is involved in these things: they have interest. "Objective" knowledge is the goal of humanism. In this knowledge, human beings take up the position of God. That is the "humanistic" gesture as well as the gesture of the bourgeois researcher.

But that is not the whole gesture. The movements of inanimate objects can be described mathematically; interesting problems cannot be to the same extent. To make mathematical—that is an old, and not a bourgeois, ideal. It was initially bound up with music making, magic, and conjuring. Mathematical expression was originally the gesture of playing lyres and flutes. Yet this gesture has changed. It has become a gesture of reading. For Islam, nature is a book written by God, and it is written in numbers (the Arabic *maktub* means "script" and "fate"). With the help of God, a human being can read it. Behind the confused numbers of nature, he will find a simple algorithm. The revolutionary bourgeois searches for the mathematical order behind the movements of inanimate objects in exactly such an "Islamic" form. His gesture of searching is also the gesture of deciphering. And it is this very aspect that has made his research "exact."

Let us summarize: the revolutionary bourgeoisie imposed its gesture

(the engagement with inanimate objects) on our society at some point in the course of the sixteenth century. In this way, it became the gesture of so-called pure research. In this way, a new sort of "nature" was discovered. And this nature permitted the search for an objective and exact knowledge. Human beings became the transcendent subjects of this nature. The gesture of the transcendent subject is the gesture of the natural sciences, and it has become the model for all our gestures. But this gesture is about to change. "Crisis."

The only surprising thing about it is that this crisis has come so late. For bourgeois nature has spread out and become more and more interesting. In the course of modernity, and roughly in this order, it has incorporated animate beings, the human mind, and society (biology, psychology, and sociology). Interesting things, that is. And it has become painfully obvious that this expansion of "nature" raises new questions about the gesture of "pure" research. Knowledge gained in biology, psychology, sociology, and economics (as well as in the so-called humanities) has shown itself to be neither very "objective" nor very "exact." The "pure" gesture of searching appears inadequate for dealing with such things. That became clear in a painful manner at least two centuries ago. Still, there was no crisis at that time, for the Industrial Revolution got in the way. This revolution proved how well the "pure" gesture of searching suited inanimate objects. But the Industrial Revolution is now digested, and the crisis of "pure" research is upon us. It threatens to be even more dangerous for being late.

It has now become obvious that objectivity and precision are "ideals" (of bourgeois ideology), that there are no such things as "pure intellect" or "absolute knowledge." That scientific research cannot be what the will of the bourgeoisie would have it be: the gesture of a transcendent intellect. And that it cannot end in the technical manipulation of an objective nature from the outside, as the bourgeois ideal would have it. Today, one notices to what mode of being science is condemned: it is the gesture of someone immersed in the world and interested in changing it to suit his needs, desires, and dreams. The crisis in the gesture of searching consists in being forced to notice it.

The gesture of searching for objective and exact knowledge is about to become impossible. Yet, just now, another type of gesture of searching is emerging.

A perceiving subject searches for objective understanding of a perceptible object by means of a gesture of adequation. This presumes that subject and object are separate entities that encounter one another in the course of the gesture. Scientific research is not "free of assumptions": this separation is its assumption, one whose difficulties have, it is true, been acknowledged at least since Descartes. No one understands how "understanding" becomes an equivalent for the thing it understands, or how a "thinker" can be equivalent to the thing thought about, and Descartes spoke of having recourse to God ("concursus Dei"). But acknowledgment of such basic problems did not inhibit researchers for centuries to come from eagerly pursuing the ideal of objectivity. Now the problem has become intractable.

At present, the gesture of searching is providing increasingly compelling evidence that subject and object are always interwoven. A subject is always the subject of some sort of object, and an object is always the object of some sort of subject; there is neither subject without object nor object without subject. This is not the perception of a subject encountering an object. It is an actual relationship from which subjective and objective poles can be abstracted. Subject and object are abstract extrapolations of a concrete relation. The "transcendental mind" and "objectively given world" are ideological concepts extrapolated from actual reality—reality we are and in which we are.

The gesture of searching itself shows it. In physics, it shows the extent to which the gesture of searching produces, defines, and changes the object under consideration. In psychology, it shows how forcefully the object under consideration produces, defines, and changes the researcher's gesture. And it shows this even more in sociology, economics, linguistics and related disciplines. There is neither an object that searching has not first turned into an object nor a subject that is not in search of something. To be an object means to be sought, and to be a subject means to search. The ideological concept of objectivity, whether "idealistic" or "realistic," obscures our access to the gesture of searching. It needs to be taken out of such contexts. Yet this will change the gesture's structure.

The bourgeois researcher approaches his object "without prejudice." He does not "evaluate." What a fine contradiction! The value of the "pure" researcher consists in permitting no values. This contradiction was always

recognized yet never kept researchers from searching for purity. Now, it does. For then, the gesture itself showed that it was a human act, the act of a living being immersed in the fullness of reality. No one can search without also wishing and suffering, without having "values." Perception is among other things passion, and passion is a form of perception. All of it happens in the fullness of human life, in its "being in the world." The gesture of a "pure," ethically neutral attitude is a fraudulent gesture. It is inhuman, an estrangement, a madness.

With the perception of inanimate objects, this estrangement is only epistemological. In such cases, it is just an error. But when it comes to other things (diseases, wars, injustices), this estrangement becomes criminal. The researcher who approaches society as if it were an ant colony, the technocrat who manipulates the economy as if it were a chess game, is a criminal. He maintains that, through objective perception, he rises above ideologies. He is in fact a victim of the ideology of objectivity. Technocracy is the form of government of bourgeois ideologues who would turn society into a mass that can be manipulated (into an inanimate object).

Technocracy is dangerous because it works. Society does in fact become an object if it is regarded from an ethically neutral position. It becomes an objectively perceptible and alterable apparatus, a human being an objectively perceptible and alterable functionary. Through statistics, five-year plans, growth curves, and futurology, society does in fact become an ant colony. But that is mad. So a society is not a society that interests us, a human being is not one that lives in the world with us. These days we can observe this madness at work. And we know that it is the result of "pure" research. The gesture of searching itself now shows that objectivity is criminal. The secret is out. Even this cannot in itself change the structure of this gesture, however. For by its very nature, it assimilates subject to object. It proceeds as though the object wanted to be grasped by the subject and the subject were in a position to grasp the object. The gesture consists of two strategies, that is, one "objective" and another "subjective."

From the subject's side, the strategy consists in avoiding value judgments and being programmed in advance in mathematics and logic. In this way, a thoroughly peculiar, suspicious subject arises, the "researcher." In literature, he appears as Frankenstein; in laboratories, as a scholar; and in history, as the case of Oppenheimer. From the object's side, the

strategy consists of separating a phenomenon from its concrete context by means of a definition, turning it into an object. This transformation of a phenomenon into an object is an operation performed in material and mental laboratories. So the song of a bird becomes an acoustic vibration, and pain becomes a dysfunction of the organism. Once the subject and object of research have been established in this way, the process of adequation begins. Here is a superficial description of the next gesture.

The researcher must first undergo a catharsis. He puts it out of his mind that someone is paying for this research, that he must either publish it or be ruined (publish or perish), that he will become famous if he discovers something, that his discovery could turn out to be good or bad for society, along with any other value-laden considerations. In this way, he achieves a clear conscience. Then he commits to memory logical and mathematical structures, along with certain propositions about previous scientific research. Then he approaches an object that has already been prepared for the purpose and tries to find out whether this object can be reconciled with the stored structures and propositions. He tries not to do violence to the object through his gesture; he allows the object to say yes or no to the suggested structures and propositions. This phase of the research is called "observation." If the object says yes, the structures and the proposition can be "confirmed by observation," and the object will be considered "explained." But real research begins only if the object says no. The researcher retracts one of the stored propositions and suggests another. The withdrawn proposition becomes a "hypothesis falsified by observation" and the newly proposed one an "operative hypothesis." This phase of the research is called "methodological doubt," and a sequence of propositions of this type is called "scientific progress."

The operative hypothesis (working hypothesis) is a research tool that can be applied many times. It can even serve to decontextualize phenomena that have not yet been prepared for research. Such phenomena are said to be "discovered objects." For this is the only way some objects, such as stars, biological species, or nuclear particles, could have been discovered, with the help of operative hypotheses. This is why the world of scientific research is always expanding. The expansion requires in turn that research branch out. That is then called the "progressive specialization" of scientific research.

Operative hypotheses generally have the logical and mathematical structure stored in the researcher's memory. So they can be divided into groups to see whether they are coherent. This phase of research is called "theory." The coherent groups of hypotheses, that is, the theories, are explanations of additional areas of the objective world. They have the advantage of being broadly conceived. But if even just one of their hypotheses is falsified by observations, the entire theory must be thrown out. This phase of research, which tries to undermine theories, is called "basic research." Falsified theories can be replaced with others that work "better," in the sense of being simpler and more comprehensive than the falsified ones. That is the famous "paradigm shift."

The gesture of searching, described only superficially here, has always been accompanied by a chorus of critical objections (through the philosophy of science). This chorus asks questions. What is the "truth" of scientific propositions, and is that a scientific or a philosophical question? Are theories more or less true than hypotheses? Is the logical and mathematical structure of propositions determined by the preprogramming of the subject or by the structure of the physical world, or how are these things related otherwise? These questions, and others of the same type, have never had a satisfactory answer. For they were not good questions, as is becoming clear now. All of them assume the separation of subject and object, as does the gesture itself. Yet it didn't matter that there was no answer. Technology was functioning, and that was an irrefutable pragmatic argument. Today our questions about the gesture of searching run in a different direction. How would the "pure" researcher, this suspicious subject, this Frankenstein, this specialist, be able to grasp reality at all? Aren't his propositions always just ideological abstractions? And is this context of objects of which the researcher speaks, separated from concrete reality, actually the world we know and wish to change? Is it not a fantastic, unimaginable world? Rather than finding something, hasn't the researcher lost everything? Is the whole of "progress" not madness?

It would seem that the pragmatic argument remains in force all the while, that technology functions superbly with inanimate objects. There is nothing surprising about it. For we do more or less transcend what is relevant to such objects. And this technology does function, for example, road bridges hold together more or less as intended. But with other things,

technology functions wonderfully only when the things have first been rendered inanimate. If dental bridges function as well as road bridges, for example, it is because the dentist treats the patient as inanimate material. It is in fact surprising that to have such a bridge, one is turned into an inanimate object. It may be that people are prepared to turn into inanimate objects for the sake of a well-built dental bridge. But it is not unconditionally desirable. And the pragmatic argument for technology begins to wobble.

We have lost our faith in this argument and in technology. Of course we have no doubt that the tangible world can be manipulated further through technology. But we believe that this world has its limits. There is no doubt that more and more ingenious technical frivolities can be contrived. The human body can be objectified and then controlled. The economy can be manipulated. The human mind can be programmed and so manipulated. Perhaps human beings can be fabricated. But there are two concerns. The first is whether this progressive objectification is not accelerating the loss of concrete reality. The second is whether this progressive objectification is interesting. These are existential doubts.

The gesture of searching raises epistemological, ethical, and existential doubts. It is false, criminal, and not very interesting. It must be changed, and with it all our gestures. For it is the model for all our gestures. We find ourselves in crisis.

The foundation of the gesture of searching was the difference between subject and object, human being and world, I and it. We are about to abandon this foundation. This ontological revolution has epistemological, ethical, and aesthetic consequences. All our gestures are changing. For we no longer understand the world as an object of manipulation or human beings as subjects that manipulate. We begin to grasp the world as our environment, in which and with which we engage, and that engages with us, and we are beginning to see human beings, including their manipulation of objects, as a pantomime of the environment itself. We no longer believe that we make gestures but that we are gestures. This ontological revolution, which bourgeois (humanist) cosmology and anthropology dismissed through false problems of "idealism" and "realism," appears as a change in our gestures and, above all, as a change in the gesture of searching.

Research does not proceed from a hypothesis on one side and an observation on the other but from a concrete, full, living experience of being-in-the-world. It has nothing to do with empiricism in the seventeenth-century sense. It is rather an "aesthetic" starting point, if we translate *aistheton* with "experience" and *aisthesthai* with "to live through." Exactly like art, science, too, is a gesticulation, and that is to say a fraud, and with that the whole healthy middle-class distinction between the two collapses. But lived experience is not only aesthetic in the narrow sense of the term. It is also pleasure and suffering, and it creates values. The researcher who starts from such experience is trying to reach a value: freedom. He is trying to go beyond his limits. In this way, he does away with the ominous bourgeois distinctions between science, technology, and politics. For politics is concerned with freedom. The researcher ceases to be a "pure" subject to become a living person, that is, someone who lives epistemologically, ethically, and aesthetically all at once. So research changes its structure and alters the meaning of the concept "science." It is basically a revolution in interest.

Suddenly it becomes clear that the researcher is embedded in an environment that interests (matters to) him, both at close range and at a distance. There are aspects of the environment that interest him intensely and others that hardly touch him. The more an aspect of the environment interests the researcher, the more "real" it is for him. This intensity of interest, this "proximity," becomes a measure of how real it is. And from this mass, the structure, the "mathesis" of his research arises spontaneously, providing a map for orientation.

The researcher is located at the center of his environment. It doesn't matter where—wherever he is, that is the center. Many things are happening around him, some of them of great concern to him. They press themselves on him, and he throws himself toward them, projects himself against them. Toward the horizon, the mass of events becomes sparser and less interesting. Nevertheless, the mass comes nearer, and the researcher moves toward the horizon. The dimension of "proximity" is therefore dynamic. Its dynamic is that of human life. In this dynamic structure, that is to say, in his life, the researcher seeks his way in the direction of his horizon.

As a result, the concept "theory" changes its meaning in a revolutionary

way. For the ancients, "theory" was a contemplative examination of eternal forms. For the bourgeois, it was a group of coherent hypotheses. In the present, theory is becoming a strategy for being-alive-in-the-world. The contemporary researcher, the contemporary theoretician, measures the nearness of the environment, but neither to observe its form nor to hypothetically explain it. It is rather to transform the approaching possibilities into freedom. Even in its theoretical aspect, the gesture of searching is once again becoming a gesture of living.

Proximity is a dimension completely different from the "centimeters per second" measurement of bourgeois research. It does not measure intervals between objects. The "centimeters per second" that separate me from the dentist for whom I am waiting are not those that separate me from my son who expects to meet me. Proximity is certainly related to "centimeters per second," but the first makes the second existentially relevant. Proximity measures my hope, my fear, my plans. It measures my beckoning to the distance, which is to say, that which is meant by the prefix *tele-*.

But this proximity is by no means "subjective." The contemporary researcher is no solipsistic subject wanting to rise above the world. Others are always in the world with him. They, too, measure their environments by proximity. And inasmuch as these environments are bound to mine, these various measurements, too, mutually affect one another. We measure together. So research becomes dialogic. Proximity is an intersubjective dimension. It measures the being I share with others in the world. I encounter others spontaneously in the course of researching my environment. They are more or less close to me, more or less interesting. I must apply the measure of proximity to others. But if I meet them, we can then measure together. So the gesture of searching once again becomes a gesture in search of others.

That lends research a "progressive" character, completely different from bourgeois "progress." Bourgeois research is a discourse whose utopian goal lies in an increasingly objective perception of the world. At present, research is turning into a dialogue whose utopian goal is an increasingly intersubjective perception of our living conditions. The utopian result of bourgeois research is a technology that manipulates the whole objective world. At present, the utopian result of research consists of the optimal

transformation of living conditions to bring possibilities closer: telematics. So there is no linear progress for this kind of research. Progress is rather the approach to one another with the purpose of gathering shared possibilities.

That demands a change of models as well. For bourgeois research, time was modeled as a river, flowing from the past through an imaginary point called the "present" into the future. And the model of space was an empty box, its center fixed by convention and its axes lost in infinity. Today we are forced to develop an entirely different model for the environment. We can no longer accept a division between time and space. The center of our model is the present, and the present is here and now, where we are. Events press in from all sides toward the present, and so all sides are the future. But all sides are equally the space of events. Present and future therefore represent space-time concepts. As for the past, it is no longer a temporal dimension on the same level as present and future. In our model, the past is an aspect of the present that may be accessible in the form of remembering or hidden in the form of forgetting. Remembering and forgetting are space-time concepts as well.

We can see that the new model, coming from a change in the gesture of searching, refers back to the gesture itself. This becomes clear in the context of historical research. We can no longer reconcile historical events with the bourgeois arithmetic scale of measurement. That is a scale divided into years, centuries, and geological epochs, whose degree zero is lost in the void of the past and which ends in the present. We need to set up a logarithmic scale for historical events whose degree zero is in the present and whose divisions become finer and more indistinct the closer they get to the void of remembering and forgetting. This means that we can no longer explain the present through the past, for the present is our starting point. For us, the present no longer opens onto the past; it opens toward the future. For us, the direction of the flow of events no longer passes from the past to the future but from the future toward the present. It means that our gesture of searching is no longer directed downward in the bourgeois sense. It is not digging.

Of course, the change in the model changes the gesture of searching in all its parameters, the physical as well as the psychological, the sociological as well as the economic. But the most revolutionary aspect of this change becomes apparent in the gesture's historical parameter. We can no longer

project the past into the future using developmental curves, statistics, and futurological predictions. In our model, the flow of time runs against this kind of projection. We no longer project the past into the future; rather, we project ourselves. That is what best characterizes the new structure of the gesture of searching: it is a projection of itself into a future pressing in from all sides, a projection of scenarios into the future. So the gesture of searching has become human: as if with the long arms of apes, we swing wide again, drawing consequences from the inconsequential.

Our gestures are about to change. That is to say that our way of being is about to be transformed. We are facing a slow and painful crisis. Many of our gestures still have the traditional structure. Others are surprising and so sometimes repulsive. The new is always monstrous. We find it difficult to orient ourselves amid this diversity of old and new gestures. For it is not just among others that they can be observed; we ourselves gesture in this contradictory way. Our crisis is not just on the outside. In the strict sense of the word, it is ours.

But an orientation is possible. For the gesture of searching is the model for all our gestures. In keeping with the thesis presented here, the painful and complex transformation in this gesture underpins alternations in all our other gestures. The transformation can be observed in all areas of research, in physics as well as in biology, in the economy as well as in archaeology. It basically concerns not so much a methodological as an ontological revolution. A different formulation may be preferable: it concerns a new faith that struggles to arise. That is why our gestures are changing; our reality is in transformation. We no longer believe that the objective world is reality, and that it is the antithesis of the human mind. We are starting to believe that reality is the fact that we exist with others in the world. But isn't this belief in the other a new form of the old Judeo-Christian and even "humanist" and Marxist belief? Of course. But that is not what is interesting. What is interesting is the concern with a new form. That the new form is in fact what is interesting can be observed by watching how the gesture of searching is currently changing, from digging down for reasons to reaching out broadly for attractive possibilities.

Appendix

Toward a General Theory of Gestures

Motif

A general theory of gestures would be a means of orienting ourselves in the circumstances in which we find ourselves with respect to things and people. It would be an "interface" theory, because it would draw diverse disciplines together, especially the various anthropologies, psychology, neurophysiology, and communication theory. So it would be a theory running across the branches of the tree of science and would above all bridge the gap between the natural and human sciences. This would be apparent not only from its methodology but also in its rejection of any claim to being "value-free." That is, it would be aware of its instrumental character and would, even as it employed the methods of the so-called exact sciences, be engaged in effecting change in human beings. As an "interface" theory, it would break through the structures of the sciences as they have been elaborated and are currently institutionalized in universities and elsewhere. In this sense, it would have an antiacademic character. But it would also have an anti-ideological character, because although it would be interested in people and events, it would proceed with a minimum of assumptions. These aspects of the theory, namely, its interdisciplinary, antiacademic, and anti-ideological qualities, will presumably characterize a whole range of future theories. Accordingly, it would be a project pointing beyond the current crisis in the sciences. The impetus must come from communication theory, because the communicative aspect of a gesture overshadows all else. Yet it would not be a special area within communication theory. On the contrary, it would be a general theory, and communication theory would be concerned with one specialized aspect of gestures, namely, the communicative. So communication theory would not be concerned with

the phenomenon of gesture among other phenomena. Rather, it would be subsumed under the general theory of gesture. Communication theory, which is currently wedged into the structure of the sciences like a foreign body, would then find its "organic" place in a restructured science.

Defining Competencies

Gesture can be seen as a kind of movement. For this purpose, movements can be classified as (1) those which can be adequately explained through an understanding of the effects of external forces on the moving bodies; (2) those which require an understanding of the effect of forces within the moving body to be adequately explained; and (3) those that can be explained as in class 2, but for which such an explanation is unsatisfying. An example of class 1 would be an object in free fall; of class 2, the swimming movements of an amoeba; of class 3, the movement of the hand in writing. A partial overlap in categories would not be important to such a classification. Because the criterion of classification is epistemological, it would depend only on the way the movement is recognized. Movements of class (3) would be called "gestures" and taken to form the field of competence for a general theory of gestures.

What separates gestures defined in this way from other movements is their epistemological overdetermination. They can be explained too well, to put it paradoxically. When I lift my arm, I can explain the movement perfectly well as the result of a force vector affecting the arm from the outside. This thesis leaves nothing unexplained. But strangely, a mechanical explanation misses the core of the movement, leaving the observer dissatisfied (unless an eighteenth-century type of mechanical explanation is specifically being sought). Such dissatisfaction with this kind of "full explanation" arises because many inner forces have taken part in the movement and have not been acknowledged. I can give a "better" explanation of the arm movement if I take such vectors into account. It will become clear in the process that these vectors come from diverse ontological fields. The arm movement involves physiological, psychological, cultural, economic, and other factors in equal measure, for example. The arm movement can then be explained as typically "human" or "neurotic," or "Brazilian" or "bourgeois." The arm movement can be fully explained at any of these

levels. It is an entirely physiological, psychological, and so on, phenomenon. Yet any of these kinds of explanation leaves a residual dissatisfaction (unless one indulges in vitalism, psychologism, culturalism, economism, or similar ideologies) because they all bypass the heart of the phenomenon. Nor can the dissatisfaction be resolved through a combination of various or even of all explanations. Such a combination does make the explanation more complete (although it is, strangely, already complete at each independent level) but does no better at addressing the arm movement.

This dissatisfaction arises from my knowledge that I lifted my arm because I wanted to. Of course, I also know that my arm movement was determined, in fact, overdetermined, as the various explanations show. But this second knowledge does not extinguish the first one; in fact, it doesn't even touch it. Of course, I can speculate about this dialectic of consciousness, and so explain it, too. For example, I can say that my freedom is an effect of my overdetermination, that I am at once both entirely determined and (in the case of the arm movement) entirely free. But explanations of this type (which in fact no longer explain but rather "explain away") can't be seen as satisfying either. I know I made a free decision to lift my arm, and for this reason, it is not the motives for this decision that are determining but rather the fact that I would not have lifted it if I had not wanted to. This negative side of my knowledge renders all objective explanations of the arm movement, even the dialectical ones, unsatisfying.

To this extent, the concept of "gesture" may be defined as a movement that expresses a freedom. The gesture, as the movement it is, is in fact determined, as are all other movements, and in this sense completely explainable. But what makes it unique is that, untouched by any of this, it expresses a subjectivity[1] that we are forced to call "freedom." Accordingly, the competence of a general theory of gestures would be the study and ordering of acts of expressions of freedom. It would not be a formal theory, for it would not be concerned with freedom but with its phenomenal, visible expressions. For this purpose, it would have to refer back to all accessible information that the relevant objective disciplines offer but could not stop there; for because it is dealing with expressions, it would be a study of meaning, a semiology. The dialectical tension between objective information and meaning would be the field to which it would necessarily apply.

Still, with such a definition of gesture and the competency of a general theory of gestures, the essential thing has not yet been said. For when I observe someone else's arm movement, I cannot be sure of deciphering his innerness, his freedom, directly. Freedom, rather, possesses the strange capacity to hide itself in the gesture that expresses it. Freedom has the capacity to lie. Because this capacity to lie appears to stand at the center of the phenomenon of gesture, it—and in connection with it the method of discovering the lie—must also be the center of a general theory of gestures. In this way, the theory takes on an ethical (even engaged) character. The definition can be reformulated: gesture is a movement through which a freedom is expressed, a freedom to hide from or reveal to others the one who gesticulates. Through this redefinition, the receiver of the gesture is drawn into the competence of a general theory of gestures, and the theory becomes a meta-theory of the theory of communication.

Some Methods

The foregoing definition of the concept of gesture was developed from an epistemological point of view. This was done in the interests of distinguishing one theory from another. But the definition reached in this way has the disadvantage of having grasped the gesture as a movement without speaking of what motivates it. To divide the class, gestures, into types, so as to be able to assign the relevant theory a field in which to work, our point of view with respect to the phenomenon of gesture must change. It will mean that specific gestures will have to be observed, that criteria will have to be found for ordering them. As Abraham Moles would put it, an inventory of gestures will have to be made. We may disregard the difficulty that is known to arise in such cases, that criteria must be presumed before the work can begin, but only the completed inventory actually affords criteria. The criteria that serve the purposes of the inventory can be discarded after use. What must not be overlooked, however, is the question of what motivates the gesture—for the answer to this question contains the most obvious criterion for the ordering of gestures.

Taking that which motivates it as a criterion, gesture can be divided into two types: (1) gestures in which a human body moves and (2) gestures in which something else connected to a human body moves. It is to be

understood from this definition that for type 1, not every movement of the body can be regarded as a gesture. Body movements for which an objective explanation is adequate, and that therefore are not expressions of freedom (e.g., closing the eyes in strong light or clenching the fist in pain), are not gestures, even if, phenomenally, they recall gestures vividly. With type 2, it would seem reasonable to start by calling things that move in such a way "tools." The concept of a tool can be defined in such a way as to encompass everything that moves in a gesture and, accordingly, everything that is an expression of some freedom. Calling tools extensions of body parts, and body parts tools of freedom, could, of course, render the proposed boundary unclear. But this would not be a good approach, for it conflates rather than articulates. For methodologically, it is exactly the difference between the gesture of moving fingers and the gesture of the moving pen that is of interest in determining the essential in each of the two gestures. For by seeing tools as instruments of freedom, it is possible to approach them from two different angles: from one standpoint, the pen may be regarded as a finger prosthesis (a lengthening outward, so a "finger extension") but, from another standpoint, as an "epithesis" of the pen (an inward extension of the pen, a "pen-internalization"). It soon becomes clear that research into the first type will emphasize methods different from those for the second; the first, for example, will need to rely more on physiology and, second, more on technology.

Type 1 may be subdivided by taking the movement of any one part of the body as a criterion. Such a classification will not be carried out here, because there would be too many subdivisions. Think of the delicacy needed just to distinguish, for example, between the gesture of waving with a finger and that of waving with a hand. At this point, it is necessary to point out, however, that gestures are not all equally relevant to the theory. In particular, the sort of gesture involving specialized parts of the mouth, such as the tongue or lips, would stand out. So it would turn out that a general theory of gestures would be a meta-theory of linguistics, because language is seen to be a particular kind of gesture. This would have decisive consequences for the methodologies of the theory proposed here. For language would no longer serve, as it always has, as a model for deciphering all other gestures (so that one speaks of a "language of dance" or a "language of pantomime"). On the contrary, a general theory

of gestures would have to furnish a model for deciphering the gesture of language.

Type 2 could be ordered by moving tools. Distinctions would have to be made between "hammering," "painting," "steering," "shooting," "writing," and so on. Again, the classification will not be carried out here. But just the thought of such an effort at classification is enough to indicate how far the competence of the theory proposed here would extend. It would encompass the field of all "genuine" activity, including activity that expresses a freedom. Those who up to now had had the impression that the designation "general theory" was framed too broadly may now be feeling that it is not the designation but the theory itself that is too general. As a danger, it cannot be dismissed, but this danger is already inherent in the definition of gesture itself. For as it was defined, it does in fact refer to human beings' active being-in-the-world. Despite the danger, the definition of gesture cannot be made narrower without losing the essence of the phenomenon. The etymology of the word *gesture* (from the Latin *gestae,* "acts, deeds"), too, in a sense, suggests the definition.

The classification of gestures suggested here gives the impression of the way methods whose theories would be at issue, and that at the beginning were referred to as an "interface," would intertwine. It becomes even clearer that the theory involves collaboration among completely different disciplines when one considers that the classification suggested here is just one among many possibilities (and not even the most interesting one methodologically). Overall, preference would be given to a classification that took the structure of a given gesture—the "core"—as its criterion.

Following this lead, four kinds of gestures might be experimentally defined: (1) gestures directed at others, (2) gestures directed toward a material, (3) gestures directed at nothing, and, finally, (4) gestures directed (back) at themselves. Type 1 might be called "strictly communicative gestures," type 2 "gestures of work," type 3 "disinterested gestures," and type 4 "ritual gestures." The first three could be grouped together under the heading "open or linear gestures," whereas the fourth would be elevated to a category of its own: "closed or circular gestures." Such a division comes with the proviso that both structures, presented as category-specific, appear mixed in any actual phenomenon of a gesture, and more, that no actual gesture belongs entirely in any of the four categories suggested

here. The four types, that is, represent a theoretical construction. Methodologically, that is not a disadvantage but rather an advantage. For the theory would then have to inquire of each specific gesture to what extent it was communicative, to what extent work, to what extent disinterested, and to what extent ritual.

Even with the classification just suggested (against which objections may be raised, eliciting countersuggestions), the danger of too broad a competency for the general theory of gestures is again inherent. For it presents itself as a meta-theory (1) of the theory of communication; (2) of the theory of work, including art criticism; (3) of a future theory of the absurd that would have to overlap that of art criticism; and finally, (4) of a meta-theory of magic and ritual. The individual categories would look something like the following.

With type 1, the communicative gestures, the theory would have to distinguish the gesture's message from its means, for example, that which is being said from how it is being said. Of course, these two aspects are dialectically bound together, but from a theoretical perspective, we are dealing with two different dimensions of the gesture. Deciphering an expression exposes the freedom of the one who gesticulates, that is, it shows the one who is deciphering whether the one who is gesticulating is concealing or revealing himself (whether he is being authentic). The deciphering of a message shows the decipherer what the gesticulating person meant (namely, whether the intersubjective expression rings true). We are concerned here with two different codes that need to be deciphered using different methods. Only when both codes are deciphered at the same time can we speak of a "genuine" communication. For only then is a gesture, say, of speaking, received by another. Then it would be clear that the sentence "The expression (the medium) is the message" rests on a confusion of codes, a confusion that would not occur if communication theory were integrated into a general theory of gestures. The need to distinguish between gestures, for example, between those in which the expression dominates and those in which the message dominates, would be clear as well. The error in the sentence from McLuhan quoted earlier can be traced back to the dominance of expression over message in television. Such an error could be avoided if television images were defined as gestures of category 2 with respect to the first classification (as moving

tools) and as gestures of type 1, communicative gestures, within a general theory of gestures. As this example shows, bringing communication theory into a general theory of gestures would change communication theory.

With type 2, gestures of work, the theory would first have to distinguish between "true" and disingenuous gestures. For if a gesture is defined as the expression of freedom, then the overwhelming majority of body and tool movements directed at materials would turn out not to be gestures. For although gestures that can be deciphered using objective explanations are ordinarily defined as work, most of the theory of work would lie outside the competency of a general theory of gestures. The theory does not address such movements as can be observed along conveyor belts, at bank teller windows, or on motorways, because entirely satisfactory explanations of these movements can be based on objective theories. Yet we cannot distinguish rigorously even between a gesture that is genuine and one that is not. So, for example, instances of genuine gestures of work could suddenly occur at the places mentioned. Then objective theories would no longer be valid for those places, and the general theory of gestures would have to take over. It suggests the tension that would arise between existing theories of work and the theory of gestures proposed here. Their competencies would overlap, and where they cross, the objective theories would have to yield to the general theory of gestures. In any case, the general theory would need to refer back to the methods of theories of work, without being able to adhere to them. Having separated "genuine" from "illusory" work (the "free" from the "alienated"), the theory would need to direct attention to the dialectic that plays out between the gesture and the material at which it is directed. Various materials would need to be studied, because the gesture, in changing them, accommodates itself to them. So the theory would need to take all workable materials into account (of whatever sort, whether reinforced concrete, musical sounds, or mathematical equations), if only from the standpoint of their malleability. From the standpoint of the theory, the result of the dialectic—the product of work—would be regarded as a gesture fixed in material and, as such, an appropriate object of study. Each work (e.g., a skyscraper, a hit song, or an economic forecast) would need to be deciphered as graphology deciphers letters: as a gesture that, despite being shaped by the material, has still managed to disclose a freedom. Broad areas of art criticism would

thereby come within the theory's competence. The cultural environment in which we find ourselves would thereby have taken on the character of a text to be deciphered, for its phenomena would be regarded as frozen gestures. The concept of the codified world would become methodologically fruitful. And the competencies of cultural and historical theory would be partly absorbed into the field of the general theory of gestures. This would mean that the general theory would need to reconsider the methods of the fields that have been absorbed.

With type 3, disinterested gestures, the theory would be on uncharted ground. Although it could start from Kant's *Critique of the Power of Judgment,* and although outstanding research has been done in this area (Gide's study of the *acte gratuit* and Camus's *Reflections,* on one hand, analyses of the behaviorists and gestalt psychologists, on the other), in addressing this sort of gesture, the theory would no longer be shedding new light on known phenomena but would rather be discovering something. Gesture as an expression of a freedom, which is its own purpose, the "empty" gesture, is certainly not art for art's sake, nor a game, nor a "theoretical being-in-the-world," although all these dimensions lie within it. What it is at its core could only be discovered by the theory proposed here. It would need to regard children's spontaneous jumping, action painting, or the play of pure logic in abstract symbols as disinterested gestures. In doing so, a number of disciplines enter into the theory's purview (e.g., game theory and decision theory), and these methods would be available to the theory of gestures. But in this area, the general theory of gestures would first have to formulate a specific theory of disinterested gesture. It seems likely that this specific theory would somehow touch the concept of the "sacred."

For type 4, ritual gestures, the theory would have to distinguish between "genuine" and "pseudo"-ritual. A genuine ritual (e.g., doffing one's hat to someone or saying prescribed prayers) is inherently as purposeless as disinterested gestures are but differs from them in having a fixed structure that is circular. A pseudo-ritual (e.g., spitting three times on the ground on seeing a black cat or appealing to the spirit of Èṣù in Candomblé) does at first appear to be another gesture without purpose but is in fact an action with a specific goal. A theory of gestures would accordingly have to take pseudo-ritual gestures (magic) out of the category of "ritual gestures" and

align them among "gestures of work," researching magic as a form of work (one kind of technology). "Real" ritual, conversely, which is radically antimagical by virtue of its purposelessness, would require other research methods. One question to pursue, for example, might be to what extent Judeo-Christian religion actually is antimagical, that is, truly ritual, and to what extent it incorporates magical elements (is Isaac's sacrificial gesture pure ritual, for example, or does it, like Iphigenia's sacrificial gesture, have a magical dimension?). Such a study would show any ritual gesture against two horizons: that of magic and that of purposelessness. This would make the methods of theology, philosophy of religion, mythology, and more available to the general theory of gestures. For ritual gestures probably constitute a significant part of all our everyday gestures, not necessarily just those with religious overtones. It may be that gestures such as tying ties, shaving, and eating with a knife and fork belong in this category. Psychoanalytic methods (especially for the study of neuroses and obsessive behavior) would become important for the theory of gestures at this point.

From a methodological standpoint, the classification of gestures according to structural criteria would therefore involve not only some research methods other than classification by phenomenological criteria but also the development of new methods. The same would probably be the case for all other possible classification criteria, the diversity of which has already been pointed out. Statistical criteria should be mentioned as well, for example, which would be used to classify gestures on the basis of the frequency with which they appear and also to engage the methods of information theory. Pragmatic criteria would be used to classify gestures on the basis of their effects, engaging the methods of sociology and anthropology. But in an initial sketch of the theory, it is not actually necessary to press further into possible kinds of classification. For the possibility, the danger, that the theory proposed here has far too broad a competence has already come into view. In fact, the danger cannot be dismissed, and a theory that is too general is unproductive, because it uses concepts that are very "elevated," which is the same as "empty." But competence is a field in which a discipline may be, but needn't necessarily be, applied. Which part of the competence of a given discipline is actually required depends on the methods being used. The methodology of a discipline extends beyond the limits of the discipline's competence; at the

same time, the methodology counterbalances that competence. The great generality of the theory proposed here is, then, an advantage rather than a disadvantage. The danger that the theory could become uninteresting as a result of being too broad is averted by the interest it evokes in methods that continually intersect.

The Relationship to the Philosophy of History

There can be no doubt that, in a specific sense, the "General Theory of Gestures" and the "Philosophy of History" are synonyms. If a gesture is defined as an expression of a freedom, that is, as an active being-in-the-world, then the sum of gestures *(res gestae)* is history. To turn the question around, the philosophy of history may be defined as a general theory of actions (which is to say, gestures). And still, it is just as clear that, in another sense, the theory proposed here would disavow the philosophy of history. For it would be antihistoric. Perhaps one could say that the history of philosophy would play out its role in a "posthistorical" situation, and this for two reasons in particular: first, the phenomena it researched would be microelements of those phenomena taken up by the philosophy of history—*micro-événements,* to use Moles's expression. In this way, the theory of gestures would be related to the history of philosophy in roughly the same way nuclear physics relates to Newtonian physics. Also, in such a theory, the temporal dimension is just one of four dimensions of space-time in which gestures occur, whereas in the history of philosophy, the temporal dimension forms the principal axis for events. So the theory of gestures would be related to the history of philosophy in roughly the same way as dynamic topology is to arithmetic. Following is an example to illuminate the doubled relationship of the theory to the history of philosophy, synonyms on one hand, antonyms on the other.

Suppose we set out to research "baroque." The general theory of gestures and the history of philosophy are equally competent for this problem and, in this respect, synonymous, inasmuch as the problem has the same significance for both: it is a matter of getting behind the baroque gesture to decipher the freedom expressed in it and in fact not, as for the other disciplines (even if they are equally competent), to find some sort of cause or motivation for the gesture, whether of an economic, social,

or psychological sort, so as to "explain" the baroque. The synonymy of the history of philosophy with the theory suggested here consists in trying not to explain but to decipher gestures in being theories of meaning (semiologies).

But they have an antonymic relationship in their attitude toward the task of deciphering the "baroque gesture." For the history of philosophy, the baroque gesture is primarily a "gesture of work" that has solidified into numerous concrete works. It is an "art form." From the concrete works, a specific kind of active being-in-the-world can be deciphered, which can be called the "baroque mentality." This mentality predominated at a particular time, for example, in seventeenth-century Europe, which can be established statistically using the source texts. Of course, that does not mean that the gesture occurs exclusively in the form of artworks. On the contrary, the history of philosophy must concede that there is a baroque style of communication, a baroque ritual, and a baroque absurdity (e.g., Cartesian discourse, a baroque way of doffing a hat and a baroque religiosity). And it certainly does not mean that this gesture occurs exclusively at the time called "baroque." On the contrary, the history of philosophy must concede that a baroque gesture may occur at any time. But it does mean that, for the history of philosophy, the baroque gesture is a "universal" phenomenon, the deciphering of which may be modeled on artworks of seventeenth-century Europe. In other words, for the history of philosophy, the baroque gesture is an expression of a being-in-the-world that may occur anywhere, at any time, but that predominated in Europe of the seventeenth century.

For the general theory of gestures, the "baroque gesture" is above all a specific aspect of ritual gesture as it can be observed in everyday life. It has a circular specificity, for it tends to distort a circular movement toward a parabola or ellipse. The theory of gestures might examine this baroque specificity in the movements of the spoons of people eating soup, so as to move from this and many other similar microelements to look for structurally analogue expressions in other forms of gesture, for example, for baroque elements in communicative gestures (newspaper articles, television programs, etc.), in gestures of work (freeway bridges, pipe forms, philosophical theses, etc.), and in disinterested gestures (e.g., gestures in the nursery, outbursts of anger, or among audiences for a football game

or a television program). Having made an inventory of gestures with a baroque character, the theory could research materials most and least appropriate to them. It could then refer to plaster or arithmetic equations as "baroque materials" and window glass or Morse code as "antibaroque materials." The theory could go on to draw a picture of the freedom expressed in the baroque gesture: a freedom that tends to be in the world ritually and that expresses this tendency in all its actions. This is only an example—for the theory proposed here, the baroque gesture is one aspect of many (possibly all) observable gestures.

The antinomy between the history of philosophy and the theory of gestures can perhaps be summarized as follows: the history of philosophy regards the gesture as a "universal phenomenon" in which a "universal human freedom" comes to expression (e.g., Hegelian spirit or Marxist subjectivity) so that the freedom does, in the course of time, come to expression. By contrast, the theory proposed here regards the gesture as a "quantized phenomenon" in which a specific, individual being-in-the-world is expressed in each instance, so that the expression occurs in a space-time specific to the individual, whereby an individual can, for his part, be considered a knot in an intersubjective network.

At first glance, it could look as though we are not dealing with an antinomy at all but only with different yet reciprocal points of departure. One might argue as follows: the history of philosophy proceeds analytically and finally reaches the individual gesture, at the end of its analysis. The theory proposed here, by contrast, proceeds synthetically and at the end reaches the vista of the history of philosophy. But this argument rests on an error. For the history of philosophy starts from the premise that freedom exists in time, and in fact in a very specific time: the linear. It depends on this hypothesis for grounds on which to analyze the phenomenon of gesture at all. The general theory of gestures suggested here tries, conversely, to proceed with as few assumptions as possible. This is why it is forced, so to speak, to take the concrete phenomenon of a single gesture as its starting point. So we are dealing with a genuine antinomy, one that has become familiar as that of "water and sand." The trickling kernels of sand called "gestures" vividly recall the historicist "flow of gestures," but this similarity is misleading. For in the history of philosophy, process is paramount, whereas for the theory proposed here, process is an extrapolation from

a concrete phenomenon. So the history of philosophy and the general theory of gestures are synonymous only inasmuch as both are disciplines that try to decipher gestures as expressions of a freedom. Yet there is an antinomy between them inasmuch as for the one, an individual gesture is the expression of a hypothetical "universal" freedom that develops in linear time, whereas for the other, this "universal" freedom (and linear time as a whole) represents a theoretical extrapolation from concrete, individual gestures. The antihistorical character of the theory proposed here is an important aspect of its anti-ideological character. The history of philosophy is necessarily ideological. The general theory of gestures would, conversely, act as a history of philosophy without ideology.

The Engagement

One criterion for judging theories is their applicability to practice, that is, to what extent they could figure in the training of technicians. Conversely, there clearly are technicians who have no theoretical grounding. People have been gesturing since who knows when without having a general theory of gestures and without feeling the lack of such a theory. Still, this is not an argument against the necessity of risking such a theory. People made working gestures from who knows when until the sixteenth century with no theory of work and without feeling the absence of a theory of work. And nevertheless, the theory of work, slowly developed under the impetus of mechanics, changed the human gesture of work so fundamentally that since the Industrial Revolution, we have been forced to attribute a completely different meaning to the concept of "work." The inquiry, then, would be, does the theory suggested here have practical implications for the technologies of human gesture, and if so, what are they?

This question can be approached from two angles: from practice as well as from theory. With respect to practice, it is no longer quite the case that no one senses the lack of such a theory. In some strange way, gesticulation has recently become "more conscious" (more conscious of its own technicity, that is) than it was before. It is easy to find examples of this change in practical attitude toward gesture: therapies known by the name *body expression,* for example, or the *happening* as "pure gesture" or phenomena such as *living theater* or *action painting.* That this change in

attitude toward gesture has characteristically spread from America, by the way, suggests that it is a symptom of a general revolutionary change. One result is the beginning of a search for theories of gesture. It has been shown that among the theories currently available, Wilhelm Reich's stands out as perhaps the best formulated. Even it suffers the disadvantage of being "special," however. At issue are psychoanalytic, behaviorist, sociological, and aesthetic theories (etc.), all of which try to grasp and explain gesture from the perspective of more or less well established academic disciplines. For reasons that have already been discussed, such efforts miss the essential thing about gesture. They don't consider gesture theoretically at all; their theoretical object is, rather, conditioned movement. But the practice of gesticulation itself gives rise to a demand for another theory of gesture that is not "special" but general.

From a theoretical point of view, the question presents itself differently. If gesture is defined as the expression of a freedom, then the question of gesture's technical dimension seems self-defeating. For there seems to be a contradiction between a "free" gesture and an expression that is technically "prescribed." One might be inclined to say that when a gesture is technically informed, it is no longer free (and so is no longer a gesture). But this is a naive error. For what makes a movement a gesture is not that it is free but that a freedom is "somehow" expressed in it. And "somehow" means "by means of some technology." The technical application of a theory of gestures would not touch on the fact *that* a freedom expresses itself in the gesture but on *how* it expresses itself. Nevertheless, such an application would probably have far-reaching consequences for active being-in-the-world, for it would permit a gesticulating person to be theoretically aware of his gestures and so to draw back and away from them. Such a "formal" transcendence would surely have practical consequences. One would act differently.

For the time being, such a step back can be achieved only speculatively and so remains for the most part utopian. And yet it is already clear that it would provide a distance from which a person could "technically" control his own being-in-the-world. An enhanced rather than a diminished freedom would then come to expression in a gesture. This sums up the engagement of the theory presented here: to contribute to an enhanced freedom, and to be able to actually make gestures in the full sense of the

concept defined previously. That would mean, however, to be able to step outside history, continuing to act, in fact acting truly "historically," for the first time. Such a theory would not be value free; rather, its value would be freedom. It would consciously be an instrument of liberation and so antiacademic. But because it would be "formal," it would simultaneously be antihistorical (anti-ideological). In this sense, the theory of gestures would be a discipline of a future that would call itself "posthistorical": a discipline of so-called new people—in theory as well as in possible practice.

We are probably in a revolutionary situation (although we cannot get an overview and therefore cannot say with certainty whether it is "objectively" revolutionary). This, our feeling of being in a revolution, manifests itself as, among other things, a sense of having to reorient ourselves to be able to act at all, as a sense of needing to develop new kinds of theories. The suggestion of a general theory of gestures came from such feelings: of gestures, because they concern the concrete phenomenon of our active being-in-the-world, and of revolution, because a revolution is always, in the end, about freedom.

Translator's Notes

Translator's Preface

1. "Editorische Notiz," in *Gesten: Versuch einer Phänomenologie* (Dusseldorf, Germany: Bollmann, 1991), 277.

2. In his English version of "The Gesture of Writing," Flusser writes that, although ideas can and do occur to him in any of the languages he knows, they most often occur in German. "The Gesture of Writing," *New Writing: The International Journal for the Practice and Theory of Creative Writing* 9 (2012): 33.

3. This hierarchy is based on the proportion of texts in each language now preserved in the Flusser-Archiv, Universität der Künste, Berlin.

4. Flusser, "Gesture of Writing," 33.

5. Rainer Guldin, *Philosophieren zwischen den Sprachen* (Munich, Germany: Wilhelm Fink, 2005), 280.

6. Ibid.

7. Anke Finger, Rainer Guldin, and Gustavo Bernardo, *Vilém Flusser: An Introduction* (Minneapolis: University of Minnesota Press, 2011), 48–50.

8. Vilém Flusser, *Does Writing Have a Future?*, trans. Nancy Ann Roth (Minneapolis: University of Minnesota Press, 2011), 33.

9. Finger et al., *Vilém Flusser*, 61–62.

10. "Editorische Notiz."

11. Flusser, *Does Writing Have a Future?*, 44.

Gesture and Affect

1. The German word *Gestimmtheit,* which also appears in the chapter title, raises difficult questions for a translator. It is a construction that turns the idea of a mood, state of mind, or feeling *(Stimmung)* into a more generalized substantive, something like "the condition of experiencing" a mood

or feeling. Perhaps following a similar pattern of word formation, Flusser chose the English *sentimentality* ("Gesture and Sentimentality," typescript, Flusser-Archiv, Berlin) as an equivalent. And yet a contemporary reader of English will almost certainly make many associations with sentimentality that seem distant from the meaning the author is trying to "ambush" (as he puts it) in this essay. The word *attunement,* an equivalent that has appeared in other translations of German philosophy, has the distinct advantage of emphasizing the idea of intention, the phenomenological understanding that consciousness is always consciousness of something, toward which that consciousness is directed, or "attuned." Still, the word *affect,* "the conscious aspect of an emotion considered apart from bodily changes; *also*: a set of observable manifestations of a subjectively experienced emotion, e.g., patients . . . showed perfectly normal reactions and *affects*—Oliver Sacks" (Merriam Webster, s.v. "affect"), seemed a better overall match. Not only does its use extend to a number of disciplines, serving one of the important purposes of Flusser's theory of gesture as a whole, but it unites the sense of an internal experience with its external, observable manifestation.

2. The German word *Stimmung* has a broad range of meanings, including "mood," "emotion," and "subjective view"; "states of mind" is intended to be inclusive.

3. The play between *art, artifice,* and *artificial* circles the same area as the play among the German words *Kunst* (art), *künstlich* (artificial, synthetic), and *artifiziell* (inauthentic, disingenuous) that Flusser uses in this passage. But the individual terms don't match smoothly. The idea he is proposing, that meaning is always *made* rather than "natural," challenges the conventional understanding of these terms in either language.

The Gesture of Speaking

1. Within Flusser's writing on communication, these two terms are regularly encountered together, distinguishing between two different kinds of communication. Discourse preserves and distributes information within a given society. Most print and broadcast media function in this way. Dialogue, a free exchange of information stored in memory—human or artificial—has the potential to generate new information. In fact, it is the only way this is possible. Some information generated in dialogue is usually absorbed into discourse and preserved, and some is lost. Both modes are essential, yet one can overpower the other. As Flusser describes it, discourse is overpowering dialogue in contemporary society, threatening to undermine our capacity for invention, change, surprise. Flusser, *Into the Universe of Technical Images,* 83–84.

The Gesture of Making

1. In Plato's *Symposium,* Aristophanes relates a creation myth involving three original sexes: female, male, and androgynous. *Plato: The Collected Dialogues,* ed. Edith Hamilton and Huntington Cairns (New York: Pantheon Books, 1963), 542.

2. In a 1939 essay titled "Proof of an External World," *Proceedings of the British Academy* 25 (1939): 273–300, George Edward Moore (1873–1958) put forward an argument for common sense and against philosophical skepticism. To substantiate the claim to know that he had two hands, he raised one, saying, "here is a hand," and then raised the other, saying, "and here is another." Knowing that there are at least two objects in the external world, he is justified in rejecting the skeptical premise that there are none. The argument has come to be known as "Here is a hand."

The Gesture of Loving

1. The German word is *Passion,* ordinarily a cognate for the English "passion," despite the apparently conflicting sense of "letting go" it carries in this passage.

The Gesture of Destroying

1. The negative particle *not* does not appear in the German text. Given the sense of the sentence, its absence seems to be a misprint, in both German editions.

2. Although the use of *disturb* seems strangely mild in the rest of the chapter, it has been retained to preserve the distinction between disturbance and destruction Flusser makes at the beginning, using German words.

The Gesture of Filming

1. In the German text, the word is in English and in the past tense, i.e., *traveled,* which appears to be an error.

The Gesture of Listening to Music

1. France Musique is a public radio station owned by Radio France.

The Gesture of Smoking a Pipe

1. The word *Negerkunst* might be translated as "black" or "African" art. As becomes clear in the remainder of the essay, in any case, the analysis relies on Flusser's experience of art forms practiced in Brazil among people of African and European descent.

The Gesture of Telephoning

1. The German is *pathetischste*, literally, "the most pathetic."

The Gesture of Searching

1. The word *Wissenschaft* is most often translated as "science." In this context, however, it takes on associations with an older, broader, and more literal meaning, a "condition of knowing."

Appendix

1. *Innerlichkeit*, literally, "inwardness."

Index

adequatio intellectus ad rem, 30
aesthetic criteria. *See* criteria,
 aesthetic
affect: as a means of representing
 states of mind, 5; proximity to
 art, 5–6
ager (field), as opposite of *oikós*
 (science of relationship), 104
agricultura: as controlled agitation,
 104; as reversal of hunting and
 gathering, 101
agriculture, as domination of
 nature, 101
alienation, 40
alphabet: compared to videotape,
 143; eliminated from telephone
 code, 137; as factor in
 development of writing, 20; as
 inadequate to contemporary
 problems, 25; stored in
 typewriter, 2; unnecessary for
 computer function, 24
analysis: as extrapolation from
 concrete phenomenon, 66–67;
 historical, 89; self-, as feature
 inherent in gestures such as
 painting, 65, 69, 70; semantic,
 turns phenomenon into enigma,

65; structural, compared to
 gesture of filming, 89
analysis, causal: as distinct from
 semantic, 65; insufficient to
 analyse a movement that
 points toward something, 64;
 insufficient to explain an enigma,
 64; turns a phenomenon into a
 problem to be solved, 64
apparatus: body as, 106; camera
 as, 74, 77, 80; camera as
 "categorical," 80; as end of
 history, 18; film as "processual,"
 80; film as projection, 88; formed
 by synchronization of machines,
 15; human being as attribute
 of, 16; human body enmeshed
 with, 80; impossible to question
 cause or purpose of, 17; as
 indispensible for human life, 16;
 power of, 145; shaver as, 106;
 society as, 152; telephone as,
 135–38; work as function of, 14
Arendt, Hannah, 125
art: in relation to affect, 5–6,
 9; African, as "purer" than
 Western, 129, 131; for art's
 sake, 18, 169; "better than

Vilém Flusser (1920–1991) was born in Prague. He emigrated to Brazil, where he taught philosophy and wrote a daily newspaper column in São Paulo, then later moved to France. He wrote several books in Portuguese and German. *Writings* (2004), *Into the Universe of Technical Images* (2011), *Does Writing Have a Future?* (2011), and *Vampyroteuthis Infernalis* (2012) have been published in English by the University of Minnesota Press. He was killed in an automobile accident in 1991.

Nancy Ann Roth is a writer and critic based in the United Kingdom. She was the translator of *Into the Universe of Technical Images* and *Does Writing Have a Future?*